Future Texts

Electracy and Transmedia Studies
Series Editors: Jan Rune Holmevik and Cynthia Haynes

The Electracy and Transmedia Studies Series publishes research that examines the mixed realities that emerge through electracy, play, rhetorical knowledge, game design, community, code, and transmedia artifacts. This book series aims to augment traditional artistic and literate forms with examinations of electrate and literate play in the age of transmedia. Writing about play should, in other words, be grounded in playing with writing. The distinction between play and reflection, as Stuart Moulthrop argues, is a false dichotomy. Cultural transmedia artifacts that are interactive, that move, that are situated in real time, call for inventive/electrate means of creating new scholarly traction in transdisciplinary fields. The series publishes research that produces such traction through innovative processes that move research forward across its own limiting surfaces (surfaces that create static friction). The series exemplifies extreme points of contact where increased electrate traction might occur. The series also aims to broaden how scholarly treatments of electracy and transmedia can include both academic and general audiences in an effort to create points of contact between a wide range of readers. The Electracy and Transmedia Series follows what Gregory Ulmer calls an image logic based upon a wide scope—"an aesthetic embodiment of one's attunement with the world."

Books in the Series

Future Texts: Subversive Performance and Feminist Bodies, edited by Vicki Callahan and Virginia Kuhn (2016)

FUTURE TEXTS

SUBVERSIVE PERFORMANCE AND FEMINIST BODIES

Edited by Vicki Callahan

and Virginia Kuhn

Parlor Press
Anderson, South Carolina
www.parlorpress.com

Parlor Press LLC, Anderson, South Carolina, USA
© 2016 by Parlor Press
All rights reserved.
Printed in the United States of America on acid-free paper.

S A N: 2 5 4 - 8 8 7 9

Library of Congress Cataloging-in-Publication Data

Names: Callahan, Vicki, editor. | Kuhn, Virginia, 1961- editor.
Title: Future texts : subversive performance and feminist bodies / edited by Vicki Callahan and Virginia Kuhn.
Description: Anderson, South Carolina : Parlor Press, 2015. | Series: Electracy and transmedia studies | Includes bibliographical references and index.
Identifiers: LCCN 2015038076 (print) | LCCN 2015040148 (ebook) | ISBN 9781602357679 (pbk. : alk. paper) | ISBN 9781602357686 (hardcover : alk. paper) | ISBN 9781602357693 (pdf) | ISBN 9781602357709 (epub) | ISBN 9781602357716 (iBook) | ISBN 9781602357723 (Kindle)
Subjects: LCSH: Women in mass media. | African Americans in mass media. Mass media--Social aspects.
Classification: LCC P94.5.W65 F88 2015 (print) | LCC P94.5.W65 (ebook) | DDC 700/.4522--dc23
LC record available at http://lccn.loc.gov/2015038076

1 2 3 4 5

Electracy and Transmedia Studies
Series Editors: Jan Rune Holmevik and Cynthia Haynes

Cover image: HERadventure by Ayoka Chenzira & HaJ, 2012. © Ayoka Chenzira. Photo courtesy of Ayoka Chenzira. Used by permission.
Copyeditor: Jared Jameson. Indexer: Meagan Blakesley

Parlor Press, LLC is an independent publisher of scholarly and trade titles in print and multimedia formats. This book is available in paper, cloth and eBook formats from Parlor Press on the World Wide Web at http://www.parlorpress.com or through online and brick-and-mortar bookstores. For submission information or to find out about Parlor Press publications, write to Parlor Press, 3015 Brackenberry Drive, Anderson, South Carolina, 29621, or email editor@parlorpress.com.

Contents

Acknowledgments *vii*

1 Introduction *3*
 Vicki Callahan and Virginia Kuhn

Part 1: Afrofuturism in Popular Culture 11

2 The New "Material Girls": Madonna, "Millenial" Pop Divas, and the Politics of Race and Gender *13*
 Shelleen Greene

3 A Window Seat to History: Erykah Badu's Dealey Plaza Remix *27*
 Vicki Callahan

4 The Possibilities of Liminality: Black Women's Future Texts as Productive Chaos *43*
 Nina Cartier

5 Re-Creating Niobe: The Construction and Re-Construction of Black Femininity through Games and the Social Psychology of the Avatar. *60*
 Nettrice R. Gaskins

6 "Ghana Meets the World": Remixing Popular Culture on OMG! Ghana *75*
 Lorien R. Hunter

Part 2: Feminist Disruptions of Gender and Narrative Codes 89

7 Adapting Lisbeth for Hollywood: The Politics and Franchising Practices behind Sony's *GWTDT* Reboot *91*
 Courtney Brannon Donoghue

8 Recasting The Best Years of Our Lives: Gender, Revision, and Military Women in the Veteran's Homecoming Film *110*
 Anna Froula

9 Television's Queer Future? The Possibilities and Limitations of Web Series, Digital Distribution, and LGBT Representation in *Husbands* *128*
 Melanie E. S. Kohnen

10 *Sucker Punch* and the Aesthetics of Denial: Future Perfect Tense *149*
 Virginia Kuhn

Contributors *165*

About the Editors *169*

Index *171*

Acknowledgments

Our collection emerged from two conferences, the Society for Cinema and Media Studies (2011) and Console-ing Passions (2012). We were excited by the diversity of perspectives and topics taken on by young feminist scholars at the events, and we decided to organize a collection around some of the provocative work presented. We send our appreciation to our contributors for their enthusiasm with the project as well as their timely submissions and responsiveness to our feedback.

We also would like to thank Dr. Ayoka Chenzira (Spelman College and Ayomentary Productions) HaJ (Urban Chameleon Media) for permission to use an image from their project, *HERadventure*. Our thanks as well go to Nettrice Gaskins, one of our contributors, for connecting us to the artists.

Our sincerest gratitude is also extended to Cynthia Haynes, Jan Rune Holmevick, and David Blakesley for supporting our belief in a collection that ranges across genres, methods, and points of view. We were delighted to find editors who recognized that cohesion often is invoked in the service of ideological rigidity. Our hope was that a break from formulaic structure and theoretical uniformity would lead to a more robust dialogue on the urgent issues of race, gender, and sexuality.

The labor of bookmaking is not often remarked upon and yet, like any text, the formal and conceptual elements are inextricably bound. Indeed this link between form and content is a key theme of the collection. Thus, we offer our sincere thanks to Jared Jameson for his keen eye and thorough work copyediting the manuscript. We also acknowledge the excellent work that takes place in the summer HASTAC event, the Feminist Scholars Digital Workshop (FSDW). The FSDW provides a space, unbounded by geography, where feminist scholars can share their work with like-minded individuals. Indeed, one of us received excellent feedback via the FSDW for her contribution to this collection.

Future Texts

1 Introduction

Vicki Callahan and Virginia Kuhn

This collection sketches several possibilities for "future texts"—those alternative languages and writings that imagine new pathways through the forms and formats used to express contemporary questions of race, gender, and identity. The collection's area of investigation is situated within popular culture, not as a place of critique or celebration, but rather as a contested site that covers an increasingly splintered terrain. Our use of "future texts" was inspired by and an intentional nod to Alondra Nelson's introduction to the special issue of *Social Text* on Afrofuturism that dismantles the utopian trajectory of the digital world founded on an erasure of history and racial difference via technology and tacit assumptions about its liberatory potential. As feminists who imagine a space of dialogue that resists old binaries and imagines new paths across a variety of divides, we are also mindful of the array of histories, voices, bodies, and technologies that have not been served by the dominant narrative. Thus, following Nelson, we see the value of Ishmael Reed's conception of *synchronizing*, of mixing disparate artifacts within a single timeline, since, it is only by viewing them simultaneously that the gaps and contradictions in a heretofore seamless through line can be viewed. The essays in this collection address such synchronized "texts" as they confront the possibilities of new media. Likewise, the collection itself enacts a form of synchronization as it unites two groups of texts: those which problematize race as a first concern, addressing the ways in which emergent digital formats may unsettle hegemonic structures, and those which primarily focus on sexuality and traditional narrative form in general and, specifically those that, in some way, betray the impact of digital technologies.

Indeed, the impetus for this collection came from two events: The first one was a presentation given at the annual conference of the So-

ciety for Cinema and Media Studies that focused on Afrofuturism and emergent media. The panel, which included several of the authors in the first part of this collection, speculated about the possibilities for a revitalized approach to identity politics that might offer a space for intervention, primarily in issues of race, though we also considered the complications of adding gender to the equation. The second event came a few months later during the twentieth anniversary of the Console-ing Passions conference, in a panel centered on emergent media and, primarily, its implications for issues of gender equity. This panel, which included many of the authors in the second section of this volume, speculated about the liberatory potential of the breakdown of inherently patriarchal narrative structures. Both panels, we felt, touched on issues that are absolutely vital to consider in the context of contemporary culture, they both demanded further investigation and, combined, they would create a whole that is stronger than its constituent parts. In other words, we felt that putting these essays into conversation with each other, synchronizing them, would enrich each and every one.

While there is a valuable and established tradition that runs through feminist writing founded on avant-garde and experimental types of expression that counters classical narrative lines, and by extension, disrupts patriarchal culture, that approach has far too often failed to consider fully issues of race and class. This is especially evident in the dilemma faced by black feminists who, alienated from dominant feminism's failure to consider their experience, have been forced to choose whether they were black or women first. Indeed, as bell hooks recounts the white feminists who "did not welcome our questioning of feminist paradigms that they were seeking to institutionalize" even as "many black people simply saw our involvement with feminist politics as a gesture of betrayal, and dismissed our work." There was simply no room for conceptualizing or practicing a black woman's full identity.

In an attempt to push back against such myopic splintering, this collection begins with the politics and aesthetics of Afrofuturism, only then turning to recent feminist explorations across an array of media forms, from music video, to games, to global journalism. In concert, these future texts create a discourse that is both within and outside formal history, within and without conventional storytelling and its attendant formats. The essays enact a type of polyvocality that honors commonality as well as difference, the political and the personal, con-

vergences and divergences. This approach is intended to offer enough structure to demonstrate and illustrate the intransigence of inequities, while simultaneously avoiding the trap of over-generalization that can become simply another form of rigidity, one that becomes as alienating as it is inclusive.

Likewise, we felt the need to enact a polyvocal approach in this introduction that is meant to contextualize and historicize the often implicit through lines of the collection. Thus, much of the introduction is constructed as a dialogue. This format not only allowed us to exert our individual voices, but it also helped us to conceptualize an appropriately contingent and situated academic intervention. This is fitting, particularly when considering the perpetually shifting discursive events that coalesce around popular culture. But this approach also forced us to consider our own imbrication in the (semiotic) systems that dominate the cultural landscape, forcing the sort of self consciousness that is key to critical consciousness and is incumbent upon academics, without exception, to consider. As feminists though, we hold ourselves doubly accountable, for it is not enough to critique structural inequity, we must also offer alternatives, however fleeting they may be.

VC: It seems as though we are at a time when people are once again seeing a "new wave" of feminism, on the popular culture front but also with a renewed vibrancy within academic discourse. On one hand, we might see this as another generational wave ready to make its contributions to gendered equality and human rights concerns. We might also attribute the resurgence to the rise of networked feminism through social media; the numerous blogs, Facebook groups, and dynamic feminist Twitterverse that have connected and extended the discussion on issues around gender and sexuality, representation, identity formation, and structural forms of oppression. There is a certain immediacy, and indeed even effectiveness, in the transmissions of information along social media channels that have brought urgent issues and events into the public discourse, such as birth control and health care (Sandra Fluke's Congressional testimony, Wendy Davis's filibuster in Texas Assembly); representation of women in media (Anita Sarkeesian and GamerGate harassment); and domestic violence (Ray Rice's videotaped assault on his then fiancée and now wife, Janay). Each of these began as personal efforts or dramas that quickly entered into the public sphere and sparked larger debate and directed campaigns for change.

However, in some sense, one is tempted to ask, what is the "new" in this wave. The issues above are certainly not new issues and there is a certain repetition in the patterns that is daunting and dispiriting from an activist perspective.

Feminist theorists have long noted that any real change must be accompanied by reimagined personal, social, and political possibilities, but as Elizabeth Grosz has pointed out, "thinking the new" is extremely difficult since we must move beyond established systems of knowledge and power (16). Rosi Braidotti more directly asks, where does "the new come from?" (*Nomadic Subjects,* 3). Both thinkers, Braidotti and Grosz, point to strategies or poetics of movement (Braidotti's "nomadic subjects" and Grosz's "becomings") as a way out of our fixed locations and intractable roadblocks. The question for our collection is, how can mediaworks contribute to the "new" and this poetics of change?

VK: The Eugene Lang College at the New School recently conducted a series of conversations with prominent cultural critic bell hooks in order to address the current state of gender and racial issues in the US. In one aptly named conversation—"Are You Still a Slave?"—hooks maintained that contemporary assaults on feminism nearly always issue from visual media. She then adds that she finds pop singer Beyoncé to be, in many ways, anti-feminist, since her images comprise one such assault, making her a terrorist, and this is especially true when considering the impact of these images on young girls. hooks notes that the "tirades against feminism" are rampant in the "image making business," and Beyoncé is a main offender.

VC: Beginning a discussion of Beyoncé at the level of the image rather than her musical style or lyrics is a good place to start, as it brings to mind Braidotti's essay on posthumanism, in which she notes that this era has "turned visualization into the ultimate form of control," arguing that it "marks not only the final stage in the commodification of the scopic, but the triumph of vision over all other senses" (204). To be specific, Braidotti is not asking us to discredit our visual senses as flawed or deceptive, but rather to understand the structure of looking that is integral to our ways of thinking and knowing. That is, a system of "disembodied viewing" that sets out an all-knowing and unbiased subject that objectifies and consumes all that is before it. Bringing this back to Beyoncé, and specifically to her 2014 VMA performance,

that's where Braidotti's argument hits home for me. Musically, we had a series of greatest hits snippets aligned with Beyoncé's textbook performance of classic scopophilia—and here I mean the explicitly male subject pleasure of looking at the female body as object as well as the female "pleasure" or rather participation in this regime by her own pleasure to be looked at (as an object). This culminates with the stage going dark and the giant text of "FEMINIST" etched across the stage with the shadow of the singer standing in front. Now the spectacle of the star's body and the spectacle of the word, "feminist," collapse, melt together. There is nothing in the performance, in the visual structure of the segment that does anything to disrupt the "disembodied" viewing that we have known for far too long.

VK: Yes, exactly. And the very pairing of this particular word with this particular image demonstrates both the power and the danger of disembodied viewing: the word need not justify its pairing, the spectacle need not situate itself in history, nor make any claims capable of being interrogated, nor is there any nuance or finesse to the word/image pairing. It's little more than a visual soundbite, emblematic of the increasing paucity of contemporary cultural communication and the attention economy that, by its very nature, encourages hyperbolic headlines and engenders binaries. Indeed, in response to bell hooks's rather nuanced discussion of Beyoncé's imagistic assault on feminism, the online headlines screamed "bell hooks calls Beyoncé a terrorist." (Although I must confess that part of me would love to see that VMA moment rewritten, Guerilla Girls style, with the word TERRORIST replacing the word FEMINIST.)

VC: These pop cultural moments, which much like the Emma Watson "HeforShe" UN speech/campaign, were praised by many as a "breakthrough" moment for feminists, suffer from the same point of departure, which is in fact a string of uncontested binaries that a "disembodied," detached, objective, male observer is essential to the acknowledgement and well-being of the object, female.

VK: The Emma Watson campaign I find particularly interesting given its reactions, parodies and semi-tenuous links to the infamous 4Chan's leak of celebrity nude photos. On the one hand, my experience with undergraduate students who are often resistant to seeing sexism as a contemporary issue—and this has been especially true of

white females—persuades me that any time a young woman in the public eye invokes the mantle of feminism and includes men in the struggle, it can't help but be productive. On the other hand, as has been eloquently argued by Mia McKenzie among others, Watson's discussion of men not being invited to the conversation, along with the ways in which they also "suffer" from patriarchy ignores the very real struggles of women worldwide while consolidating the centrality of men in one of the few spaces not previously occupied.

VC: It is at these moments, which are accompanied in the press by incessantly cheerful proclamations about the "new generation" of feminists that Donna Haraway's "informatics of domination" is particularly instructive. By this phrase, Haraway is underlining the intersecting systems of power of race, class, gender, and nation, which are of course standard categories for feminist analysis, but also asking us to reconsider the very categories themselves. Something has changed in the circuits and networks of power that has altered the scopic regime's impact on discourses of difference. This is not to say that difference is erased, insignificant, or ineffective, but that the language we employ (visual, textual, spoken) must find new ways to confront the old binaries, even including the binary of patriarchal set against *feminist* since the term *feminist* itself faces appropriation through the spectacle of the commodity and celebrity culture.

VK: But is it a case of something actually having changed in the circuits and networks of power? The "informatics of domination" is one of the foundational concepts of Haraway's prominent *Cyborg Manifesto* and one that she has refused to edit in the nearly quarter century since its publication. She finds the concept's usefulness, however limited, in its refusal to a-historicize information, while also acknowledging that "the networks are not all powerful, they're interrupted in a million ways" and, although they sometimes look like nothing more than a "house of cards" it's because they are neither and they are both.

While there is no denying the profound impact of the "turn to the visual" on issues of difference, the dangers and potentials are both present. In adopting bell hooks's view of "feminism" as a verb, a movement, Haraway brings the possibility of nuance among these contradictions. And it seems to me that this view of feminism as verb—similar to Braidotti's "nomadic subjects" and Grosz's "becomings"— proves especially useful in mobilizing the "informatics of domination," since

as a conceptual frame it is particularly helpful in its acknowledgement of both the power of names and naming, but also the systemic nature of semiotic dominance, as well as its vulnerability.

VC+VK: With movement in mind, the future texts in this collection attempt to break the scopic regime's "disembodied viewing" by examining feminist texts and feminist works that operate within, across, and against the informatics of domination, adding performance and play via strategic synchronizing. Sampling and remixing are powerful techniques in all cases, and history and aesthetic precedent provide insight into efforts to configure truly new forms for language, culture, and identity. With a paradigm of remix as linguistic play and reconfiguration, the book's chapters confront the question of narrative codes and conventions. More specifically, they examine the ways in which emergent platforms, such as YouTube and web-based TV, as well as cross-platform storytelling (from books to film to games) alter or abet gendered conventions. Most importantly, we argue these new forms and formats re-write the relationship between *hegemonic* and *resistant* texts so that each iteration from either "side" of the spectrum cannot be easily segmented into binary understandings of race and gender. The effect is truly *uncanny*, that is, the familiar (divides) are made strange. Thus the collection closes with an essay that explores the return of the repressed as an uncanny female body turned back against the *post-racial* and *post feminist* mythology.

Works Cited

Braidotti, Rosi. *Nomadic Subjects: Embodiment and Sexual Difference in Contemporary Feminist Theory*. New York: Columbia UP, 1994. Print.

—. "Posthuman, All Too Human: Towards a New Process Ontology." *Theory, Culture & Society* 23.7-8 (2006). 197-208. Web. 4 Oct 2014.

Eugene Lang College, New School. "Are You Still a Slave? Liberating the Black Female Body: A Public Dialogue with bell hooks." Online video. YouTube, 7 May 2014. Web. 15 September 2014.

Gane, Nicholas. "When We Have Never Been Human, What is to Be Done: Interview with Donna Haraway." *Theory Culture Society* 23 (2006): 135–158. Print.

Gross, Kali. "Black Women are Already Dead in America." *HuffPost Black Voices*. 15 Sept. 2014. Web. 30 Sept. 2014.

Grosz, Elizabeth. "Thinking the New: Of Futures Yet Unthought." *Becomings: Explorations in Time, Memory, and Futures*. Ed. Elizabeth Grosz. Ithaca: Cornell UP, 1999: 15–28. Print.

hooks, bell. *Teaching to Transgress: Education as the Practice of Freedom*. New York: Routledge, 1994. Print.

Nelson, Alondra. "Introduction: Future Texts." *Social Texts*, 71 20.2 (2002): 1–15. Print.

McKenzie, Mia. "Why I Am Not Really There for Emma Watson's Feminism Speech at the UN." *Black Girl Dangerous*. 24 Sept. 2014. Web. 30 Sept. 2014.

Robinson, Joanna. "Watch Emma Watson Deliver a Game-Changing Speech on Feminism at the UN," *Vanity Fair*. 26 Sept. 2014. Web. 30 Sept. 2014.

Part 1: Afrofuturism in Popular Culture

In his essay "Black to the Future," Mark Dery notes that African-American culture is Afrofuturist at its core, "[c]oncretizing [William] Gibson's shibboleth, 'The street finds its own uses for things'" (185). The authors in this section examine an array of artists who sample and reconfigure images, sounds, gestures, and even spaces of cultural capital that, once remixed, serve to create what we label *future texts*. The future texts that Alondra Nelson describes—following Ishmael Reed's discussion in the novel *Mumbo Jumbo*—are those works that reveal a merging of the past, present and future, and offer "a vision of the future that is purposely inflected with tradition" (8). Besides a temporality that is characterized by *synchronicity* crossing disparate moments in time rather than a linear and discrete trajectory cut off from a forgotten or rejected past, future texts function to counter the hegemonic view of Western culture as ever more progressive and innovative.

The heritage of Afrofuturism in these future texts situates the works within a context that functions as both a playful and pointed critique of commercialism, while invoking the signs and sounds of a history that dominant (i.e., white) culture has sought repeatedly to erase. In turn, white culture has *sampled* Afrofuturism's cultural resistance with widely divergent aesthetic and political consequences. Nonetheless, Afrofuturism's resilience in establishing a new body politic comes from its "street aesthetic" and synchronous temporal logic whereby any and all samples can be *remixed* and re-situated in a history that cannot be displaced or forgotten, for future texts are ultimately texts of cultural memory.

Works Cited

Dery, Mark. "Black to the Future: Interviews with Samuel R. Delaney, Greg Tate, and Tricia Rose." Ed. Mark Dery. *Flame Wars: The Discourse of Cyberculture*. Durham: Duke UP. 1995: 179–222. Print.

Nelson, Alondra. "Introduction: Future Texts." *Social Texts*. 20.2 (2002) 1–15. Print.

2 The New "Material Girls": Madonna, "Millenial" Pop Divas, and the Politics of Race and Gender

Shelleen Greene

In her 1992 essay "Madonna: Plantation Mistress or Soul Sister?" theorist bell hooks writes of pop culture and feminist icon Madonna: "Tragically, all that is transgressive and potentially empowering to feminist women and men about Madonna's work may be undermined by all that it contains that is reactionary and in no way unconventional or new" (164). Citing Madonna's appropriation of "blackness," particularly black, gay culture, as a means to both critique and gain access to white capitalist patriarchy, hooks concludes that for all her radical potential, Madonna, in relation to the marginal identities she appropriates for her own self-reinvention, ultimately perpetuates "racism, sexism and heterosexism" (164).

Throughout her career, Madonna has been championed and admonished by feminist scholars for her ambivalent relationship to the movement's political, cultural, and social objectives. The various debates surrounding Madonna reveal the divisions within second and third wave feminism. While her financial success as a commercial artist separates her from a "radical" second wave feminist critique of patriarchal capitalism, her images of sexual empowerment and transgression, and her postmodern embrace (or appropriation) of the "cultural politics of difference," embodies the quandaries of feminist struggle in our era of late capitalism. While the majority of Madonna's groundbreaking interventions into popular culture occurred over twenty years ago, among them *Express Yourself* (1989), an anthem to women's empowerment through

13

sexuality and performance, and *Vogue* (1990), which brought gay black and Latino dance hall culture to the mainstream, Madonna remains a center of debate and contestation in the postfeminist era.

While I will return to Madonna's still significant presence on the pop cultural scene, I would like to consider her influence on "millennial" pop divas. Taking the term used to describe "Generation Y" or the youth generation born between the mid-1980s and late 1990s, *millennial* pop divas, among the most prominent being Britney Spears, Christina Agulliera, and Lady Gaga, achieved global superstardom in the first decade of the twenty-first century. Although not exclusive, these artists model their careers upon and borrow strategies from Madonna, putting forth a "materialist" feminism that is seemingly void of a radical, or for that matter, any politics. In this essay, I would like to consider the ways in which, at an over twenty-year remove from the Culture Wars of the 1980s, Madonna herself is now appropriated and deployed by this new generation of pop divas and, in particular, by black female hip hop, R&B, and genre-hybrid artists such as Janelle Monáe, Nicki Minaj, and Azealia Banks. These artists are not only post-feminist, contending with the legacies of second and third wave feminism as well as the interventions of black feminists such as bell hooks, Audre Lorde, Michelle Wallace, and Joan Morgan, but also "post-black" cultural producers in an era where signifiers of blackness are challenged and transformed.

In many ways, artists such as Monáe, Minaj, and Banks, as well as their conceptual art counterparts, were anticipated in the late 1980s and early 1990s by cultural theorists such as Stuart Hall in his "What is this Black in Black Popular Culture?" (1993) and Michelle Wallace in "Modernism, Postmodernism and the Problem of the Visual in Afro-American Culture" (1990). Hall and Wallace theorize the emergence of black identity as construct in the postmodern era. Through an analysis of their public personas and music videos, I argue that Minaj, Monáe, and Banks interrogate and extend Madonna's politics of reinvention for an era in which identity has become ever more fluid, unstable, and contingent. Artists such as Minaj and Banks explore the limitations and rearticulate Madonna's cultural politics, opening a space for new debates regarding LGBT rights, racial commodification, and feminist politics in the first decade of the twenty-first century. I look specifically at the Afrofuturist stylings of Janelle Monáe in *Metropolis: Suite I (The Chase)* (2007) and *The ArchAndroid* (2010). In their various personas, these millennial pop divas use performance to insert black women into public debates con-

cerning race, gender, and class—debates that are still often relegated to "blacks and women."

Since entering the popular music scene in the early 1980s, Madonna's reception has fallen mainly into two camps: those who praise her as a "real" feminist of the postmodern era, most notably Camille Paglia in her December 1990 *New York Times* opinion piece, "Madonna—Finally a Real Feminist," and those, such as bell hooks, unconvinced that her work is transgressive or radical. Carolyn Lea articulates the ambivalence of Madonna's reception:

> [Madonna] transgresses the boundaries of traditional femininity by assuming a stance of active female sexuality, by positioning herself as center, and through her "looking at." These decodings, however, are always re-encoded as Madonna negotiates her sexuality through the phallic paradigm of dominance and submission, positions herself as dominator over an exoticized "other," and positions herself as spectacle and sexualized object of the gaze, albeit male or lesbian. The potential for subversion is always undermined in her work (220).

The new millennial pop divas such as Spears and Lady Gaga have adapted Madonna's "active female sexuality" without any of the subversive elements that made Madonna's work the subject of feminist inquiry. Indeed, Paglia, commenting on the comparisons between Madonna and Lady Gaga suggests that Gaga is an "asexual copycat," devoid of sexuality, transgressive or otherwise. Paglia continues: "for Gaga, sex is mainly décor and surface, she's like a laminated piece of rococo furniture." While Paglia's suggestion that feminism be relegated to sexuality and eroticism is questionable, Lady Gaga, more than Spears or Aguilera, seems consciously to work through Madonna's legacies, bringing to the fore the limitations of the icon's sexual and racial politics for "third wave" feminists.

Madonna's ambivalent legacy can be seen in the video for Gaga's single *Telephone*, from her 2009 album *The Fame Monster*. Gaga shares the small screen with R&B/hip hop star Beyoncé. In a reworking of the feminist appropriation of the road movie, *Thelma and Louise* (1989), Beyoncé and Gaga drive off into the desert after poisoning a traitorous lover. Although this is a single from Lady Gaga's album, Beyoncé's presence in the video is not one of an appropriated racial other whose role consists only of enhancing Gaga's "whiteness" or allowing her to gain ac-

cess to white capitalist patriarchal power (although that may not be said for the transgendered people featured in the opening prison scene). Not only is Beyoncé a major pop star who demands equal (perhaps more) screen presence than Gaga, Beyoncé also asserts agency through performance, enacting as many costume changes as Gaga, and using postmodern strategies of parody and reflexivity that characterize Madonna's work. Beyoncé's appearance alongside Lady Gaga is in marked contrast to what has been critiqued as Madonna's "racial tourism" and the marginalization of racial and sexual "others." It seems that for the millennial pop divas, anyone can have "blonde ambition," regardless of race.

Although much more can be said about *Telephone* and Beyoncé in particular,[1] I would like to turn to two other millennial pop divas who, like Beyoncé and Gaga, are indebted to Madonna, but can be read as enacting a different black feminist engagement with popular culture, an intervention that is accomplished by recourse to *Afrofuturism*. The term originates in the early 1990s, most notably through the work of cultural theorist Mark Dery in his 1993 essay "Black to the Future." Dery examines a body of work created by African American and African diasporic cultural producers that uses science fiction themes and iconography to reflect upon and represent the modern and postmodern experiences of the African diaspora.

Dery notes that in its speculative nature and status as a literary subgenre, science fiction is in many ways resonant with the African American experience of racial violence, political disenfranchisement, and social marginalization (179–180). He comments that African Americans, a product of the Middle Passage of the transatlantic slave trade, are "alien abductees" subject to technologies that monitor their movements and have violated their bodies. Afrofuturism becomes a vehicle to take present conditions, informed by knowledge of the past, along with technology and science to envision possible futures (180). Alondra Nelson traces the Afrofuturist imaginary back as far as the early twentieth-century in such works as W.E.B. DuBois's *The Souls of Black Folk* (1903), in which "double consciousness," the knowledge of a self that is black and American, and of being perceived differently from how one perceives the self, already offered a model of the multiple self that is a celebrated characteristic of the digital era (3–4). In the following discussion of Monáe and Minaj, I examine the ways Afrofuturism can be read as operative in their work, opening a space for a black feminist interrogation of race, gender, and sexuality in popular culture.

The cover of Janelle Monáe's genre hybrid "emotion picture," *The Archandroid* (2010), features the singer in the guise of her alter-ego Cindi Mayweather, regaled in a headdress reminiscent of both the famous bust of the Egyptian Queen Nefertiti and the cyborg Maria from Fritz Lang's *Metropolis* (1927). *The Archandroid* is the follow-up album to Monáe's *Metropolis: Suite I (The Chase)*, released in 2007, where we first encounter Mayweather, an android who falls in love with human Sir Anthony Greendown and escapes from an underground society, controlled by The Great Divide, when she is threatened with disassembly. In *The Archandroid*, Mayweather is sent back in time to free the underground community from their enslavement by The Great Divide. Similar to Lang's *Metropolis*, Mayweather takes on a role similar to that of Fred Frederson, the "mediator" between the underground workers and the aboveground masters. Although one reading of the ending of *Metropolis* interprets the mediating role as a means of suppressing a proletariat revolution, or even the representation of the rise of National Socialism (Kracauer 2004; Elsaesser: 44–47),[2] Monáe used *Metropolis* to speak of a general global "minority" and the need for greater tolerance and acceptance of difference.

The Archandroid is an Afrofuturist text in its use of science fiction and "Africanist" themes to bring past and future together to create a new vision of freedom and self-determination. Monáe's music and image have been compared to jazz innovator and Afrofuturist Sun-Ra (Herman Blount), and can also be placed alongside the Afrofuturist imaginary of George Clinton and Parliament-Funkadelic. More contemporary references can be found in the work of Gnarls Barkley, whose recent album, *The Odd Couple* (2010), features the song *Going On* with a video that imagines two African-Caribbean youths entering a portal to another dimension. A closer connection to the contemporary Afrofuturist imaginary can be found in Monáe's producer Big Boi (Antwan Patton) and his collaborations with André 3000 (André Benjamin) as OutKast, whose work makes reference to Afrofuturism, from *ATLiens* (1996) and their 2004 double-album *Speakerboxx/The Love Below* and the video for the single "Prototype" in which André 3000 appears as an alien from the planet Proto, arriving on earth and experiencing love.

The video for *Tightrope* is set in The Place of the Dogs, an old and staid asylum where dancing is forbidden. Monáe/Mayweather is a prisoner in the palace along with members of her art collective, Wondaland Arts Society. Dressed in her signature black tuxedo, an homage to

her working-class upbringing, Monáe/Mayweather starts a dance rebellion in which she and her cohorts bandy through their prison until their nurse turns them in to the asylum's mirror-faced sentries, an allusion to Maya Deren's *Meshes in the Afternoon* (1943).

After ominous shots of the exterior, we see the nurse walking through a hallway pushing a tray of medicine. Once again, we find an Afrofuturist allusion to the use of African Americans for medical experimentation. Here, *Tightrope* makes reference to the Tuskegee Syphilis experiment, in which beginning in the early 1930s until its discovery in 1972, approximately four hundred African American men, mostly uneducated sharecroppers, were subject to the advanced stages of syphilis under the guise of receiving treatment (Roberts 85). In "Black to the Future," Dery notes:

> [African-Americans] inhabit a sci-fi nightmare in which unseen but no less impassable force fields of intolerance frustrate their movements; official histories undo what has been done to them; and technology, be it branding, forced sterilization, the Tuskegee experiment, or tasers, is too often brought to bear on black bodies (180).

Hence, the tightrope. The first lines of the song, "Another day / I take your pain away," ring ironic in the context of the video. However, the use of black American vernacular performance, including bee-bop, jazz, rock 'n' rook, funk, R&B and hip hop as a means of survival throughout Western modernity, is merged to the Afrofuturist project through the concept of *synchronicity*, which as Alondra Nelson describes, is an anachronistic bringing together of "disparate elements . . . into the same time" in order to "reprioritize" technology [in this case, dance as "tool" for survival], thus making it purposeful for a community's particular interests and political, social, and cultural needs (8). By prioritizing black cultural production as survival strategy, Monáe's project is also in keeping with the concerns addressed by what Kimberly Springer calls third-wave black feminism, one being "young Black women's relationship to [their] personal and political histories. This history includes our relationship to past social movements, our biological mothers, and our political foremothers" (1061).

As Mayweather is being taken back to her cell, she sees the figure of a black dandy with cane and bowler hat. Traditionally, the dandy is a class outsider who transgresses boundaries and attempts to move in aris-

tocratic circles through his use of wit and style (Miller 8–9). The dandy's frivolity or extraneousness can be read as a political act, in the sense of creating avenues for social mobility, but also in terms of the dandy's ability to transgress normative gender and sexual categories. However, as Monica Miller argues, black dandyism is a product of the African modernity, which has allowed black subjects to use style as a form of agency, challenging racial stereotypes and hierarchies (Miller 2009). While Miller focuses on black masculinity, dandyism, or at least a certain use of style, is integral to Monáe's cultural politics. Thus, Monáe fashions herself as a twenty-first century female dandy, using clothing, along with hybridized music and dance movement, to comment upon the political landscape of the post-Civil Rights, post-feminist era. Toward the end of *Tightrope*, rather than phase out as a cyborg in the hopes of being re-activated, Mayweather escapes the sentinels by magically walking through walls. Although she is eventually returned to her cell, the dandy's presence assures that Monáe/Mayweather's imprisonment is temporary, as she awaits another opportunity to escape.

In the *Tightrope* video, emancipation is imagined as a project equally shared by black men and women. Except for a trio of beatnik back-up singers in the video's central dance sequence, the men and women in the video are dressed in similar black suits, white shirts, black ties and wing-tip shoes. Rather than scantily dressed video vixens, the men and women share similar dance techniques and prowess, both take center stage in turn or as a group. The collective dance is a metaphor for collective action toward freedom from the asylum, but also towards emancipatory and human justice goals that are still pertinent in this post-Civil Rights generation. Monáe's performance also embodies many of the tenets of hip hop or third-wave black feminist goals in that hip hop/R&B is used to show the integral connection between and necessary struggle against racism, sexism, and heterosexism.

Emancipation is a theme that also underscores the single, *Many Moons* from Monáe's 2008 release *Metropolis: Suite I, The Chase*. The video is set an "annual android auction" in the future city Metropolis. Hosted by Lady Maxxa, the Golden Hostess, and peppered with a series of characters influenced by retro-1940s and neo-noir science fiction films such as *Blade Runner* (1982) and *Brazil* (1984), *Many Moons* includes such characters as Chung Knox, the Tech Dandy; Sir Lucious Leftfoot, Auctioneer Extraordinare (performed by Big Boi); and of course, Cindi Mayweather, the Alpha Platinum 9000.

The video manifests the tension between Monáe/Mayweather's ability to control her image and her placement on the auction block for consumption by a voracious audience. I would suggest that this struggle to control the image and representation also connect Monáe's work with the Afrofuturist project. By using the sci-fi *mise-en-scene* and the use of digital imagery, Monáe evades easy classification of the black female as "video vixen," or its antecedents in the black female body as spectacle, such as with the Hottentot Venus or on the slave auction block. In a discussion of the video for Monáe's single, *Cold War*, where Monáe appears in close-up of her face and shoulders taking off her tuxedo suit, Shana Redmond argues that Monáe uses her body to reveal an "Afroalienation," one that collapses the struggles of the Cold War with that of collective struggle towards freedom. Redmond writes "Monáe's [s]patial dislocation of the Cold War therefore does not fix it in any one locale but instead highlights its duality as a radical everywhere-ness *and* a concrete experience by mapping its negotiation onto the nonnationalized body of the black woman" (401). Similarly in *Many Moons,* although she is on the auction block, Monáe has some agency through the display of her body in the performance of multiple personas that collapses the past of institutional slavery with the futurity of the mobile, hybrid black female body. At the end of the short film, Monáe's Mayweather whispers, "I imagined many moons in the sky lighting my way to freedom." Monáe's final words make reference to the Underground Railroad, and like the video for *Tightrope* the theme of escape through music, dance, performance, and supernatural acts, is in keeping with the Afrofuturist imaginary.

Also invoking Afrofuturism, but to different ends is hip hop artist Nicki Minaj. Described in a 2009 *New York Times* feature as the "Cindy Sherman of rap" (McGarry), Minaj has become one of the leading female hip hop artists of the new century. Referencing the hyper-sexuality of female rap artists such as Lil' Kim and Foxy Brown, Minaj's performative and self-reflexive gestures mock the overly sexualized image of the female rap artists. Minaj's performance also incorporates a range of popular culture icons, from Barbie to "Marilyn Monroe, Chaka Khan, Mickey Mouse, and even Harry Potter's pal Hermione" (McGarry).

While Minaj raises the issue of black female sexuality in mainstream hip hop videos, in the performances I look at, such as the Harajuku Barbie and Wonder Woman persona, I would like to find what Rana Emerson refers to as "contradiction and ambivalence" in Minaj's persona. Emerson suggests:

> Black women performers frequently re-appropriate often explicit images of Black female sexuality. This strategy of self-representation as sexual may, on one hand, be interpreted as a sort of false consciousness that reflects an acceptance of the controlling images of Black womanhood. However . . . these sometimes explicit representations of Black women's sexuality actually exemplify a process of negotiating those contradictory and often conflicting notions and, more significantly, represent an attempt to use the space of the music video to achieve control over their own sexuality. (128)

Nicki Minaj's alter ego, Harajuku Barbie, is a reference to the popular shopping center in Tokyo, and also the term "Harajuku Girls," which refers to punk-inspired fashion popular among the millennial youth generation. Minaj's use of Harajuku style can also be read as a form of Afrofuturism as she fashions a type of cyborg-identity through the style's link to sci-fi imaginary. In several of her videos she appears as different variations of the Harajuku, and makes reference to sci-fi/fantasy imagery in her videos, such as the *Tron* inspired "Check It Out" or *Predator* for the "Massive Attack" video. On the cover of her mixtape, "Beam Me Up Scotty," she combines the iconic reference to *Star Trek*, an image of the Starship Enterprise, with a Wonder Woman inspired outfit. In one image, Minaj appears flying through an urban environment, reminiscent of George Clinton and Parliament/Funkadelic album cover for the *Mothership Connection* (1975). Like Parliament-Funkadelic, Minaj places the black female body in places it is not usually seen. Is this transgressive, or does Minaj, like Madonna, conflate women's empowerment with sexuality, particularly since becoming a "mainstream" pop icon?

On the cover of her *Pink Friday* album, Minaj appears as "Barbie," with pink wig, confection dress, and elongated legs. Along with her now ubiquitous look of incredulity, Minaj's performance can be read as a critique of the Barbie icon, one that sets beauty standards through breast, hip, and feet size that are anatomically impossible, but also beauty standards that make black women marginal, or qualified as "black" Barbie as opposed to the real (white) Barbie. Minaj's Barbie reveals the absurdity of the female icon, the female as spectacle, but also a desire to inhabit and become the icon. Although comparisons have been made between Minaj and Lady Gaga, Minaj does not receive the same attention for her performative gestures, or through her "Barbie," "Wonder Woman," and "Harajuku Lover" personas, what could be called a queering of pop cul-

ture female icons. While Gaga merges mainstream, popular culture with avant-garde, conceptual art practice, as the *New York Times* piece notes, Minaj's work can also be read as influenced by feminist performance art beginning in the 1970s, not only Cindy Sherman, but also path-breaking artists such as Martha Wilson and Adrian Piper.

Now a "mainstream" hip hop artist, Minaj has more explicitly aligned herself with Madonna in performances for the 2012 Super Bowl XLVI half-time show and the video for Madonna's *Gimme All Your Luvin'* (2012), both of which feature British-Tamil artist M.I.A. (Mathangi Arulpragasam). In the Super Bowl half-time performance, Madonna first appears on stage in a Greek-inspired medley, beginning with her now canonical song *Vogue*, then moving to a more recent hit from her thirty-plus year career, *Music* (2009). With acrobatic hip hop dancers and a cameo from the electronic pop duo LMFAO, Madonna proves herself to be still at the cutting edge of popular culture. Finally, with a football-inspired set design, Madonna begins *Gimme All Your Luvin'* supported by the talents of Minaj and M.I.A. The performance staging resonates with Madonna's 2003 Grammy performance with then reigning pop stars Britney Spears and Christina Aguilera. Although the song, on one level, is a comeuppance to a potential lover, the lyrics could equally be directed towards Minaj, M.I.A. and all the millennial divas who aspire to Madonna's "crown."

Madonna begins: "I see you coming and I don't wanna know your name / I see you coming and you're gonna have to change your game . . ." The lyrics simultaneously speak to women's "independence" and competition, not only between Madonna and younger artists, but also between two competing discourses within third-wave feminism: one that embraces racial and sexual diversity, yet still struggles with the hegemony of white capitalist patriarchy. In *Gimme All Your Love*, Madonna seems to call for a truce, imploring the younger divas to "Give me all your love . . . Let's forget about time . . . And dance our lives away." Of the two younger artists, M.I.A., whose conceptual and commercial art production speaks directly to the intervention of postcolonial theory, black, and third-world feminism that inaugurated the third-wave over thirty years ago, is the most resistant, giving a censored middle finger during the Super Bowl performance and countering Madonna's refrain of "Give me all your love" with "I don't give a shit." If at the beginning of the twenty-first century, the appropriated "others," in this instance, Minaj and M.I.A., are using postmodern strategies of reflexivity and

identity performance to insert themselves at the "center," they do so with perhaps the same ambivalent results as Madonna.

Finally, I would like to turn to another notable contemporary of Minaj and Monáe, Azealia Banks, who in her song *1991* (2012) makes direct reference to Madonna's early 1990s period. Perhaps more than Minaj and Monáe, Banks re-appropriates Madonna's early career appropriation of gay dance hall music and performance.[3] Being the year of her birth, Banks's *1991* video operates as a primal scene of sorts, as she inserts herself into the pop cultural *Zeitgeist* of the waning years of the Culture Wars. Not only does Banks channel Madonna's mainstreaming of black and Latino house culture, but also through her presentation as a subject to be photographed, Banks evokes the supermodel culture of the early 1990s in which Naomi Campbell became a central and groundbreaking figure as the first model of African descent to grace the cover of American *Vogue*. Banks's *1991* also pays homage to the black divas of the early 1990s pop, techno, and house culture music, including the power girl group *En Vogue*; Robin S (Robin Stone); CeCe Peniston; and even on one cover for the single, the inimitable Grace Jones. The song's opening lines: *Excusez-moi, est-ce que vous savez où est un bon restaurant par ici?* / Oh, là, là, là/ Flirting with a cool French dude named Antoine/ Wanna taste the pastry chocolate croissant . . ." even harkens back to the *Bal Negre*, French negrophilia of the 1920s, and Josephine Baker, perhaps the most spectacular and sexually fetishized black female body of the early twentieth century.

1991's lyrics play on racial and sexual fetish, with Banks running through a series of stereotypes placed upon her by a would-be French lover such as "pastry chocolate croissant," "Café au Lait," and later: "He took her to the Louvre in Paris / He want a chance with a youngin / Wanna ruin her weave ..." Banks treads a fine line between the young black female ingénue in the European metropolis often portrayed by Baker and to a certain extent, Jones and Campbell, and the worldly, self-possessed, and self-conscious lyricist that defies sexual commoditization by the male suitor. Rather than remaining on the sideline next to Madonna, Banks places herself on par with her iconic predecessor. What distinguishes Banks's *1991* from Minaj and aligns her with the Afrofuturist anachronism of Monáe, is her reference to other black female artists and icons of previous generations, who influenced Madonna, but often, remained in her shadow.

In focusing on Minaj, Monáe, and Banks, I do not dismiss the innovative and genre-crossing work of other mainstream and alternative female hip hop and R&B artists such as Lil' Kim, Missy Elliot (particularly the Afrofuturist and feminist stylings of her 1997 collaboration with Da Brat in the video for the single *Sock It to Me*), Erykah Badu, and Meshell Ndegeocello. However, I would maintain that these two artistic expressions are, in their divergent ways, performances of survival. Through their use of Afrofuturist imagery, Minaj and Monáe also offer an opportunity to investigate how race overlaps with a feminist project, a core concern of hip hop feminism. In "Black to the Future," Dery makes reference primarily to African American male artists, such as Sun-Ra, Rammellzee, and Jean-Michel Basquiat, while significant female artists, such as science-fiction author Octavia Butler (who Monáe has noted as an important influence) and Nalo Hopkinson, are not mentioned prominently in the essay. In addition, even with the creative autonomy of both artists, both Minaj and Monáe were mentored by established male hip hop artists: in the case of Minaj, Dwayne Carter, Jr. (aka Lil Wayne) and with Monáe, Antoine Patton (aka Big Boi).

In conclusion, *millennial* divas, including Minaj, Monáe, and Banks, negotiate the legacies of second and third-wave feminism in diverse ways with ambivalent results. Their work poses questions to the feminist project at the beginning of the twenty-first century, in an era variously called post-Civil Rights, post-racial, and post-feminist. In a period of advanced capitalism, ever-widening economic inequality that persists along racial and gender lines, bell hooks's condemnation of white capitalist patriarchy remains salient. However, as Madonna did over twenty years ago, the millennial divas compel us to further investigate the role of culture and cultural production towards achieving feminist objectives. Working within the mainstream music industry, Minaj, Monáe, and Banks have achieved visibility, albeit through a certain gender conformity in order to become profitable artists in a competitive global multimedia industry. However, their use of Afrofuturism and postmodern performance is an acknowledgment of past struggles for racial, gender, and sexual equality, struggles that persist in the current period but require new strategies as the identity categories themselves undergo rapid change.

Notes

1. See Daphne A. Brooks's analysis of Beyoncé in "Suga Mama, Politicized."
2. In *From Caligari to Hitler: A Psychological History of the German Cinema* (1947), Sigfried Kracauer put forth a reading of *Metropolis* as a "proto-fascist" narrative which anticipates the propaganda films of the Nazi regime, particularly the organization of the masses into spectacle in the films of Leni Refenstahl. Monáe's appropriation of *Metropolis* is in keeping with the various interpretations to which the film lends itself, including an appeal to communist revolution. See Thomas Elsaesser's discussion of Kracauer's as well as alternate interpretations of the film in *Metropolis* (BFI Film Classics).
3. *1991* (2012) uses a sample from electronic music artist Machinedrum's single *DDD* (2012).

Works Cited

Mitchell, Justin. "1991." Online Music Video. *YouTube*. YouTube, 2 Sept. 2012. Web. 1 June 2013.

Brooks, Daphne A. "Suga Mama, Politicized." *The Nation.com*. The Nation Institute, 18 Dec. 2006. Web. 18 April 2013.

—. "'All That You Can't Leave Behind': Black Female Soul Singing and the Politics of Surrogation in the Age of Catastrophe." Meridians: Feminism, Race, Transnationalism 8.1 (2008): 180–204. Print.

Dery, Mark. "Black to the Future: Interviews with Samuel R. Delany, Greg Tate, and Tricia Rose." *Flame Wars: The Discourse of Cyberculture*. Ed. Mark Dery. Durham: Duke UP, 1994. 179–222. Print.

Emerson, Rana A. "'Where My Girls At?': Negotiating Black Womanhood in Music Videos." Gender and Society 16.1 (February 2002): 115–135. Print.

Elsaesser, Thomas. Metropolis (BFI Film Classics). London: British Film Institute, 2008. Print.

Ferguson, Alan and The Wondaland Arts Society. "Many Moons." Online Music Video. *YouTube*. YouTube, 3 Oct. 2008. Web. 1 June 2013.

hooks, bell. "Madonna: Plantation Mistress or Soul Sister?" Black Looks: Race and Representation. Cambridge, MA: South End Press, 1992. 157–164. Print.

Kracauer, Siegfried. *From Caligari to Hitler: A Psychological History of German Film*. 1947. Revised and Expanded Edition. Intro. Leonardo Quaresima. Princeton: Princeton UP, 2004. Print.

Lea, Carolyn. "Madonna: Transgression and Re-inscription." Mediated Women: Representations in Popular Culture. Ed. Marian Meyers. Cresskill, N.J: Hampton Press, 1999. 205–224. Print.

McGarry, Kevin. "The New Queen Bee | Meet Nicki Minaj." *The New York Times*. The New York Times, 4 June 2009. Web. 16 May 2013.

Madonna. "Gimme All Your Luvin." Online Music Video. *YouTube*. YouTube, 2 Feb. 2012. Web. 1 June 2013.

Miller, Monica. *Slaves to Fashion: Black Dandyism and the Styling of Black Diasporic Identity*. Durham: Duke UP, 2009. Print.

Monáe, Janelle. "Tightrope." Dir. Wendy Morgan. Online Music Video. n.d. Web. 1 June 2013.

Nelson, Alondra. "Introduction: Future Texts." Social Text 71, 20.2 (Summer 2002): 1–15. Print.

Paglia, Camille. "Lady Gaga and the Death of Sex." *The Sunday Times Magazine*. News UK. 12 Sept. 2010. Web. 7 March 2011.

Redmond, Shana L. "This Safer Space: Janelle Monae's 'Cold War.'" Journal of Popular Music Studies. 23.4 (2011): 393–411. Print.

Roberts, Dorothy. Fatal Invention: How Science, Politics, and Big Business Recreate Race in the Twenty-first Century. New York and London: The New Press, 2011. Print.

Springer, Kimberly. "Third Wave Black Feminism?" Signs 27.4 (Summer 2002): 1059–1082. Print.

—. "Madonna—Finally a Real Feminist." *The New York Times*. 14 Dec. 1990. Web. 7 March 2011.

3 A *Window Seat* to History: Erykah Badu's Dealey Plaza Remix

Vicki Callahan

From early works such as Andy Warhol's print series *Flash: November 22, 1963* and *Jackie*, Bruce Conner's short film *Report* (1967), Ant Farm's video/performance *Media Burn* (1975) to more recent projects like the mainstream films *JFK* (Stone 1991), *Interview with the Assassin* (Burger, 2002), *Parkland* (Landesman, 2013), and the videogame *JFK Reloaded* (video game 2004), the Kennedy assassination has proved to be a recurrent and resilient iconographic site of cultural exchange (Simon; Anderson). As Steve Anderson notes of the diverse explorations of the shooting from mainstream to alternative media and digital contexts, the result has been less one of "closure" and "certainty" as to the events of the killing, but rather of multiple and divergent possibilities for the incident (34–36; 134–135). In many ways, the Kennedy assassination represents the ultimate intersection of the American twin fixations of media spectacle and violence and the numerous disparate representations have served both to critique and to fetishize these qualities. In this essay, I explore how the artist Erykah Badu transforms this iconic spectacle into an exemplary womanist performative turn with her controversial music video, "Window Seat" (2010), a work that I argue is consistent with her career's larger aesthetic and social practice.

Badu's video is perhaps one of the most unlikely iterations of "Kennedy Death Art." At first glance, her video appears to operate as a cry for personal expression against narrow social conventions, which Badu's disrobing and closing commentary against "group think" seem to reinforce. While this might be one way we should situate and how many have read the video, "Window Seat" is indicative of Badu's larger creative approach, which participates in a far more radical political commentary.

Consistent with previous music, fashion, and imagery selected by the artist, Badu's "Window Seat" engages a strategy of remix, using known historical materials to create an alternative African-American womanist universe.

As Layli Phillips, Kerri Reddick-Morgan, and Dionne Patricia Stephens point out in the essay, "Oppositional Consciousness from an Oppositional Realm: the Case of Feminism and Womanism in Rap and Hip Hop, 1976–2004," female artists have played a crucial and complex role in a musical genre and culture that is often stereotypically viewed as misogynistic and male centered. While Phillips, et al. note the empowering voices across an array of female artists in hip hop, female strength and solidarity is frequently linked at the same time to an understanding and alliance with black men, whose lives have been shaped by the dominant racialized ideology (272–273). The authors use Badu's early songs "Other Side of the Game" (1997) and "Danger"(2003) as illustrative of this social critique since in both cases the lyrics provide a portrait of a black woman supporting a male partner who is on the wrong side of the law. In both songs the woman, a young mother (or in "Other Side . . ." a mother to be), does not judge but rather notes her partner's lack of options (269, 270). This alliance across class, race, sex, and gender expands the cultural context of Badu (and many other female hip hop artists as Phillips et al. detail) from the white privileged perspective of mainstream feminism to the more thoroughgoing and radical *womanist* view as defined by Alice Walker in her book *In Search of Our Mothers' Gardens*. Given the discourse that has surrounded Badu's career and her own artistic strategies, it is instructive to review in detail some of Walker's description of what the term designates. Beyond her opening definition of *womanist* as "black feminist or feminist of color" and "usually referring to outrageous, audacious, courageous or *willful* behavior. Wanting to know more and in greater depth than is considered "good" for one," Walker notes the terms designates:

> 2). *Also:* A woman who loves other women sexually and/or nonsexually. Appreciates and prefers women's culture, women's emotional flexibility (values tears as a natural counterbalance of laughter), and women's strength. Sometimes loves individual men, sexually and/or nonsexually. Committed to wholeness of entire people male *and* female. Not a separatist, except periodically, for health. Traditionally universalist as in: "Mama, why are we brown pink and yellow and our cousins are white, beige,

and black?" ans.: "Well, you know the colored race is just like a flower garden, with every color flower represented" (xi).

Badu's counter vision, as Rana Emerson argues, declares an agency and identity with black experience through a re-imagination of key cultural texts seen in her early music video *On and On* (from *Baduizm*, 1997), which remixes *Cinderella* and *The Color Purple* and transforms a Cinderella/Celie figure in the rural south from her farm and housework setting to a singer in an evening "juke joint." Tellingly, the transition from home to club is due to her own creativity and initiative, and not from a Prince Charming (Emerson 125).

In the instance of "Window Seat," Badu's placement in Dealey Plaza and striking shift of gender and racial markers from the original referent, underscored by her slow motion disrobing, situates the historical trauma as an ongoing memory for all Americans, across class, race and gender boundaries, rather than as a nostalgic look backwards at a rarefied and segregated Camelot. In this way, Badu's "Window Seat," along with her larger and generally labeled "neo-soul" music/video catalogue, can be placed within an Afro-futurist context. Here as Alondra Nelson has described, "future texts" are defined not so much by a projection into a solely original and isolated future, but what Ishmael Reed has called a "synchronizing" of past, present, and future (Nelson, 8). Unlike many futurist strategies, which strive to banish or leave behind the past (Nelson 7), Reed sees history as crucial to a reconfiguration of the present and future, a writing process he describes as "necromancy." As Reed notes, "Necromancers used to lie in the guts of the dead or in the tombs to receive visions of the future. That is the prophecy. The black writer lies in the guts of old America, making readings about the future (qtd. in Nelson 7).

Badu's musical and visual presence can be read then not as "retro" or as the *New York Times* labeled it, "[an] appealingly eccentric neo-soul sex goddess/funky earth mama/black power revolutionary persona" (Ryzik), but as a deliberate and focused vision of the artist's stated desire to set out alternative models for female and black identity. As Erykah Badu herself noted in a 2001 *Jet* magazine interview: "I want to be a different example of what a Black woman is, what a Black person is. I wear my headwrap because a headwrap is a crown, and I am a queen. A headwrap demands a certain amount of respect—it just does, and I am always headwrapped" (Waldron 63). Badu explicitly situates her life (e.g., her music and selection of her clothing) as distinctly within Black culture. Her objective

from fashion to art is to be a positive and uplifting force for the community (Waldron, 63). Clarence Waldron notes that even the title of her album, *Mama's Gun*, can be seen as a "weapon of empowerment" but with a positive focus for nurturing, or, here again we might add, as a womanist force (64). As Badu states: "My words and my music are my weapons of choice. And as you grow you need something to go out there in the world to protect you. I urge folks to use my music and my words as they will, as they should, as they see fit" (qtd. in Waldron 64).

It is instructive with Badu to examine the consistent political and cultural strategies throughout her career, as well as the work of her last two albums and their critical reception, to see how one might want to resituate Badu from fairly static labels into a more fluid and indeed interesting account of an experimental Black womanist artist. Her work has repeatedly traversed the terrain of remix and relational aesthetics, with an avant-garde sensibility that the artwork should be shared, collaborative, and with a community-centered focus. In earlier collaborations, Badu lent her voice to collective efforts that foregrounded a shared social experience as particularly evident in her music video "Love of My Life (an ode to Hip Hop)" featuring Common. The video is a loving history of the expanse of hip hop culture from street art to dance and includes a short rap with Badu and the legendary pioneer female rap artist, MC Lyte. A pointed social critique also comes through with Badu's collaboration, along with Cee-Lo and Big Rube, on OutKast's exploration of "Liberation" in the complex context of the black experience. Other examples of Badu's musical associations that attend to societal concerns include her song with Busta Rhymes, "One," the Five Percenters praise of the united black family, and "You Got Me" with The Roots, where the social component looks to break free of a larger community distrust in male/female relationships. There is also the remix of her hit with Common into the almost feminist anthem-like "Love of My Life Worldwide," which features a who's who of female hip hop artists: Queen Latifah, Angie Stone, and Bahamadia.

In her last two albums, Badu's attention to collaboration, an important component in much of contemporary hip hop, is most striking in its range of partnerships. Parts I and II feature an extraordinary group of musicians and producers, Questlove, Madlib, James Poyser, and the group Sa-Ra, whose participation contributes to the unique sound of the work. Part Two collaborators include the group above but also the legendary late producer J. Dilla as well as Georgia Anne Muldrow, an

"underground soul" vocalist and producer whose work is often politically pointed, as co-writer and producer on "Out of Mind, Just in Time" (Cowie). "Gone Baby, Don't Be Long" features Flying Lotus (Steven Ellison) the musician and producer, who works within the genre of experimental electronica music and is connected to a rich musical heritage that includes John, Alice, and Ravi Coltrane as extended family (Ellison is the great nephew to John and Alice Coltrane).

Despite the diversity of her artistic collaborations and musical styles employed, Badu is typically labeled as exemplary of the "neo-soul" genre, which often stands in as nostalgic but hipper version of the rhythm and blues (R&B) tradition due to its fusion of jazz, rap, rock, and funk. "Neo-soul" is a label that many artists within the "genre" are uncomfortable with, as they see their work as part of a direct heritage from "soul" and R&B and are reluctant to place their expression within the confines of what is essentially an industry marketing term (Mitchell 30). Although some critics do point to "neo-soul" as the more "thoughtful," musically rich (due to the fusion components and diverse African American musical heritage drawn upon), or socially attuned genre, the "social" here is not particularly defined as a critique as much as personal introspection (Cox; Mitchell). While critics point to politically attuned dimensions to R&B, usually noting the work of Marvin Gaye, Curtis Mayfield, and neo-soul artists like Badu and Jill Scott as following in that tradition, these are typically pointed out as a separate musical thread pursued on exceptional instances by artists more attentive to personal relationships in their work (Mitchell, Cox, George). Ignored is the long and connected tradition of socially conscious work from jazz to soul (or rhythm and blues) to neo-soul, from Billy Holiday, Nina Simone, Sam Cooke, James Brown, and Stevie Wonder to the Isley Brothers and many others.

Like rhythm and blues, Badu's music is also framed within this dualistic vision of a personal versus a political focus to the work as if these were two distinctly separate possibilities. Here it is instructive to look at the map of the last two albums as sketched by most critics. *Amerykah, Part I*, (4th World War) had a mixed critical reception, but the work was seen generally as a distinct move away from her earlier earth mother, neo-soul roots, towards a Marvin Gaye and Curtis Mayfield inflected political turn, the inevitable two figures invoked in the socially conscious "soul" music context (Abebe, Guerilla, Butler, Barrett). For some, the supposed shift to politics was too stark or even "unhinged" (Cardace). A *New York Magazine* review of the CD saw it as an "oddball

work more along the lines of dubby, druggy hip-hop than anything resembling neo-soul" that had left her past personal "soul sister meditations" behind (Cardace). Other reviewers pointed to the experimental structure as more along the lines of personal expression or artistic styling, and while the political elements are alluded to, these components essentially remain in the background (McPherson, Lewis). Miles Marshall Lewis discusses the Blaxploitation-like soundtrack of "Amerykahn Promise" and notes Badu's nod to Louis Farrakahn and the Nation of Islam in "Me," but oddly sidesteps these references as politically and socially significant.

The songs throughout the CD continue the remix strategy from Badu's earlier works lyrically and sonically, weaving together well-known political/cultural genres or commentaries with spoken word and lyrics. "Amerykahn Promise," like many Blaxploitation films, is a ruthless critique of the American Dream, which offers (or promises) unlimited pleasures if we just sign away our lives. The song is a remarkable remix that samples the Roy Ayers song "The American Promise" (performed by RAMP) as its core text or backdrop, but builds an elaborate soundscape around it of effects, dialogue, and Badu's singing and speaking voice (at times altered) to underscore the personal cost of the political ideology behind the dream. The grim "Twinkle" is another sonically dense soundscape that points to the longstanding conditions for significant parts of the black community that leave young people cut off from education, their language, culture, and spiritual life and on a pathway "so that they end up in prisons they end up in blood. . . . with no choices there is no hope for us." The last minute and a half of "Twinkle" employs the well-known outburst from the film *Network* (1976), where the newscaster Howard Beale (Peter Finch) recounts the dire circumstances of late consumer capitalism and implores his audience: "you've got to get mad; you've got to say, 'I'm a human being dammit. My life has value.'" The sample from the film is extensive but electronically transformed so that Beale's commentary sounds less hysterical and more calmly prophetic than the original. "Twinkle's" remix becomes not the *Network's* cynical play on Beale and the audience's emotions, but a considered call to action in the context of life for much of the African American community.

While critics did point to shades of Marvin Gaye's "What's Goin' On" throughout the *Amerykah, Part I*, they were suddenly stymied by "Honey," the Isley Brothers-esque bit of romantic pop (Greenblatt). What was that song doing there? Critics found "Honey" as then consis-

tent with the overall tone of the *Amerykah, Part 2*, which was seen by many as a decided shift away from politics back to Badu's earlier attention to the personal only. But the musical track of "Honey" begins with the return of the sampled Ayer's song "American Promise," a distinctly political focus, and a spoken word segment that states: "Ladies and Gentlemen you are on your own, *New Amerykah*, Fourthworld war and please stay tuned for Part Two, Return of the Ankh (eternal life)." The spoken segment finishes with a sci-fi countdown to "Honey" and then a clean break with the start of the Isleyesque track. The opening segment to "Honey" not only sounds like a time-travel adventure, but given the references employed from Ayers to Isley to the countdown, implies a journey that moves backward and forward simultaneously. This "synchronizing," as Reed calls it (the merging of past, present, and future), on the audio track is played out for us on the visual track of the music video. As in many of her music videos, "Honey" opens with the title card "A Story by Erykah Badu" pointing to her expansive role in the sound and design of all aspects of her music and performances. Badu walks through a record store while perusing an array of well-known album covers in which she has been inserted in the image, an act which places her directly within a consistent musical tradition; a playful yet culturally significant visual and audio remix. From Chaka Kahn to Diana Ross, Funkadelic, Eric B and Rakim, Ohio Players, Minnie Ripperton, De La Soul, and Grace Jones, there is a clear heritage traced in the video from soul to funk to hip hop with a couple of divergent references to the Beatles *Let it Be* and John Lennon and Yoko Ono's *Rolling Stone* cover for the release of *Double Fantasy* (Butta). The Lennon and Ono citation is particularly interesting given the avant-garde sensibility and performance art forays of the duo beyond their pop culture work (a point I will return to shortly). "Honey" should be seen then not as an aberrant moment in *New Amerykah, Part 1* but as a work that situates Badu in a historical and predominantly *black* musical legacy. Moreover "Honey" thus provides a context for *New Amerykah Part 2*. *Pitchfork*'s overall positive review saw *Part 2*, as did many other critics, as the "return" to her past "neo soul" style; that is, focused on personal rather than political issues, especially with regard to romantic relations (Powell, Richards, Gill). The *Pitchfork* review begins with the peculiar comment that "Erykah Badu is a narcissist, but narcissism is her art," and ends with the artistic (and personal) platitude: "Her life is her art and her life—like anyone's—is too messy and varied to contain" (Powell).

To understand Badu's *New Amerykah Part 2*, it is best perhaps to explore the uproar over "Window Seat," which was discussed both as a publicity grabbing stunt and as a courageous personal and artistic expression (Duke; Lori). The video filmed at Dealey Plaza, the area overlooking the Kennedy assassination, sees Badu slowly removing layers of her clothing until nude and completes the sequence by her collapsing on the ground. Many found the video distasteful and offensive, and the song's ostensive topic of a failing romance seemed to trivialize a key cultural moment (Starr). Womanists and feminists were conflicted, worried that this was yet another exploitative use of the female black body (Khan, Hopkinson), while others saw Badu constructing a narrative counter to past voyeuristic practices imposed on African American women through her agency of public disrobing, rather than a socially imposed strip tease (ewwillia). Luso Mnthali explored the video in light of who "owns" the images of the black body and the fixed external coding that comes into play:

> I am almost immediately struck by how much it makes me think of Saartjie Baartman. How we don't see black women's bodies in this way, where they are just bodies, just human beings. Everything about us, it seems, has either been demonised or sexualized, and this is a real problem. It doesn't only happen in America, but even in communities you'd think would be more understanding, and loving of black women, yet are not at the point where they should be.

For Mnthali, Badu's "Window Seat" goes a long way toward reclaiming the image of the black body as autonomous subject, and a closer examination of the video provides evidence of her argument. "Window Seat" begins as if we are viewing documentary footage from the Kennedy tragedy by using the voiceover from a newscast of Kennedy's arrival in Dallas as we see a white car, seemingly from the era, pull into the frame. Scratched grey film and projector noise follow with the artist's trademark title card "a story by Erykah Badu," which then shifts back to a film style that employs washed out color, slow motion, and a hint of iris around edges. We see that Badu has been driving the car; she parks, feeds the meter, now surrounded by anachronistic contemporary automobiles, and then she walks and jogs over to the Dealey Plaza area of Dallas, all still in slow motion. Once in the Plaza, filled with people taking in the memorial site, she begins to strip off her clothes, and from behind we see

the words "evolving" written across her back. The video maintains the slow motion effect for the entire work, adding to the documentary feel, which seemingly reenacts an historical event. As she removes her underwear amongst the crowd, the image is strategically pixilated over her nude body. Suddenly we hear a gunshot and Badu drops to the ground as if shot and as she falls the words "group think" appear on the sidewalk next to her. This is where most discussion of the video usually ends, but the video features a voiceover addendum where Badu states, as the text spills out by her fallen body,

> They play it safe, are quick to assassinate what they do not understand. They move in packs ingesting more and more fear with every act of hate on one another. They feel most comfortable in groups, less guilt to swallow. They are us. This is what we have become. Afraid to respect the individual. A single person within a circumstance can move one to change. To love herself. To evolve.

The camera tracks up towards the sky and around the space, then circles back with Badu reappearing and walking toward the camera smiling as the last part of the spoken segment is heard: "To love herself. To evolve." The video ends with Badu in a tight close-up before she exits the frame.

The lyrics of the song, dealing with a difficult personal relationship, employ the "synchronizing" strategy of merging time's tenses at the level of cultural reference (from Lightnin' Hopkins to *Star Trek*) as well as mentally. The song notes the desire of being elsewhere physically and psychologically ("So can I get a window seat? Don't want nobody next to me. I just want a ticket outta town. A look around and a safe touch down"), while also trying to resolve a quarrel with a demanding lover at present. The song continues this back-and-forth between the seemingly fixed or present time and the drift beyond, and at one point, notes: "I don't wanna time travel no more, I wanna be here, I'm thinking." But ultimately, the relationship and time move on and the lyrics conclude with "I just need a chance to fly. A chance to cry and a long bye-bye."

Badu, an active user of Twitter, used the site to comment on the controversy and point us to a productive line of inquiry regarding the video: "I would never disrespect JFK. His revolutionary thinking is my inspiration. My performance art has been grossly interpreted by many" (Armenian News—Tert). While it is sometimes risky to interpret an artist's words or indeed someone's Twitter feed in literal fashion, Badu in

an interview at the Tobago Jazz Festival claimed her video was "performance art in the tradition of Josephine Baker or Yoko Ono or any other brave woman who took a stand for something" (Flow and Mugs). The opening title card for the video (before any images or sound) states that the video is "Inspired by Matt and Kim," a reference to a similar public art event staged by the indie rock duo for the video "Lessons Learned." In their video, Matt and Kim both strip while walking down a busy daytime sidewalk in New York's Times Square, surrounded by crowds of people but mainly dwarfed by images and advertising.

Similarly the examples of the "Kennedy Death Art" noted earlier, Andy Warhol's *Flash: November 22, 1963* and *Jackie*, along with the Ant Farm's *Media Burn*, are questioning the media spectacle surrounding the event (at the time and with repeated viewings over the years) and the account of the news and media more generally. It is not the "truth" of the event that is revealed, but rather the staging of spectacle via the media's coverage that encourages viewers to buy into the media's *own* authenticity and the viability and veracity that accrues to the narrative surrounding the event (Rushton). As Steve Rushton argues, pseudo-events such as press conferences, congressional hearings, etc. are in fact a (quoting Foucault) "discourse produces objects," or rather a mechanism to authenticate "facts" as seen in the case of the US government's "proof" of weapons of mass destruction through a "feedback loop of legitimacy." Ant Farm's video *Media Burn* offers precisely the same critique (Rushton). At one point, before driving a car through a wall of television sets, the Kennedy-like "artist-president" holds a news conference and asks: "Who can deny that we are a nation addicted to television and the constant flow of media, and not a few of us are frustrated by this addiction. Now I ask you, my fellow Americans, haven't you ever wanted to put your foot through your television screen" (qtd. in Rushton).

The impetus in Badu's "Window Seat," following Matt and Kim, works much the same, regardless of whether or not Badu was specifically quoting Ant Farm's *Media Burn* (although she might well have been). In both "Window Seat" and *Media Burn*, the videos function as a revolt against the established order and ruling discourse by claiming our public space, placing ourselves in a specific historical time and place, and stripping it of the controlled circulation of signs by creating our own space, writing our own history. We might reconsider Badu's opening remarks of "Honey," remixed with the Blaxploitation "Amerykan Promise" funk sounds: "After this ladies and gentleman you are on your

own." Re-contextualized, the words call not for despair and hopelessness, but are instead more in line with *Part 1*'s earlier invocation, by Howard Beale, for us "to get mad" in the track "Twinkle." Like Ant Farm's *Media Burn*, "Window Seat," along with "Honey," "Twinkle," and Badu's larger remix strategy, tell us that the tools are such now that we can make our own media events, destroy television/institutionalized media, critique our news, make our own programs, make our own history. In "Window Seat," history cannot be passively received but situated, and we must enter, embody, and inscribe ourselves in that place as Badu writes herself into that history.

But again, why invoke the Dallas scene and the explicit assassination reference for "Window Seat?" Here, the well-known national trauma is invoked to help us connect the personal and political. It is a distinction that Badu blurs consistently in her music and interviews and is consistent with her ongoing womanist aesthetic and philosophy. In a conversation with Christopher Farley, Badu notes that the *New Amerykah, Parts I and II* were created as one piece looking at both social and emotional elements important to her, and these were divided into two parts mainly due to the volume of the material. The assembly of the two CDs, she notes, was done *sonically*, rather than on the basis of content, with darker elements placed in Part I and with more melodic materials in Part II. As she discusses the controversy around the video for "Window Seat" with Farley, she begins by framing the concept for the video as "liberation" and the need for "shedding baggage" to prevent group think. Although she explores the idea of "liberation" through the lens of the "individual" and "non-conformism" she concludes by placing the discussion within an ethical frame: "I think it was Martin Luther King that said 'I don't want to save the world, I just want to be its moral compass'" (Farley).

Badu's Tobago Jazz Festival interview takes these ideas and a blurring of the personal and political even further. She begins by talking about her individual need to have the courage to make the video and move past group think, but as she develops her point regarding "non-conformism," again she attaches these quickly to larger issues of race and gender. As she explores issues of body image, the movement back and forth between the personal and political is seamless: "It was, like I said, petrifying. I was horrified to do it [the video], because I don't love my body . . . I think we as women have been put in such a position or predicament to try to fit a criteria that we would never fit into physically, you know. I am a mother of three, I am forty years old, and I am also beautiful and also relevant."

Significantly, she continues by noting that female nudity was especially threatening when not "packaged" according to dominant imagery:

> What I really learned was that when it was packaged the way I was with no high heel shoes, or long hair, or spinning around a pole, or popping it, people have a hard time processing it when it is not packaged for the consumption of male entertainment. So they don't know quite what to do with it, or how to place it, or what to say. Because surely, a woman couldn't be intelligent enough to be making a point. It has to be for publicity or for some kind of sales. . . . I don't make money from records selling . . . I make money from performing and I don't need help for that. I have been doing that for many, many years.

Badu's clarity on the exploitation of women's bodies in the context of music video imagery explains her anger over the lascivious use of her nudity in the Flaming Lips 2012 video, "The First Time Ever I Saw Your Face." The video, posted without Badu's prior agreed upon approval, included shots of Erykah Badu nude in a bathtub intercut with additional images of her sister Nayrok, also nude, with glitter and fluids resembling blood and semen covering her (Fitzmaurice and Phillips; Davies). The edits were made in such a way that one might easily assume that this was Erykah and not her sister in the more offensive imagery. Using Twitter to protest, Badu minced few words:

> As a human, I am disgusted with your what appears to be desperation and poor execution. . . . As a director, I am unimpressed. As a sociologist I understand your type. As your fellow artist I am uninspired. As a woman I feel violated and underestimated (Davies).

The Flaming Lips' video had violated Badu's understanding of the black woman as regal and dignified so it is probably not coincidental that her recent collaboration with Janelle Monáe returned to more empowering images with the music video "Q.U.E.E.N." The voiceover introduction to the video describes Monáe and Badu (as Badoula Oblongata) as frozen time-traveling rebels "who launched a musical weapons program Q.U.E.E.N. in the twenty-first century." The narration continues that "researchers are still deciphering the nature of this program and hunting the freedom movements that Wondaland disguised as songs, (e)motion pictures and works of art." The frozen rebels then come to life and sing

and dance to lyrics that highlight a nonconformity with ruling models of race, class, and gender. As Monáe announces "I will love who I am" Badu enters and the music shifts from funk to jazz with a more minimal instrumentation and mellow vibe. Badu sings "baby, here comes the freedom song" and follows with the lines that link the political, the aesthetic, and the body:

> Too strong we moving on
> Baby this melody
> Will show you another way
> Been trying for far too long
> Come home and sing your song
> But you got to testify
> Because the booty don't lie.

After a short musical interlude, Monáe closes the song with a lengthy and intense spoken word segment while dressed in her usual tuxedo in homage to her own past background as a maid and her family's working class heritage (Rivas). Her commentary and dress make the racial, class, and gendered politics explicit, and she at one point states: "I'm going to keep leading like a young Harriet Tubman." Remixing musical genres, history, and cultural artifacts in the science fiction setting, Monáe and Badu claim Afrofuturism for a womanist agenda.

Badu's YouTube channel is called, "Analogue Girl in a Digital World," and one might yet again be tempted to limit Badu by seeing her name as a "nostalgic" turn back to the past if you have not been following her "synchronizing" and time travels closely. Alexander G. Weheliye argues in the article, "Feening Posthuman Voices in Contemporary Black Popular Music," cyber theory is not only overwhelmingly white, but moreover, bereft of a body (21-22). The black subject stands outside of this future as a body and indeed a voice too much. Moreover, the recognized signs of their humanity within white establishment is then through their "authentic" and soulful voices (Weheliye 27-28). Hence, if we consider the critical reception of *New Amerykah Part 2*, it becomes clear that the efforts to understand Badu's later work as a return to her "neo-soul" roots is actually part of a failure by the imagination of white culture. It is a failure to imagine an "analogue girl," as a black human being in a digital world and in a diverse and collective future. With "Window Seat" and "Honey," and her many other creative works, Badu rewrites history with black women's bodies and voices as subjects with agency.

Works Cited

Abebe, Nitsuh. "Erykah Badu: New Amerykah Part One: 4th World War." *Pitchfork*. Pitchfork Media, 6 June 2008. Web. 20 Dec. 2013.

Anderson, Steve F. *Technologies of History: Visual Media and the Eccentricity of the Past*. Hanover, N.H.: Dartmouth College Press, 2011. Print.

Antfarm. *Media Burn* 1975 ed. Online video. *Media Burn*. Media Burn Archive, n.d. Web. 1 Jan. 2014.

Armenian News-Tert.am. "Erykah Badu's 'Window Seat' Video: Too Far, or Artistic Expression?" *Tert.am*. TERT AM, LLC., 4 Feb. 2010. Web. 31 Dec. 2013.

Badu, Erykah. –"On & On." Online Music Video. *YouTube*. YouTube, 16 June 2009. Web. 27 Dec. 2013.

—. "Love Of My Life (An Ode To Hip Hop)" Music Video. *YouTube*. YouTube, 18 Oct. 2013. Web. 28 Dec. 2013.

—. –"Window Seat." Online Music Video. *YouTube*. YouTube, 2 Apr. 2010. Web. 1 Jan. 2014.

Barrett, Sian. "New Amerykah Part One (4th World War)." *Socialist Review* Apr. 2008: n. pag. Web. 28 Dec 2013.

Butler, Nick. "Review: Erykah Badu—New Amerykah Pt. 1 (4th World War)." *SputnikMusic*. Sputnik Music, 27 Feb. 2008. Web. 30 Dec. 2013.

Butta. "'Honey' Video: The Original Album Covers." *Video Soul Bounce*. SoulBounce. SoulBounce.com, Feb. 2008. Web. 9 Mar. 2011.

Cardace, Sara. "Way Off the Deep End." *New York Magazine*. New York Media, LLC, 3 Mar. 2008. Web. 30 Dec. 2013.

Compton, Josette. "A Few of Roy Ayers' Favorite Things." *Entertainment Weekly*. Time, 3 Nov. 2008. Web. 31 Dec. 2013.

Cowie, Del F. "Georgia Anne Muldrow's Family Ties" *Exclaim!* Ontario Media Development, August 2009. Web. 31 Dec. 2013.

Davies, Madeleine. "Erykah Badu to Flaming Lips Frontman: 'Kiss My Glittery Ass.'" *Jezebel*. Gawker, 7 June 2012. Web. 15 May 2013.

Dery, Mark, "Black to the Future." *Flame Wars: The Discourse of Cyberculture*. Durham: Duke UP, 1994. 179–222. Print.

Duke, Alan. "Singer Erykah Badu Strips at JFK Assassination Site in New Video," *CNN*. Time Warner, 29 Mar. 2010. Web. 1 Jan. 2014.

Emerson, Rana "'Where My Girls At?': Negotiating Black Womanhood in Music Videos." *Gender and Society* 16.1 (Feb. 2002): 115–135. Print.

ewwillia. "Erykah Badu's Window Seat: The Scary Black Body Strikes Again." *Feminist/queer/troublemaking*. feminist/queer/troublemaking, 5 Apr. 2010. Web. 1 Jan. 2014.

Farley, Christopher John. "Erykah Badu on Her Controversial 'Window Seat' Video and New Album." *The Wall Street Journal*. News Corp., 29 Mar. 2010. Web. 1 Jan. 2014.

Fitzmaurice, Larry, and Amy Phillips. "Erykah Badu Is Super Pissed at the Flaming Lips Right Now, About That NSFW Video." *Pitchfork*. Pitchfork Media, 6 June 2012. Web. 23 Dec. 2013.

Flow, Sista and Phil Mugs. "Window Seat: Erykah Badu's explanation (Tobaga Jazz Festival Interview)." Online Music Video. *YouTube*. YouTube, 26 Apr. 2011. Web. 26 Dec. 2013.

George, Lynell. "Pop Music; Socially Conscious Neo-Soul and a Plan; Donnie's Music Has a Message, but He's Not against Selling Records, Especially via Grass-Roots Publicity: [HOME EDITION]." *Los Angeles Times*. Tribune Co., 2 Mar. 2003. Web. 30 Dec. 2013.

Gill, Andy. "Album: Erykah Badu, New Amerykah Part Two: Return of The Ankh (Island)—Reviews, Music" *The Independent*. Independent Print Limited, Mar. 26, 2010. Web. 6 Mar. 2011.

Greenblatt, Leah, and 2008. "Music Review: New Amerykah, by Erykah Badu." *Entertainment Weekly*. Time, 3 Mar. 2008. Web. 31 Dec. 2013.

Hopkinson, Natalie. "Freeing the Black Woman's Body." *The Root*. The Slate Group, 30 Mar. 2010. Web. 1 Jan. 2014.

Lewis, Miles Marshall. "Erykah Badu: The Plebeian, Militant Homegirl." *Village Voice*. Voice Media Group, 4 March 2008. Web. 31 Dec. 2013.

Lori. "Erykah Badu's New Video for 'Window Seat': Feminist Art or Shameless Publicity Stunt?" *Feministing*. Feministing, 30 March 2010. Web. 31 Dec. 2013.

Mitchell, Gail. "Soul Resurrection: What's So New About Neo-Soul?" *Billboard*. Prometheus Global Media, June 2002. Web. 30 Dec. 2013.

Mcmurray, Anaya. "Hotep and Hip-Hop: Can Black Muslim Women Be Down with Hip-Hop?" *Meridians: feminism, race, transnationalism* 8.1 (2007): 74–92. Web. 30 Dec. 2013.

Macpherson, Alex. "Erykah Badu, New Amerykah Part One (4th World War)." *The Guardian*. Guardian News and Media Ltd., 13 Mar. 2008. Web. 31 Dec. 2013.

Matt and Kim. "Lessons Learned." Online music video. *YouTube*. YouTube, 21 Apr. 2009. Web. 1 Jan. 2014.

Mnthali, Luso. "Erykah Badu's Nude Video: Leaning Too Far Out The Window or Seated Just Fine?" *The Huffington Post*. The Huffington Post Media Group, 31 Mar. 2010. Web. 31 Dec. 2013.

Monáe, Janelle, Erykah Badu, and Alan Ferguson. "Janelle Monáe—Q.U.E.E.N. feat. " Online music video. *YouTube*. YouTube, 1 May 2013. Web. 2 Jan. 2014.

Nelson, Alondra. "Introduction: Future Texts." *Social Text 71*, 20.2 (Summer 2002): 1–15. Print.

Phillips, Layli, Kerri Reddick-Morgan, and Dionne Patricia Stephens, "Oppositional Consciousness within an Oppositional Realm: The Case of Femi-

nism and Womanism in Rap and Hip Hop, 1976–2004," *The Journal of African American History* 90.3 (Summer 2005): 253–277.

Richards, Chris. "Click Track—Album Review: Erykah Badu, 'New Amerykah, Part Two: Return of the Ankh.'" *The Washington Post*. Graham Holdings Co., Mar. 30 2010. Web. 30 Dec. 2013.

Rivas, Jorge. "Janelle Monáe On Being a Former Maid and Why She Still Wears a Uniform." *Colorlines*. Race Forward, 5 Nov. 2012. Web. 4 Jan. 2014.

Rushton, Steve. "They Came to See Who Came." *Closed Circuit*. Rod Dickson, n.d. Web. 30 Dec. 2013.

Ryzik, Melena. "The Mind of a One-Woman Multitude." *The New York Times*. The New York Times Co., 2 Mar. 2008. Web. 30 Dec. 2013.

Simon, Art. *Dangerous Knowledge: The JFK Assassination in Art and Film*. Philadelphia: Temple UP, 1996. Print.

Starr, Colleen. "Erykah Badu 'Window Seat' Video Unedited Version Is Too Risque or Just Bad Taste?" *Examiner.com*. Clarity Digital Group, LLC., 31 Mar. 2010. Web. 31 Dec. 2013.

Waldron. Clarence "Cover Story, Erykah Badu." *Jet*. Johnson Publishing Co., 8 Jan. 2001. Web. 30 Dec. 2013.

Walker, Alice. *In Search of Our Mothers' Gardens: Womanist Prose*. Orlando: Harcourt, 2004. Print.

4 The Possibilities of Liminality: Black Women's Future Texts as Productive Chaos

Nina Cartier

INTRODUCTION

Post-modern. Post-soul. Post-black. We have numerous appellations for our current moment in black popular culture. With help from mass media, popular US culture transforms into black popular culture, especially if we consider the immense popularity of hip hop as an international force, as well as the continual appropriation of other black artistic practices and modes of being. Versions of black vernaculars and fashions top the list of these practices and modes of being, of which hip hop has become the dominant example. However, as we re-imagine the trajectories of "black" in American black popular culture, it becomes helpful to consider how we might shift our understanding of representations of black women in mass media, since the media tend to blur the line between mainstream pop culture and black pop culture.

Towards this aim, *future texts*—representations with freely floating signifiers—proffer new paradigms for black women to re-present and create anew the "black" in popular culture, as well as new reading strategies by which to understand black women's representation. In this essay, I consider how pop-culture screen figures such as Nicki Minaj and Zoe Saldana, in their roles as the Bride of Blackenstein and Lieutenant Uhura respectively, problematize black female subjectivity today, as well as in the multiple time-spaces they embody. These figures manifest some of the possibilities of the future text as a paradigm. I also track the future

text through the two body genres of horror and science fiction, as they alternate between fixing black female subjectivity in particular times and spaces, and disavowing the connectedness of time and space written on the black female body as a site of that subjectivity. Shifting from past to present and to future, all of these screen representations offer new possibilities for interpreting the spatiotemporal discourses of black popular culture. In addition, these representations foreground the ways that an actor like Saldana, whose most recent controversy involves her biopic of Nina Simone, in which Saldana donned darkened makeup and a prosthetic nose, is unevenly successful in her attempts to both celebrate and adulterate the potential for power in black women's future texts as she ostensibly usurps and undermines that power in her own screen depictions (Steele). I end by contrasting these somewhat troubled mainstream depictions of black women in *SNL* and *Star Trek*, with two more successful representations in sci-fi and horror that issue from alternative black culture, Bill Gunn's "blaxploitation horror film" and Ganja and Hess and Wanuri Kahiu's sci-fi short "Pumzi," both of which manifest the possibilities of the future text as a reading strategy.

Defining the Future Text

Black people are always in a process of becoming. As viewers of American popular media representations, we scour the screens searching for images that both reflect our lived experience and offer new possibilities to free ourselves from the confining humdrum (and sometimes stifling racism) of our daily existence. We wish to see both what we have become and what we can become in the various depictions, searching for some small, tangible artifact as evidence that not only do we exist as a people, but that we matter as people beyond stereotypes and racist tropes.

Patriarchy militates against this process of becoming and somewhat stabilizes it for the black man as he can achieve plenitude through assuming the power of the phallus. Onscreen, black man still means "man," and by adopting the postures and positions of male power—though not unproblematically—the screen allows the black man to be fixed in time and space and therefore, be legible as a man. He becomes stabilized through patriarchy. No such stabilization exists for the black woman, for like all women onscreen, she always already represents a lack, and doubly so. She is neither man (and so not a person like her white female screen counterpart), nor fully woman (since the fact of her epidermis prevents

her from fully entering the realm of desire). Thus, the black woman's process of becoming remains continuous, and her body—a floating signifier—drifts easily back and forth through past, present and future, making her, quite literally, a future text.

Indeed, the body of a black woman is always already a future text. She participates in a triple signification of the past, present, and future: she is trapped by the deviant sexuality of the past (always a whore); she lives her own present in contention with current conventions of both black and white female beauty (or lack thereof); and she strives toward a future in which her body is her own to embody or transcend, unfettered by the binaries of "too black" or "not black enough" (among many others) where she can simply be how she is—sexual, not sexualized, desirous and desired—and free. But what does this look like onscreen? In the following sections I consider how my conception of the future text works in both television and film representations of black women, with varying degrees of success in terms of how effectively they can help us unpack the multiple meanings of the screen images.

Lack to the Future: Saldana as Uhura or the Failed Future Text

As the main story begins, *Star Trek: Into Darkness* works a bit too hard to be post-racial (and whatever the equivalent is for aliens—post-galactic, perhaps). The camera opens on a couple, whose race seems obvious at first; they appear to be a black man and a white woman. However, as the light changes, this certainty dissipates and we cannot discern which race or even ethnicity they are. It never becomes clear if they are indeed black and white, Southeast Asian, Pakistani, or perhaps of Middle Eastern descent. Shortly thereafter, we see Captain Kirk waking up in bed with two alien women, their tails curling sensually in the air as they protest his halting of their obvious coitus session.

On the surface, neither of these scenes is problematic. The *Star Trek* television series is one of the few shows that were multicultural from the start, though this plethora of races and ethnicities (and species, if you count the aliens) did not always insure progressive cultural politics. Kirk, lover that he was, hopped from planet to planet, and bed to bed, putting his own unique twist on the narrative's catchphrase "to boldly go where no man has gone before." Lt. Uhura, originally cast with black actor Nichelle Nichols, quickly became a symbol of both the narrative's

racial and ethnic politics as well as its sexual economy. As one of the first major franchises to cast black actors in a television series, Nichols quickly recognized the gravity of her representation of Uhura to black American audiences ("New Star in the TV Heavens"). The onscreen kiss she shared with Kirk sent shocks through the television airwaves, since when it aired in the 1960s, interracial romance was still very much taboo. But in this latest film, *Star Trek: Into Darkness*, Uhura fails as a future text, partially due to the racial and sexual politics of the film, and partially due to the tension between the trajectory of Uhura's role and Saldana's "star text" (Dyer and McDonald). Star text, derived from Richard Dyer's idea of the star image, considers the multiple iterations of an actor as suggested through various characters the actor plays, as well as through promotion, publicity, and private life. Thus, the discourse surrounding the actor, collapsing sometimes with the actor's roles and mediatized image, becomes the actor's star text. Any actor's star text can impact how we interpret any of their characters, as well as their off-screen exploits, and we often fail at our attempts to disentangle our conflation of the role with the actor due to the strong ideological impact the actor's body has upon our negotiation of the meanings we associate with the role and the actor. Our negotiation becomes especially problematic as we interpret black women's representations, since so many of their roles depend squarely on the fact of their epidermis and ostensibly explicit markers of blackness like hair texture and facial features.

The racial and sexual politics of the *Star Trek* franchise in general tend to be multicultural but not inherently progressive. True to the *Star Trek* form, a quick visual scan of the USS Enterprise confirms people that appear to be of all races and ethnicities, with various body types within those categories too. The thin, punk rock-styled, platinum blonde woman and the curvy, bald, black woman are particularly compelling in their complication of the female stereotype. Elsewhere in the diegesis, racial, ethnic, and species variety also abounds. In the bar scenes, happy couples bounce to and fro, ostensibly, as interracial as they are intergalactic, which again suggests a film that is trying too hard as the roving camera lingers on these particular couples and is insistent on heavy-handedly depicting how jubilant and carefree their mannerisms are.

It is just in these instances that the future text starts to fail, since beneath the veneer of multi-culti feel-good, *Star Trek*'s larger politics become problematic as we delve into the layers of how they are enacted in this film. To call attention constantly to the group's named above

having fun and being "normal" shouts, "Hey, look how fun and normal these otherwise boring and odd groups really are! See, race/culture/species doesn't matter at all!" The future text's liminality is not a space of unproductive chaos but a space of unlimited possibility, and when the narrative tries to stabilize that chaos, to point it out and resolve it, to make it "just like everyone else," it loses the potential of its potency. The idea that liminality can produce chaos may seem new, since the most widely known ideas about liminality highlight it as transitional space and time in the process of completing a transformation, after Victor Turner's concepts. Other historians and theorists conceive of chaos as productive, such as the concepts of an "accented cinema" from Hamid Naficy or "diasporic vertigo" from Valorie Thomas. In each of these ideas, chaos becomes productive, and what can look like disorder and disharmony can actually represent the foundations of artisanal filmmaking or a necessary ungroundedness as a hallmark of black ontological coping strategies, for both Naficy and Thomas, respectively, within oppressive societies.

Similarly, *Star Trek: Into Darkness* struggles with Uhura as it intersects with the trajectory of Uhura's role in the franchise. As with any reboot, Abrams, the writers, and any other creative personnel have the artistic freedom to interpret Uhura as they deem fit. The very name, Uhura, means "freedom," so one would surmise that her role could display a penchant for change or challenge to the status quo of women, blacks, and perhaps other groups, in enacting the very freedom her moniker defines. Indeed, Uhura's role illuminated the stories that black bodies can tell through the epidermis or the fact of insistent blackness. There was no doubt that Uhura was black, no in-between or wondering because of her skin or features, so she was legible insistently as a black woman, and one was reminded of this fact every time she had a scene (and especially during the kiss with Kirk). The old Uhrura became a future text, for at once her body proclaimed the screen possibilities for black women (as desirous, as participating, as evident) as it reflected the contemporary paucity of their representations on television and challenged (albeit unsuccessfully sometimes) the past tropes of black women in many forms of media. Temporally, and spatially, this old Uhura participated in a larger transformation of how black stories were told that occurred in her contemporary 1960s moment with other narratives like *Julia* and *In the Heat of the Night*. Like Julia or Mr. Tibbs, Uhura shifted how black bodies operate in the process of signification, or simply, she shifted

how black bodies signify and what they signify, during an era in which real black people were struggling (epistemologically) to do the very same thing. One need only recall the power of the 1960s slogan, "Black is Beautiful," or James Brown's proud refrain, "Say it loud! I'm Black and I'm proud!" as evidence of the American black population's move toward establishing a positive representation of blackness from a negative one.

However, unlike television's Uhura, whose mere presence in the narrative was enough to make screen ideologies of black freedom tangible, this latest film's Uhura plays no such race card matter-of-factly. Instead, as in the first film of the reboot, this Uhura exists in an ostensibly post-racial and post-galactic time and space, so she needs to do much more than just be "black" onscreen. But she does not, and in the spaces in which the film could capitalize upon the potential liminality of her role as a black woman in space in the future, it takes great pains to fix her and contain her within tightly prescribed tropes.

For example, *Star Trek: Into Darkness*'s Uhura appears very dated, despite the setting of the film being the future. Her long ponytail with bang "hump" was an immensely popular hairstyle in many black communities in the 1990s, so to see it onscreen as the "future" of black hair seems questionable. To be fair, none of the other main female character's hairstyles are any more progressive, but the rest of the female background cast seems to at least showcase futuristically-funky 'dos like the bald and platinum blonde mentioned earlier. Further, the long ponytail still signifies Western ideals of femininity and beauty that do not always map onto the black female body easily or unproblematically. Beyoncé wears the impossibly long ponytail extension as Sasha Fierce, but even for her it works to reify the very ideals of beauty qua power she claims to refute. For Uhura, the ponytail screams, "dated black urban chic" and "beauty by European hair proxy" simultaneously. Both of these stances ground Uhura and fix her in representations in ways a future text should not. In fact, the future text could enable Uhura to stay fluid. It could signify upon the old Uhura's groundbreaking role and play against type by changing up Saldana's Uhura hairstyle or at least intentionally mocking it to push her characterization a bit more toward camp. Such a move could act as an insider wink-and-nod of sorts to black female viewers who could then laugh at Saldana and *Star Trek* self-reflexively poking fun at black women's hair practices.

However, it is not all in the look, for the narrative fixes Uhura through her actions as well. This latest film, like the previous one, continues the

romantic relationship between Uhura and Commander Spock. Their passion runs deep, as evidenced by one of our first encounters with Uhura as she cries when she thinks he is dead, and later on as Spock—in a rare moment of human emotional expression—professes his undying love for her as they both nearly die in a firefight. However, as Uhura's anger at Spock's insensitivity intensifies and her hurt deepens, the film depicts her as playing the typical Sapphire role. Uhura snaps at both he and Kirk several times; she rolls her eyes and sucks her teeth in condescension; she speaks rapidly and with characteristic around-the-way-girl cadence as she quips that nothing is wrong, but then continues to blurt out all the things that are indeed wrong. Thus, the film uses her speech and mannerisms to clearly fix her as an urban black woman no different from our contemporary urban black women and connected to that long trajectory of Sapphires and other neck-snappin' mommas of the media's past black female representations. The penultimate scene of this connection happens as Uhura disembarks the ship to talk to the Klingons. She angrily tells Kirk, "You brought me here to speak Klingon so let me speak Klingon," and then she carefully strides over to the gang of Klingons to speak her piece. The film depicts her mannerisms as classic black girl toughness—head cocked, jaw tight, body taut—but it is her speech and its cadence again that seals the representation. Despite the lack of translation the forced speech through the teeth and the sound of her tough talk is enough to reiterate that she is indeed the tough Sapphire that no one ought mess with, lest they feel her wrath.

Saldana's star text aligns most closely with this last representation of her as Uhura, for she has gained recent media attention for her real-life tough talk and abrasive attitude. Due to her features (long hair, keen nose and lips) and perhaps her skin tone, Saldana constantly has to answer questions about her blackness. In short, most of the controversy stems from Saldana not being "black enough" physically to portray adequately the role. Saldana is not the only black pop-culture icon whose star text confuses the future text. Nicki Minaj does as well, but in more generative ways.

Nicki Minaj or the Unruly Future Text

In 2011, *Saturday Night Live* featured a skit that was a blaxploitation film spoof. The *SNL* skit, "Bride of Blackenstein," is written for deliberate sight gags and sonic jokes. We are supposed to laugh at its ridiculousness

and understand when it winks and nods at us while making insider jokes about Nicki Minaj, sketch comedy, and movie spoofs. Unlike *Star Trek: Into Darkness*, which tries to push the boundaries of what black women can achieve in a text and fails, "Bride of Blackenstein" makes us laugh in spite of and at its failures, as the comedians trip and stumble over their lines or giggle when speaking something particularly outrageous. Further, "Bride of Blackenstein" is already playing with the idea of remixing, and not necessarily as an homage like The *Star Trek* reboot, so the *SNL* skit does not take itself as seriously.

Five times throughout the short skit, the camera cuts to a close-up of Minaj as she gives her butt a sharp shake from left to right. Almost completely filling the frame, Minaj's ample posterior focuses out attention upon it, and pulls us in and out of the future text simultaneously as we contemplate how big her butt is in the skit, how big it is in real life, and if the rumors surrounding her rear-end plastic surgery are true. As such, her butt becomes a site of dislocation from her body and takes on a life of its own, almost. Though fraught with the dangers of Hottentot Venus stereotyping, Minaj's playful shake seems to laugh in the face of such racism and sexism even as it acknowledges it and refutes it. Intertextually interpolating video vixens, other rap divas, plastic surgery culture, pin-up models and perhaps every song ever made about butts, Minaj's future text cathects for a short time on her ample derriere, before pinging haphazardly to her hair and her mouth, proving to be as unruly as the jiggle she provides.

SNL repeats form with difference, which allows Minaj to play with stereotypes even as she ostensibly reifies them. Akin to Houston Baker's mastery of deformation/deformation of mastery paradigm, the *SNL* skit operates deformation on two levels. It masters deformation as it deforms the blaxploitation form, reducing it to 1970s lingo, booties, and funk songs. It also deforms Minaj, attempting to reduce her to a hair weave, big butt and jargon, yet she exceeds the reduction whereas the blaxploitation form in this instance does not. The skit is framed as a self-reflexive commentary that rolls back upon itself with meta-commentary: mirroring the mirror, if you will, to manifest the deformation of mastery. To achieve this, the skit depicts a Robert Osborne-like figure (the host of Turner Classic Movies), commenting upon blaxploitation. The fake film itself comments upon how our expectations of nostalgia can be thwarted, even more so when spoofed; Minaj comments upon black women's media representations as well as the great attention the media (and she

herself) gives to her hair, her butt, and her bad mouth/rap flow. Each instance subverts the idea of mastery as the penultimate reflection of the perfection of a pursuit, as well as a reflection of total understanding of the goals of a pursuit. The success of the skit relies on Minaj's star text as an asset, not a liability. As an audience we are also making fun of a woman who makes a living partially by making fun of us, our culture, our values, and our hang ups, not only through her lyrics and videos but also with her own bodily self-expression. In this skit, Minaj showcases her voluptuous body herself by stroking her breasts and torso and patting her hair, before the camera cuts to her shaking butt, mirroring this showcasing effect. Collapsing for a moment with her star text, Minaj, in this skit and offscreen, celebrates her sexuality through her skimpy outfits which accentuate her curves. Here she dons a tall, white-streaked, squarish afro-wig; offscreen, she often wears multi-colored outrageous hair weaves, especially in her signature Barbie pink. In either case, she utilizes her bodily self-expression to her own advantage, despite the negative interpretations such expression can sometimes engender.

The "Bride of Blackenstein" never existed as a blaxploitation film. Minaj, whose barbs in the sketch spew from a mouth taken from a hoe who didn't know her place (literally, that is where the hunchback mined the body part that forms the Bride of Blackenstein's mouth), squarely places her own body within a tradition of hip hop artists—rappers in particular—who play with images and tropes from the blaxploitation era as well as reject the supposed "places" women are allowed to occupy both in hip hop and American society. The overwhelming star power of Nicki Minaj's body forces us to recognize her in the present, while the past and future collide in a nostalgic look back to a blaxploitation narrative that has not even been created yet.

Nicki Minaj creates an unruly future text: the futuristic "Bride of Blackenstein" that has yet to be invented fully absorbs the energy of the blaxploitation past. Nicki, the self-proclaimed Harajuku black Barbie and inheritor of Queen Bee Lil' Kim's legacy, provides us with an intriguing example of how gender politics inflect her afro-futurisic hip hop stylings in our contemporary times. For just like Lil' Kim, Minaj willfully samples blaxploitation tropes and sexual mores, throwing caution to the winds, in a move to reinvigorate the playfulness of both hip hop and blaxploitation. The "Bride of Blackenstein" skit creates the ultimate remix, since by definition, the body of a Frankenstein monster comprises several disparate body parts from various people from various

times and places, as well as mechanical parts like screws and sockets. Minaj's "Bride of Blackenstein" body comprises a brain from a woman at the DMV, fingernails from a Walgreens cashier, a mouth from "a hoe who didn't know her place," and a fake booty created by over-filling basketballs with jello.

Further, Minaj's star text overflows with speculations about her own butt implant surgery and possible nose-job, as well as her quite obvious multicolored, outrageous weaves and make-up applications that borrow form the stylistic trappings of everything from the women of the Harajuku district in Tokyo to Malibu Barbie dolls to ghetto nail salons. A Frankenstein monster also exists in the liminal space between the living and the dead, the past and the present, and it strives toward a future in which the use of technology makes these distinctions irrelevant. It is also in this manner that Minaj's "Bride of Blackenstein" succeeds the most, though not unproblematically. For the trappings of racism and sexism still flood her future text, yet she seems content to let them exist right alongside her critique of them.

Smokin' the Role: Ganja, or Mining the Past's Future Text

Ganja and Hess (Bill Gunn, 1972), a blaxploitation horror, depicts Afrofuturist elements throughout the narrative as it plays with time, space, causality, and narrative confusion. It presents a lyrical, vampire narrative that unfolds in waves and folds back upon itself, ending practically where it began, but with a difference. In the film, Ganja, the wife of Dr. Hess's assistant Meda, comes to live with Hess and becomes his lover upon discovering her husband's suicide. Accustomed to a life of luxury and travel, Ganja quickly establishes herself within Hess's household, for her husband's death has left her without a source of income. Being a practical woman, Ganja easily decides to remain with Hess, and the film depicts both her attraction to him and her subsequent seduction of him as markers that reinforce her pragmatism. After the credit sequence, it opens as the camera roves the scene, revealing statues that depict death and rebirth simultaneously and paintings that capture the confusion of agony and ecstasy. It ends as the camera searches Ganja's face, freezing her in time just like the artworks, akin to a symphonic composition in which the dominant themes vary and repeat, resound and diminish.

Offering no real linearity or causality, the narrative depicts ethereal moments in time and space shared between the main three players, Hess, Meda, and Ganja. As such, we are never quite grounded when we experience the film, and although we end much like we began, we are left wondering exactly where we have gone, if not why. The narrative starts as Dr. Hess Green visits a museum to pick up his new assistant, George Meda. Other than briefly describing that Meda will assist Hess with his study of the ancient black civilization, Myrthia, the film offers no explanation of why Hess requires a new assistant, what happened to his old one, or why Meda was chosen. The film just drops us right into the situation, and then directly into the horrors that await them back at Hess's estate. Not too long afterwards (at least in screen time, for it is unclear how long has transpired in the film's time) Meda stabs Hess with a Myrthian bone and commits suicide by shooting himself in the heart.

The film enacts the future text to depict the liminality caused by the friction of realms colliding. In multiple ways the film articulates these tensions between spatiotemporal realms: victim/criminal, lucid/high, masculine/feminine desire, living/ dead/immortal/undead, past/present/future, dreams/reality/the uncanny, heterosexual/homosexual/bisexual, and pagan/Christian, just to name the most apparent ones.

Although the film does not introduce Ganja until about a third of the way into the screen time, exploring her future text yields insights into all the ways in which it operates throughout the entire narrative. In her very first scene, the film depicts Ganja in parts, only showing her head and shoulders and partially obscuring her face as she speaks to Hess via telephone in a booth. The film seems to drop Ganja in from nowhere: it is not until the end of her conversation that we get some sense of where she is (the Pan-Am tarmac at some airport during the day), though we know who she is right away. Ganja is someone's wife—Meda's to be exact—which we learn toward the very end of the conversation. Her call is odd and disarming, though she seems hardly bothered by the abruptness and pacing of her conversation. As Hess answers her call, she demands, icily, "I want to talk to my husband," and becomes more irritated as he dismisses her politely and ends the call. When she calls back, she explains herself only slightly more, asking to stay at Hess's house and wait for her husband's return. Not caring that Hess doesn't know her at all, and thus has no way to adequately tell the driver who to pick up, Ganja simply offers her location and says that she is valuable. We take her insistence

upon her value as her indicator of who she is, and thus a way for the driver to recognize her despite never having seen her before.

Ganja unites the slippery narrative of this part of the film, for it appears disjointed if we consider that it occurs across different times and spaces and thus defies the traditional ways in which scenes display unity. In this portion of the film, Ganja also activates the dissonance between three of the realms described above, namely victim/criminal, lucid/high, and masculine/feminine desire. The opening credits allude to the fact that Hess is a victim. Not only has he been stabbed by a Myrthian dagger made of bone, he is also a victim of circumstance, as his subsequent need for blood and his chance encounter with Ganja indicate. Luther, his driver/stableman, confirms Hess's status in a voice-over early in the film, emphatically reiterating that "he isn't a criminal; he's a victim." But just as Hess and Meda oscillate from being victims to being criminals, Ganja depicts this liminality as well, and refuses to own either category, unlike Hess and Meda who do.

Hess accepts his victim status early in the film, as he vocalizes his concern that if Meda harms himself on Hess's property, Hess will immediately be implicated since he is the only "colored" on the block. In this way, Hess is a victim suffering both Meda's and the racist society's will. Meda accepts his victim status as he relates the story of his first suicide attempt to Hess, only to actualize it in Hess's bathroom and finally become the victim of the murderer of his own hand, as in Meda's description of how suicide works. Hess's ultimate suicide, partially presented as his salvation through Christ, positions him as a victim that can only be saved through the divine grace of death. Ganja refuses victimhood; though she is the victim of the circumstance that her husband has deserted her and left her penniless, she demands that Hess take care of her and entices him to marry her.

Both Meda and Hess become criminals as they commit crimes against humanity: Meda murders Hess, and changes him into a vampire, though this causality is not exactly clear in the narrative since Hess appears to be a vampire before Meda even stabs him with the Myrthian bone. Hess becomes a murderer, killing to get blood to quench his bloodlust since he is a vampire and eventually stabbing Ganja with the bone, thus transforming her into a vampire too. Ganja seems criminal by design. From the venom she spews at Hess during their very first conversation to the multiple barbs she hurls at the butler Archie to humiliate him, Ganja appears to be a ruthless grifter, offering the lack of her

mother's love as a child and subsequent independence as the only reasons why. She seduces and tricks Hess; she kills Archie (though we do not see her do it, the eyeline matches of the film connect her to his death as the cause); and she murders her lover during coitus and drinks his blood, all actions which bespeak her criminality. When connected to her victimhood, her oscillation between the two realms delineate her future text.

The realms of lucid/high, masculine/feminine desire also delineate Ganja's future text in this portion of the film. Like her refusal to remain a victim or a criminal, Ganja sees no harm in getting high and no difference between being lucid or high. Shortly after she changes into her caftan in the beginning of her scene, Ganja smokes marijuana and talks about how "really fantastic" it is that her drug mule friend hides the marijuana in his rectum. This portion of the scene echoes Meda's first encounter with Hess, too, as both occur as the pair eats and smokes in the living room. Like that scene between Meda and Hess, these shots between Ganja and Hess are charged with masculine and feminine desire. The film telegraphs Meda's desire for Hess during an early voice-over as Meda apologizes for telling Hess how much he admires him, but then proceeds to gush about him anyway. Once inside Hess's house, Meda smokes marijuana, details a story in which a film director keeps yelling "cunt," and ends his conversation by neurotically telling Hess that he does not know what hunger or desire is, despite having smoked and eaten, ostensibly satiating his hungers and desires. Ganja repeats this scene but with difference. Meda does not know what to do with his desire: he constantly admires himself in mirrors and appears narcissistic, for he greatly desires his own body as well as Hess's. Meda's desires drive him mad, so after hanging a noose and climbing a tree (in perhaps a false suicide attempt and plea for Hess's attention), he murders Hess, cries in Hess's bed, then bathes, grooms, and shoots himself. Just as Meda's desire proves to be his destruction, Hess's desire for Ganja proves to be his demise. For after falling in love with Ganja and marrying her, he makes her a vampire in order to spend eternity with her. Upon coming to the realization that eternity as a vampire is undesirable for him for reasons the film does not disclose, Hess chooses death and begs Ganja to join him. Perhaps her refusal breaks his heart; perhaps her dissatisfaction with him breaks his heart, as evidenced by the lover to whom he introduces her. Either way, Ganja's withdrawal of her desire from him lies at the core of his choice of death. In this manner, Ganja's desire is destructive and productive, masculine and feminine. For as her desire

consumes many of the men in the narrative as she powerfully enacts it at her will, bespeaking a kind of masculine power, it also proves generative in a feminine way, as it gives birth not only to a new lover, but also to an eternal life of privilege, thanks to Hess's apparent wealth.

The spatiotemporal dissonances between living/dead/undead, past/present/future, and dreams/reality/uncanny are closely linked to the discordance the film depicts that emanate from victimhood, lucidity, and desire. The film writes these dissonances upon all of the characters' bodies, but it becomes especially evident upon Ganja's body. Later in the film during a voice- over, Ganja relates to Hess how she dreamed he murdered her, and the film narratively confuses the audience. For at first, the film depicts Ganja and Hess in coitus, then Hess naked and kneeling upon her bloodied body. Then it depicts Ganja and Hess in the fields of his estate, whereupon Hess stabs her with the Myrthian dagger. It is unclear in which time and space any of these events happen, for just as they appear in the bedroom, they also appear in the fields. The audience cannot discern how much film time has elapsed or how much time separates each act or, further, which act comes first: her dreaming he murdered her (she does not indicate how), her murder, or his stabbing her to transform her into a vampire. Further complicating this dissonance is the fact that we cannot tell exactly when Ganja transforms into the undead, though we are sure she remains so through the end of the narrative, just as we could not tell when Hess became a vampire. The film resonates with the sense that one has been here before, just as early on it re-depicts Hess picking up Meda at the museum, only the second time the scene appears blurry and the characters wear masks. This uncanny sense magnifies as Ganja reacts to Hess when they first meet as if they are old friends. There are no formal introductions; they fall very quickly into a routine of husband and wife despite not being married yet. Her fear that she has been murdered creates a déjà vu for her, for she is indeed murdered.

The final way in which the realms of the film enact the future text presents what is perhaps the most compelling case for its use against patriarchy, for it is within the dissonances between heterosexual/homosexual/bisexual and pagan/Christian that female power most stridently manifests. Toward the very end of the film, Ganja watches as the paramedics remove a dead Hess from the premises. She appears only slightly distraught and clutches herself as if to ward off a chill. Upon re-entering the estate, she opens a window and the film depicts her naked lover running across the field to meet her as she watches him. Unlike the strains

of homosexual and bisexual desire that consumed Meda, and the heterosexual desire that consumed Hess, Ganja's heterosexual desire proves to be her success. She succeeds in re-establishing her position of wealth and privilege (which the film telegraphs for us during her very first scene as she describes being stranded in Amsterdam) as well as securing the object of her sexual desire.

Unlike Meda's challenge to patriarchy through his sexual choices, or Hess's reification of patriarchy, which the film depicts through his demeanor at dinner (treating Ganja as the "little woman/madam of the manor") and during several other instances, Ganja's enactment of her sexuality successfully destroys patriarchy in the narrative, for she comes out victorious in the end. Furthermore, in choosing the eternal life of the vampire over an ostensibly redemptive death with Hess, Ganja aligns herself with the black goddess of Myrthia and the ancient African civilization's pagan ways. She rejects death in Christ, which the film posits as death for blacks through the shadow of the crucifix crossing their hearts, in opposition to its promise of eternal afterlife in Christ for Europeans. Ganja thus defeats patriarchy on a meta-level through defeating one of its most insidious manifestations, Christianity.

Conclusion: Afro Futurism and "Pumzi," or the Future's Future Text

To end, I return to my beginning, as I contemplate the black female body's triple signification and the freedom she gains by both accepting and denying that signification as a future text. If, as Cauleen Smith states, "Afro Futurism represents the strategies, tactics and materiality of history and time as a material . . . a way of talking about the individual and the collective ways of double-consciousness . . . and a way to identify with the African diaspora," then the future text depicted in "Pumzi" (Wanuri Kahiu,1992) perhaps indicates the future of the future text, and the culmination of my efforts to utilize the future text both as a subject position and as a reading strategy, making legible the multilayers of signification of media artifacts.

Set in a future Africa, "Pumzi" sketches Asha's journey to reinvigorate her barren land by planting a life-giving tree. Haunted by dreams of verdant jungle, Asha lives inside a bubble—a technotopian structure created to sustain life in Africa after the great water wars ravaged the land, rendering it acrid and lifeless. The mise en scène of the technotopia

mimics many other sci-fi films: machines abound; guards and computers secure the facility; nondescript, unemotional characters populate the facility. Asha's appearance—dark-skinned, shaved bald, and very physically fit—resonate with both typical sci-fi films as well as many visual representations of transhistorical African women, from the covers of National Geographic to the spreads in Essence magazine. Though she defeats no foe, she does succeed in bringing lush vitality back to her land, in scenes that intertextually echo the closing scenes of Hyenas (Djibril Diop Mambéty, 1992). Deftly navigating past, present, and future but relying solely on none, Asha's future text circles back to Linguere Ramatou's future text, and the Afrofuturist future text folds back upon itself to find new life.

Asha's dreams act as harbingers of prosperity, foreshadowing the lush jungle that her part of Africa can become once again if she only plants a mysterious seed that has arrived at her desk. Asha performs some sort of cataloguing duty at the facility, and she must answer to three councilwomen who chastise her for breaking specific orders not to analyze the seed, though she has already proven the seed and the soil from which it emanates is living, not dead as the inhabitants of the technotopia presume.

In an act of sheer defiance, Asha continues her analysis of the seed, refusing to believe it is just a manifestation of her dreams from which her dream suppressants—a mandatory prescription from the council—failed to suppress. Through her defiance, Asha connects to a long line of black female freedom fighters, for with her acceptance of the dream as prophecy, Asha decides to escape from the confines of the technotopia in order to plant the seed and hopefully restore life to barren Africa.

Through appearance, action, and the film's setting, Asha enacts the future text, for she triply signifies ancient black Africa, contemporary Africa, and the future of civilization, simultaneously. I have already mentioned her bald head, and when combined with her attire she completes the Afrofuturist signification. Asha, like others in the film, dons a multilayered garment that overlaps with cut-outs and missing sleeves, tightly fitted and in neutral colors. This costume interpolates not only the interchangeable Multiples fashion line from the 1990s, but also the torn, piecemeal costumes of early Destiny's Child, the clinging costumes popularized by the *Star Trek* franchise, the paneled inserts most recently displayed in *Hunger Games: Catching Fire*, and even the headscarves and wraps of various tribal African women. As such, her clothing helps her

enact the future text, for it seamlessly blends all these influences and more while embracing the signification each embodies.

I have already noted Asha's defiant actions within the film, but I would like to emphasize the film's embracing of dreams and future and past selves as emblematic of the future text, too. For in the film, Asha frequently sees herself in a dream, in which she swims in water and walks through a verdant Africa. As she embarks upon her escape from the technotopia, the film depicts Asha's dreams again, though it is not evident whether or not her dream is actualizing or she is merely remembering it. Either way, we as viewers can accept the dream because in Asha's mind, it becomes her reality. That the film ends with Asha asleep, protecting the seed she planted while the camera pans and tracks left to reveal a verdant jungle can be read as Asha's revitalization of the land, and as such, she externalizes the literal manifestation of the land black women have performed for ages through birth and the cultivation of crops and animals.

Works Cited

Baker, Houston A. *Modernism and the Harlem Renaissance.* Chicago: U of Chicago P, 1987. Print.

Dyer, Richard, and Paul McDonald. *Stars.* New ed. London: BFI, 1998. Print.

Naficy, Hamid. *An Accented Cinema: Exilic and Diasporic Filmmaking.* Princeton : Princeton UP, 2001. Print.

Steele, Tanya. "Nina Simone & Zoe Saldana—The Politics of COLOR." *Shadow and Act: On Cinema of the African Diaspora.* Indiewire, 23 May 2013. Web. 6 Jan. 2014.

Thomas, Valorie D. "'1 + 1 = 3' and Other Dilemmas: Reading Vertigo in 'Invisible Man,' 'My Life in the Bush of Ghosts,' and 'Song of Solomon.'" *African American Review* 37.1 (2003): 81–94. Print.

Turner, Victor W. *The ritual process; structure and anti-structure, The Lewis Henry Morgan lectures, 1966.* Chicago: Aldine Pub. Co., 1969. Print.

"New Star in the TV Heavens." *Ebony* January 1967. 70-76. Print.

5 Re-Creating Niobe: The Construction and Re-Construction of Black Femininity through Games and the Social Psychology of the Avatar.

Nettrice R. Gaskins

INTRODUCTION

From contemporary artist Kara Walker's use of the silhouette to create her Negress, to Ayoka Chenzira's 2013 alternate reality game, *HER*, a transmedia project that interweaves virtual worlds with digital and social media to create a gaming and storytelling experience for players, avatars offer their creators different possibilities for constructing or re-constructing self. The avatar plays a major part in online social interactions and has been used to bring about personal and social change, as well as develop new social techniques and devices to explore race and gender. Advances in communications extend the need for black female artists to find appropriate social mechanisms to explore the self or the essential being of a person, whether she is physical or virtual—as avatars that are complex; capable of movement; are allowed personalities; and take on new personas such as the cyborg, the adventurer, or the alien. The premise of this essay is that computer-based simulated environments can offer opportunities for black female artists to transcend their physical bodies and, therefore, preexisting ideas of the self in ways that grant them agency.

In virtual worlds, artists can release or extend perceptions of the self beyond material, superficial, or traditional ideas. The avatar represents the human or a fantasy-based representation of self that can constantly be altered or changed. Artists explore these representations in their work, often using their avatar as an object to effect agency or as part of the artwork itself, adding to it and often using it to perform. Thus, Niobe, a female adventurer and supporting character in the science fiction film series *The Matrix*, and avatars like her challenge what Alondra Nelson refers to as the "raceless future paradigm" and what Gary Zabel calls "ambiguity of identity." Although avatars and the names that uniquely identify them can be altered, multiplied, discarded, or exchanged at the will of the user, they can also be used to create an enhanced mirror image of a person's identity, circle of influence, and perceived worlds or realities.

Exhibiting Black And Brown Bodies From The Pre-Digital Age

In 2010, Tate Liverpool presented *Afro Modern: Journeys through the Black Atlantic*, an exhibition inspired by Paul Gilroy's *The Black Atlantic: Modernity and Double Consciousness* (1993). The book and artwork on display identify a hybrid culture that spans the Atlantic, connecting Africa, North and South America, the Caribbean and Europe. Divided into several chapters, the show included "Exhibiting Bodies" that focused on contemporary responses to the explicit objectification of black and brown bodies that, according to the show's curators, was "one of the most disturbing and damaging aspects of colonialism and slavery" (Barson, et al.). Gilroy refers to these practices as the "destructive side of modernity" (172), which, at the turn of the twentieth century, still exhibited black people as subjects to demonstrate racial inferiority. Prior to the invention of computer technology, these images were instrumental in creating what Michel Foucault called "docile bodies of the modern state" (136), or objects that operate as ideological texts with the power to affect images of the self, as a binary opposite, or as the Other.

Saartjie Baartman, AKA the Hottentot Venus, was a young Khoi-San woman from Cape Town, South Africa. Baartman was brought to Europe in 1810 and exhibited as a sideshow attraction; she was forced to gyrate her hips for audiences in order to demonstrate her "exaggerated racial characteristics" (Barson, et al.). Baartman, a person perceived by

her European sponsors and viewers as an object or a curiosity, became a well-known symbol for how black female bodies were positioned and represented in colonial and early post-colonial imagery. Barson, et al. write that,

> Women artists have returned to the representation of the black female body, framed through devices such as scientific or classificatory photography, tourist postcards, advertising and pornography, to explore racial and gender stereotypes and inequality.

Figure 1. Candice Breitz. Ghost Series #5, 1994–96. Courtesy Goodman Gallery, Johannesburg, South Africa. © Candice Breitz.

Berlin-based, white South African artist Candice Breitz's *Ghost Series* (1994-6) appropriated photographs and visual fragments of black female bodies and re-contextualized them. Breitz used "Wite-Out" correction fluid to reconstruct the spectacle of racially marked gendered bodies on display in ethnographic postcards, which would ordinarily circulate in a predominantly white tourist market. *Ghost Series* foregrounds and acknowledges the violence of whiting-out as a process at social and political levels:

> I am interested in deploying the art work as a catalyst, one which momentarily freeze-frames problematic ways of making mean-

ing, and renders them strange. My interest lies not in censoring the desires inspired by the commodity (be that commodity a hipper-than-thou consumer trademark or a cheaply printed centrefold), but in recasting them so as to expose their logic, and, in certain cases, to push their boundaries. (qtd. in *Artthrob*)

Figure 2. Kara Walker. *Excavated from the Black Heart of a Negress*, 2002. Image courtesy the artist. © Kara Walker.

African American artist Kara Walker is well known for her work with the silhouette, an image that was popular in the eighteenth and nineteenth centuries and employed by artists as a narrative device to give graphic recognition to chattel slavery in the United States and the vestiges of Jim Crow in contemporary society (Gaskins). Walker refers to Thomas Dixon's narrative of the "Negress," from *The Clansman* (1905). The "Negress" doesn't have to have real characteristics. She simply has to have a body (e.g., dark, tawny, swarthy). In Dixon's book the "Negress" is understood to be a "bad influence on the direction of the country" (91). Walker abstracts a fictional version that she calls

"The Negress" using the silhouette and the blank space around it. The silhouette itself becomes an object that gives the artist a sense of social agency. Walker's silhouetted "Negresses" are large, complex, capable of action, and allowed personalities. As we will see, artists often go beyond physically whiting-out or silhouetting images of black bodies using computer-based virtual worlds, online social networks, games, sound, and animation.

Transcending The Physical Body Through The Virtual Avatar

The origin of the avatar can be found in Hinduism, where it stands for the descent of a deity to Earth (Daniélou 24). In India and other cultures, deities are thought to be capable of manifesting themselves in any form. Ancient cultures imagined interfaces between the physical and virtual realities, a phenomenon that did not start with computer-based technologies. In the twentieth century, digital information and communication technologies such as the World Wide Web created spaces for new kinds of interaction. This includes on-screen communication between virtual representations, or images of human users. In Norman Spinrad's *Songs from the Stars*, the term *avatar* is used in a description of a "computer-generated virtual experience" (218). In the novel, humans receive messages from an alien galactic network that wishes to share knowledge and experience with other advanced civilizations through songs. Margaret Morabito writes that the term *avatar* as an on-screen representation of the user was coined in 1985 by Chip Morningstar in designing Lucasfilm's online role-playing game "Habitat" (24). Regardless of the origins, the avatar has come to represent the self that is embodied by the user in a virtual space.

Avatars offer their creators different possibilities for constructing or re-constructing the self. The virtual avatar can meet humans' need to develop new social techniques and devices to reflect life in a postmodern world. Avatars in video, animation, and computer-based games are essentially the player's physical representation in the virtual world. In many games, the player's representation is fixed; however, increasingly, games offer a basic character model or template and then allow customization of the physical features as the player sees fit. Avatars in non-gaming virtual worlds are used as two- or three-dimensional representations of a person's in-world, (virtual) self and body. These repre-

sentations facilitate the exploration of the virtual world and can usually be customized by the user. Virtual worlds can enhance common online communication capabilities and allow users to interact with others without having pre-defined rules or goals such as in a game.

Virtual and game worlds hold the promise of communication without regard for distance, physical ability, gender, or race. Every aspect of the avatar is flexible, rendering old binary oppositions obsolete. With the creation of virtual 3D worlds like *Second Life* and alternative, serious gaming, new types of characterizations have emerged. However, even with the growing array of avatar options available to artists and users, the same eighteenth and nineteenth century racializing and gendering practices of black bodies (*othering*) can be seen in gaming and non-gaming virtual worlds. *Othering* refers to the human tendency to believe that the group that they are a part of is inherently the "right" way to be human. Wagner James Au interviewed several dark-skinned avatars in-world, including a white woman who experimented with a dark-skinned avatar only to find her social circle much reduced and friends asking when she was "going back to normal" (73). A research team from Northwestern University conducted another interesting study on the biases and prejudices people carry into the virtual world.

> The issue of race can be so uncomfortable in the virtual world that black players will play as white avatars to avoid the awkward coldness experienced by the white player mentioned above. The idea that a black woman would need to play as a member of another race merely to avoid the social awkwardness of being black in the Metaverse is disturbing (qtd. in Burns).

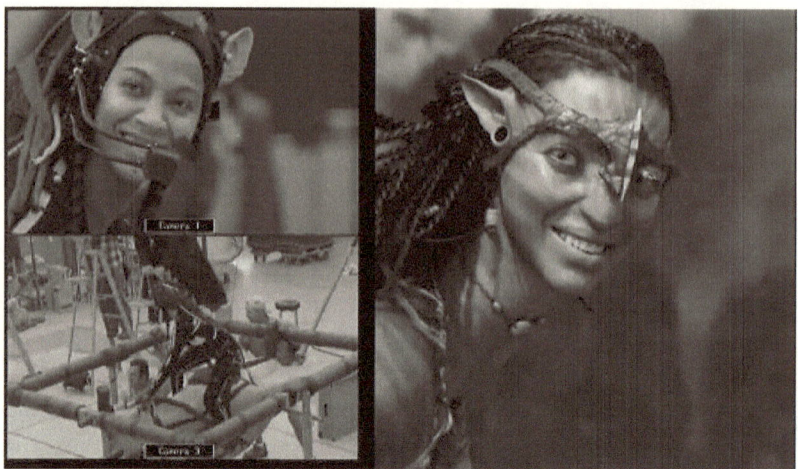

Figure 3. Performance capture of actress Zoe Saldana in the film *Avatar* (2009). Courtesy Jody Duncan Jesser and Lisa Fitzpatrick. © Twentieth Century Fox.

Artists and filmmakers had to wait until the technology caught up with their visions of avatars in virtual worlds because one of the main components hinges on the believability of the actor's performances as the characters. For *Avatar* (2009), artists needed technology that did not just capture the motion of the actor but the emotion and intent, or what senior visual effects supervisor Joe Letteri calls "performance capture." Letteri explains the software decoding of facial motion capture ("mocap") technology by saying "we try to derive which groups of muscles are activated, frame by frame, and in what proportion . . . and we sort of modify that to apply it to the Na'vi" (qtd. in Thompson). Thus, the virtual bodies on screen are actually inhabited by the ghosts of the actors, just as the Na'vi avatars on Pandora are possessed by the souls of humans sleeping in their game pods.

The human-to-avatar transport system in *Avatar* enables humans to leave or transcend their physical bodies in order to embody virtual ones. The Na'vi, or natives of the fictional planet Pandora are ten-foot tall, blue-skinned, sapient humanoids. Black or brown actors embody most of the Na'vi characters in the story but are missing on Earth (the real world). The technology in the film permits the white male hero to cross over, so to speak, and become one of the aliens. Here, instead of a black female embodying a virtual avatar of another race to escape being who she is, she now has a blue face but is still the Other. Her ghost—facial gestures, body movements and voice—are represented in the form of an

avatar but she is still not her true self. Her virtual form, or skin, is the design of someone else, someone who is white and usually male.

Figure 4. Niobe from "Enter the Matrix," 2003. © Shiny Entertainment.

THE BROWN WOMEN OF GAMING: SEXY, KICKING BUTT, OR SAVING THE WORLD

Performance-based capture, or motion capture ("mocap"), started as a photogrammetric analysis tool in biomechanics research in the 1970s and 1980s and expanded into computer animation for television, film, and video games as the technology matured. During "mocap" production, a performer wears markers near each joint on their body to identify motion by the positions or angles between the markers. Unfortunately, the cost of the software, equipment, and personnel required can be prohibitive for small productions. In other words, unlike the innovative production methods employed in *Avatar*, many animators re-use stock "mocap" performances for a variety characters. Since most of the animators and designers are white and male this presents problems as it relates to authenticity and representation of black characters, especially black female ones.

On YouTube, meanmuggah11 (a pseudonym) asks his viewers to name as many black female video game characters as they can. By using a popular search engine he discovers a staggeringly low number of black female characters except the ones used in pornography. The demographic of black female gamers is a fraction of the game industry, and meanmuggah11 suggests that maybe there would be more if there were more black female characters. In "Not All in the Game," writer and black female gamer Latoya Peterson highlights a quote from an essay that breaks down how the gaming industry came to construct the identity of a gamer.

> At its formation, the game industry used traditional market research data to understand and segment the market. They came up with their target customer: a 23-year-old single male technophile. The vast majority of computer games still focus on the tastes and preferences of the industry's first adopter, chasing him as he gets older. Because the average game player is 33 years old (ESA 2006), games offer more mature themes, lifting experiences from R-rated movies like *Rambo*. (Nicole Lazzaro qtd. in Peterson)

Peterson notes that the identity construct of the "white male technophile" gamer has been stubbornly held on to as a standard. Even with the ability to release or extend perceptions of the body beyond material, superficial, or traditional ideas, most animators and designers create highly sexualized black female characters to fit into the violent worlds of game boys' fantasies. Female avatars such as Lara Croft in *Tomb Raider* are often designed with hypersexualized representations of the female body, outfits that are unrealistic, or end up in completely over-the-top poses designed to show off their bodies. In the violent world of popular games, female characters have to look sexy and kick butt. In *The Matrix Reloaded* (2003) and *The Matrix Revolutions* (2003), Niobe is a supporting character and she is one of the main characters of the video game *Enter the Matrix* (2003). Within the virtual world of the "Matrix," Niobe is one of Zion's most gifted martial artists. In the real world, she is the most skilled pilot among the rebel forces. In the video game *Remember Me* (2013), the biracial main character Nilin is an amnesiac memory hunter. Nilin's designer, Jean-Maxime Moris, says, "She runs around, climbs, leaps, kicks guys' asses, remixes their memories, only kills a few people—and does it all in a game with no blood" (Xbox World 360). In

other words, Nilin represents the highly sexualized brown female character that kicks butt, just less of it than usual.

Figure 5. Ayoka Chenzira's *HERadventure,* 2012. © Ayoka Chenzira.

In mainstream gaming, the avatar maintains existing norms and well-known ideas of otherness. Black female characters are embodied by an assemblage of stock motion capture performances, not necessarily from black female actors or created by black women. This is not to say that there are no black female artists in gaming. The problem is that they are few and widely scattered. Lisette Titre turned her love of gaming into a career in the industry ("Changing the Game in Video Gaming"). Titre started at the Electronic Arts (EA) game studio where she worked on zombie-slaying games and dance battle games like *Dance Central 3* (2012). Ayoka Chenzira's and HaJ's *HERadventure* is both a science fiction film and alternate reality game (ARG) about HER, the name for a computer-generated avatar and inhabitant of Earth's sister planet who comes to Earth to investigate why it is causing her planet to freeze and slowly die. HER enlists a corps of "superheroes in training" (players) to take meaningful action and offer solutions to issues such as negative self-esteem, discrimination, eating disorders, and depression, which are causing women's auras to suffer. *HERadventure* players teleport through various levels of the gaming experience by using social networking sites

like Twitter and Facebook, with a goal of helping the superhero save the planet and ultimately, to serve as catalysts for positive change.

Figure 6. Camille Norment. *The Apparition Series*, 2005 - present. © Camille Norment Studio

THE BLACK FEMALE AVATAR IN CONTEMPORARY ART AND POP CULTURE

Contemporary artists create alternatives to the image of the highly sexualized black female avatar in a violent game world. Born in Silver Spring, Maryland, and living and working in Oslo, Norway, Camille Norment often uses images such as shadows and ghost-like effects as representations of the in-between or state of suspended transition. Norment often imagines herself as part of a science fiction cybernetic utopia. She notes the limitations of mainstream histories and narratives for black girls and cites the influence of emergent elements of Afrofuturism that addresses themes and concerns of the African Diaspora through a techno-culture and science fiction lens. Whereas Kara Walker's black silhouette and the white space around and between it represents the binary oppositions of race, Camille Norment's image is the avatar and her space is a visualization of sound. Norment describes avatars that are used to "live lives that the physical body can never attain, like instantaneous gender and age swapping and other experiential transformations of identity" (24). Norment's avatars project the embodied user's desires to become empowered, to take over as a primary identity, or act in a world.

Virtual worlds allow artists like Norment to explore ways to experience life as different, projected, and embodied characters, sometimes

within the same performance installation. The avatar exists as a projected presence that interrupts virtual space through sound and visual (still) imagery. Norment's *The Apparition Series* (2005–present) is an on-going multimedia project in which an apparition or ghost, appears as an African-American woman that the artist describes as an "ironic combination of historical attire and hair-dress that would be unlikely for a black woman during the period the clothing itself suggests." She contrasts her Apparition's white Civil War Antebellum gown with long dreadlocks that hang down from the avatar's head. Throughout *The Apparition Series*, the artist's use of an avatar brings together historical and contemporary representations of the black female body through its references to photography and photomontage, and to the "surreal cybernetic qualities of avatars in virtual reality environments" (Norment). *Apparition* also recalls images of Kara Walker's Negress. While Walker's work foregrounds race, gender, and sexuality through silhouette, the *Apparition* avatar is hidden among the visual noise of pixels.

Figure 7. Wangechi Mutu and Santigold. *The End of Eating Everything*, 2013. Courtesy of the artist and Nasher Museum of Art at Duke University.

Wangechi Mutu was born in Nairobi, Kenya, and lives and works in Brooklyn, NY. She is best known for her large-scale collages depicting female figures in lush, otherworldly landscapes. Her work explores issues of gender, race, war, globalization, colonialism, and the eroticization of the black female body. Mutu's *The End of Eating Everything* is

an eight-minute animated video that stars popular singer Santigold as a mysterious avatar who is part human, part cyborg, part flying island, with her own ecosystem. This sick planet creature is lost in a polluted atmosphere, without grounding or roots, led by hunger towards its own destruction. The animation's audio, also created by Mutu, fuses industrial and organic sounds. The theme of the animation is consumption, or as Mutu states, "a state of mind, you know, and how much do we really need, how much should we be sharing versus taking" (MOCAtv). A closer reading of Mutu's animation reveals connections between Santigold's persona as a hybrid cyborg and Kara Walkers's black Negress who confronts and consumes the world. These works are part of what social-cultural anthropologist Arjun Appadurai refers to as a "social imaginary" that directs viewers to critical and new aspects of artistic and cultural production. The unleashing of the imaginary through the avatar is an act of agency that gives artists the capacity to act in virtual worlds. The imaginary in the virtual world provides openings for artists' interpretations of identity, empowerment, and transcendence. Michelle P. Beverly explores how works by Wangechi Mutu, among many others, embody "a set of new possibilities for black bodies as creative and metaphysical entities." These works provide a "metaphysical template" of the black female body as "paradoxically beautiful and vile, diseased and well, procreative and vulnerable" (Beverly).

This essay takes the position that female artists demonstrate alternative notions and deeper understandings of womanhood that are contradictory to those that have been both historical and traditional, or mainstreamed in contemporary American society. The virtual avatar represents the human or a fantasy-based representation of self that can constantly be altered or changed. Black female artists frequently explore representations of black female bodies in their work, often using their avatar as an object to affect agency, or as part of an artwork, adding to it, or using it to perform. Thus, Niobe, HER and black female avatars like them challenge and address what Alondra Nelson refers to as the "raceless future paradigm" for understanding how information and communication technologies "smack of old racial ideologies." Here, blackness is the "anti-avatar" of life in virtual worlds. Rather than be seen as oppositional to a worldview, black female artists see blackness as a future text to be created, altered, and enhanced through technology. Nelson's view is supported by Gary Zabel's "ambiguity of identity" that comes from the experience of embodying avatars in virtual worlds. Zabel writes, "The

identity of the virtual person is protean and ambiguous, including indicators of age, gender, race, and even biological species." Avatars can be altered, multiplied, discarded, or exchanged at the will of the user; they can also be used to create an enhanced mirror image of a person's identity, circle of influence, and perceived worlds or realities.

Works Cited

"Afrofuturism, Science Fiction, and the History of the Future." *Journal of the Research Group Socialism and Democracy Online* 27.2 (2011): n.p. Web. 7 Mar. 2013.
Appadurai, Arjun. *Modernity At Large: Cultural Dimensions of Globalization*. Minneapolis: U of Minnesota P, 1996. Print.
"Candice Breitz Dreams and Clouds." *Artthrob*. 14 (1998): n. pag. Web. 7 Mar. 2013.
Au, Wagner James. *The Making of Second Life: Notes from the New World*. New York: HarperCollins, 2008. Print.
Barson, Tonya, et al. *Afro Modern: Journeys through the Black Atlantic*. London: Tate Publishing, 2010. Print.
Beverly, Michele P. *Phenomenal Bodies: The Metaphysical Possibilities of Post-Black Film and Visual Culture*. Diss. Georgia State U, 2012. Web. 22 Mar. 2013.
Burns, Max. "The Curious Case of Racism in Second Life." *Pixels and Policy*. Pixels and Policy, 26 Oct. 2009. Web. 22 Mar. 2013.
"Changing The Game In Video Gaming." *Tell Me More*. NPR News, 19 Feb. 2013. Web. 7 Mar. 2013.
Chenzira, Ayoka. "Digital Showcase: Black Female Superhero Solves Social Issues." *Inside Spelman*. Spelman College, 3 May 2012. Web. 7 Mar. 2013
Daniélou, Alain. *The Myths and Gods of India*. Vermont: Inner Traditions, 1991. Print.
Dixon, Thomas. *The Clansman: An Historical Romance of the Ku Klux Klan*. Lexington: UP of Kentucky, 1970. Print.
Gaskins, Nettrice. "Kara Walker: The Art of War." *Art21 Magazine*. Art21, Inc. 14 Aug. 2012. Web. 22 Mar. 2013.
Gilroy, Paul. *The Black Atlantic: Modernity and Double Consciousness*. London: Verso, 1993. Print.
Foucault, Michel. *Discipline and Punish: the Birth of the Prison*. New York: Random House, 1979. Print.
Jesser, Jody Duncan and Lisa Fitzpatrick. *The Making of Avatar*. New York: Abrams, 2010. Print.
Meanmuggah11. "Why Don't Black Female Video Game Characters Exist?" Online video clip. *YouTube*. YouTube, 8 Aug. 2011. Web. 22 Mar. 2013.

MOCAtv. "Wangechi Mutu + Santigold interview." Online video clip. *YouTube*. YouTube. 21 Mar. 2013. Web. 22 Mar. 2013.

Morabito, Margaret. *Enter the Online World of LucasFilm*. Run, 1986. 24–28. Print.

Nelson, Alondra. "Introduction," *Afrofuturism: A Special Issue of Social Text* 20.2. (2002): 1–15. Print.

Norment, Camille. *Apparition Wall Print*. Camille Norment Studio, 2003. Web. 22 Mar. 2013.

Norment, Camille. "Notes from the Oscillating Dream Space," *Sun-Ra: Pathways to Unknown Worlds*. Ed. Anthony Elms, John Corbett, and Terri Kapsalis. Chicago: White Walls, 2006. 23–5. Print.

Peterson, Latoya. "Not All in the Game." *The Guardian*. Guardian News and Media Limited, 21 Feb. 2009. Web. 22 Mar. 2013

"Real-world Behavior And Biases Show Up In Virtual World." *ScienceDaily*. ScienceDailyLLC, 11 September 2008. Web. 23 Mar. 2013.

Spinrad, Norman. *Songs from the Stars*. New York: Pocket Books, 1981. Print.

Thompson, Anne. "Avatar VFX Master Joe Letteri (Part Two)." *AnneCam*. Ning.com, 23 Dec. 2009. Web. 16 Feb. 2013.

Varady, Aharon.N. "Dogon Cosmology and the Interface of Nature and Culture." *The Cosmographic Design Initiates*, n.p. Web. 23 Mar. 2013.

Xbox World 360. "Remember Me interview: 'How stupid is this industry to only bet on stereotypes?'" *Computers and Video Games UK*. Future, 4 Nov. 2012. Web. 22 Mar. 2013.

Zabel, Gary. "Theses on the Art of Virtual Worlds." *Virtual Art Initiative*. Media Working Group, 2009. Web. 22 Mar. 2013.

6 "Ghana Meets the World": Remixing Popular Culture on OMG! Ghana

Lorien R. Hunter

What comes to mind when you think of Ghana? Grasslands and wildlife? Black bodies and kente cloth? Elmina Castle? The Ashanti Empire? Hip life? Football (soccer)? The Ghana Stock Exchange? Maybe you picture the urban metropoles of Accra and Kumasi. Or perhaps your thoughts take you toward something a little less concrete, like an abstract location such as "West Africa," or maybe simply, "Africa."

If I am honest with myself, I will admit that this project has forced me to confront some relatively uncomfortable truths about my perceptions of the world. As a mixed-race woman whose African American heritage composes a significant part of both my personal and professional identities, I have worked hard to cultivate a critical view of dominant Western discourse, and (as is often the unacknowledged underbelly of such critical views) had been rather self-congratulatory about my assumed ability to avoid being duped by it all. Yet, as I began to consider my own expectations for how a nation like Ghana might be represented online, I was humbled to find evidence of the offending discourse's influence on my carefully cultivated "oppositional" worldview. Not only did I discover that I still perceived the West[1] as largely separate from "the rest," but also, paradoxically, that I was continuing to reinscribe the power of its discourse in my own thinking by assuming (among other things) that it would also be at the center of everyone else's.

Reflecting back on my own struggles to understand and express my identity as a mixed-race person growing up in the Midwestern United States, I realize now that my initial expectation that Ghana would some-

how be reducible to a single perspective or experience was rather ridiculous. Who *I* am as a black and (but never really) white American woman is heavily reliant, not only on those identities that I see as part of myself (black, white, American, female, etc.), but also on many others that remain external from, yet connected to, me. What it means to be female, for example, is often defined in large part against what it means to be male. In a similar manner, identities such as "Muslim," "European," "Latino," "Chinese," and "Developing World" are all currently engaged in the definition of "American," although, as is made evident through this list, not all of these relationships are so easily reducible to simple binary oppositions. And if things were this complicated when discussing the identity of an individual, how could I ever expect anything less when attempting to represent something as complex as an entire nation?

Ironically, my initial presumption that Ghana and the West would somehow be kept entirely separate from one another was a direct result of the way that Africa has been, and continues to be, represented in and by the West. Often portrayed as "primitive" and "backwards," Africa has long served as the antithesis to Western identity, allowing the latter to construct itself against the former as *the* ideal model of progress and modernity. In addition to its function as a backdrop to Western identity construction, these representations of Africa have also become an essential component in the West's strategic development and maintenance of its power. As a result, there continues to be a strong emphasis placed on Africa's separateness from the West in dominant Western discourse, as a means of maintaining both Africa's presumed difference from and inferiority to the West.

In stark contrast to this approach, contemporary representations of Africa such as the one presented by the Ghanaian popular culture website OMG! Ghana offer a more complex and vibrant view of the continent and its people. Rather than situating Ghanaian life as occurring entirely outside the purview of the West, through an eclectic assortment of news and entertainment articles the creators of OMG! Ghana reveal a diverse and undeniably modern nation that is firmly connected to the rest of the world—including to the West. According to one of the site's co-founders Paa Kwasi, decisions about what stories to include (and thus, how to represent the nation on OMG! Ghana) are directly tied to his Facebook newsfeed, where his 5,000+ friends from all over the world post on a wide variety of popular topics. From this list Kwasi determines

what is most newsworthy and relevant to Ghanaian interests, and incorporates those items into the content of the website (Kwasi 25 Sept 2012).

By constructing an image of Ghana through a careful collection of news stories and entertainment objects first found elsewhere on the web, the creators of OMG! Ghana effectively use the practice of remix to generate a complex portrait of contemporary Ghanaian identity. Their use of remix to appropriate texts originally produced for a Western audience (or other non-Ghanaian populations) and repurpose them to reflect a Ghanaian world view is indicative of an ongoing expansion in the accessibility to and agency in identity representation among non-dominant and non-Western populations. In particular, the creators of OMG! Ghana are able to rewrite out the separation between Africa and the West that has been so firmly maintained through dominant Western discourse, while at the same time also managing to uphold a critical and more holistic view of present-day experiences and concerns on the continent. Engaging OMG! Ghana as a case study that illustrates just one of the myriad contemporary approaches to identity construction, I ultimately argue that such practices are evidence of the ongoing evolution in the politics of representation.

The African Savage: Power and Identity

Although the West has employed numerous tactics in its efforts to draw and uphold a separation between itself and Africa, the African Savage has been by far one of its most deleterious and unrelenting creations. While perceptions of the African as Other had already been well established in the process of constructing European identity (cultivating a sense of sameness among Europeans by drawing attention to evidence of their collective difference from "outsiders"), the Atlantic Slave Trade and colonization of Africa significantly augmented the West's need for clear demarcations between these two identities. Not only were such demarcations necessary for the preservation of the Westerner as racial and cultural lines between the two groups began to blur, but, as noted above, the West was also reliant on such distinctions to substantiate its claims of African inferiority. However, at the same time, this blurring of boundaries also meant that such categories had to remain flexible so that the lines separating these two identities could be redrawn as needed. As a result, a number of characteristics underscoring African difference and inferiority began to emerge in Western discourse during this period. In all cases,

these qualities were used to uphold European power and authority over African and African descended people by providing justification for the former's supposed "inherent" superiority over the latter.

First, it is worth noting that the designation of "savage" was a part of Western discourse long before this particular association with the African continent and its people. In fact, by the time European explorers landed along the southwestern coast of Africa they had already been using the term for centuries to describe any and all outsider groups they deemed "uncivilized," in many cases having even applied it to each other at various points in their history (Pieterse 30–1). During the Age of Discovery, European explorers and intellectuals used "savage" to connote a wide range of "uncivilized" behaviors and customs encountered in non-Western societies, spanning from differences in table manners and dress to religious ceremonies and courtship. With the rise of the Age of Enlightenment in subsequent years, this lack of civilization also became linked to a deep separation perceived between such groups and modernity.

In addition to being uncivilized, the African Savage was also portrayed as ignorant, which helped to further separate Africans from modernity in the eyes of the West. To this end, Western representations of Africans often emphasized their "primitive" nature. European anthropologists, for example, pointed to the lack of written language and comparatively simple social and economic structures in sub-Saharan Africa to suggest that Africans were at an earlier stage of human development and thus culturally inferior to Europeans. Similarly, historians also supported this hierarchy by arguing that African societies lacked evidence of human progress, thereby denying Africa's past any meaning or value worthy of European recognition. As a result of these views, colonization was often conducted under the guise of "civilization," framing European actions as benevolent attempts to bring Africa out of the darkness and into modernity. However, this process was always perceived as incomplete, thus providing the necessary justification for the colonist's ongoing (and indefinite) presence in the colonies.

While representations of the primitive African tended toward ignorance, depictions of the African as barbarian or animal relied heavily on a perceived threat of violence and lascivious sexuality. European anthropologists once again played a key role in these constructions, as did explorers, offering as "evidence" wild hypotheses surrounding African cannibalism, brutality, and bestiality. Citing these and other theories

scientists also postulated Africans as the missing link between humans (read "Europeans") and animals in the Great Chain of Being. In addition to reinforcing the hierarchy that situated those in the West as superior to Africans, these constructions also had the added benefit of mitigating the colonist's use of violence, which was less problematic if their colonial subjects were considered animal rather than human.[2] As a result, even colonists themselves propagated constructions of animalistic and/or barbaric Africans frequently, which helped cement the negative characteristics of violence and hypersexuality to the African Savage stereotype.

Finally, by defining African societies as "pagan" or "heathen," European missionaries contributed a third important characteristic to the African Savage stereotype. Similar to other constructions, the missionary relied heavily on this stereotype to underscore differences in terms of religion and ultimately used this image as justification for Europe's aggressive Christianization of the continent. As V. Y. Mudimbe explains, missionary discourse involved five major features, including the ridicule of pagan Gods, the association of pagan religions with blackness and Christianity with whiteness, the insistence that missionaries reflect God's truth, the belief that theirs (missionary's) is the only Truth, and the insistence that faith in this Truth is the sole measurement upon which one can be judged a good Christian (51). Thus, by embracing Christianity, African converts were compelled not only to reject their own traditional religious practices, but also, at the same time, to internalize European superiority, which was integral to the ongoing acceptance of European rule by Africans living in the colonies.

THE STRUGGLE OVER REPRESENTATION

Initially, efforts made to challenge these negative depictions by African and African descended people were largely reactionary. As a result of the infrastructural underdevelopment European powers enacted upon Africa during the colonial period, issues of access to the means of representation were particularly acute on the continent. The production and distribution of film and television offers a clear illustration of these challenges, as both the equipment and training were mainly kept in the European metropoles, thus severely restricting access, not only in terms of the physical location, but also in terms of funding and censorship. Similarly, literature was also limited in this manner, as both the print-

ing industries and the legitimating training grounds (i.e. the Western University) were also located almost exclusively abroad. As a result, the primary concern of individuals during this period was to gain access to the means of production, and, once with that access, to produce positive counter-images of blackness that refuted stereotypes and increased black visibility.

However, as Stuart Hall points out in his essay "New Ethnicities," this approach was somewhat limited. In order to produce a strong argument, these counter-images emphasized similarities within blackness and downplayed intra-racial differences, which continued to promote the same oversimplified version of the black experience as was found in dominant discourse. Although attempts to present a solitary pan-African subject on the continent were less reductive due to the prominence of ethnic differences and complex diversity found not only within colonies but also between them, efforts to refute negative ethnic or regional stereotypes still failed to acknowledge heterogeneity in other areas such as class, gender, sexuality, religion, and the like. As a result, these early efforts continued to promote dominant Western ideology, not only by accepting the reduction of these figures to a single experience or identity, but also by maintaining the central position of the West in the process of identity construction itself.

Following this initial phase in black cultural politics, a visible hybridization of blackness began to occur. Due in large part to the battles won by black people during this earlier period, it was no longer deemed necessary to insist "that all black people are good or indeed that all black people are the same" (Hall 445). On the contrary, rather than refuting negative stereotypes by simply reversing them (proving that black women were virtuous rather than promiscuous, for example), this new approach allowed for a broader range of perspectives and experiences to be incorporated into these representations. Referring to this shift as "the end of the [. . .] essential black subject" (444), Hall explains that this more nuanced approach to racial identity took into account the diversity of historical and cultural experiences within blackness, rather than focusing solely on racial similarities. Thus, what was once articulated as a singular black experience became multitudinous—resulting in discussions of blackness in relation to a wide variety of different local, regional, national, and transnational identities, as well as taking into account other factors such as class, gender, sexuality, and the like.

However, despite these notable improvements, this second phase of representation also had its limits. Just as efforts in the first phase addressed the negativity and marginalization of black images in dominant discourse, so too were efforts to acknowledge and celebrate diversity in the second phase also a refutation of beliefs promulgated within this discourse—namely, "that all black people [were] the same." Although this second phase is accurately presented within Hall's argument as an attempt by black people to correct their own (mis)representation of themselves, it is important to acknowledge that at the root of this (mis)representation is still the reductive nature of dominant depictions of blackness. As a result, efforts to correct this simplification in the second phase continued to define the black experience in relation to its representation in dominant discourse, thus further promoting Western ideology by maintaining the central position of the West in its (albeit nuanced) articulation of the black experience.

OMG!: A (New) Phase in Ethnicity

Turning now to consider how the creators of OMG! Ghana represent the nation online, I would like to suggest that, once again, "a significant shift [. . .] has been going on (and is still going on) in black cultural politics" (Hall 442). Using Hall's first and second phases of representation outlined above as reference points, I argue that yet again, the expansion of access to self-representation among minorities and members of the non-West has led to the emergence of a new third phase in the politics of representation. Not only is the artificial separation between the West and "the rest" unsettled, but also, although the West continues to be a visible factor in this current phase, it is, as I will detail below, often displaced from the central location it once held during these earlier stages.

OMG! Ghana is a news and entertainment website reflecting Ghanaian interests in politics, technology, sports, music, television, film, fashion and more. Its founders Paa Kwasi and Kwadwo Ofori-Mensah began that site in Fall 2011 after the forums section on their earlier site (BiGxGH.com) revealed significant interest in topics relating to music and entertainment (Kwasi 25 July 2012). Although much of OMG! Ghana's content is centered on domestic experiences, other regional and national identities are also included, along with several different international voices, both diasporic (especially African American) and non-African. According to Kwasi, "the theme for OMG! Ghana is 'Ghana Meets the

World'[,] so we [Kwasi & Ofori-Mensah] take what is from Ghana [and bring it] to the world" (Kwasi 25 July 2012). Understanding this process as a *conscious* effort to recreate Ghana online makes its inclusion of extra-national identities even more significant. To what extent might one consider these external voices as part of Ghana? And in what ways might they contribute to the imagination of it as a place and/or an identity?

In her study of Indian diasporic communities online, Ananda Mitra reveals the internet as a highly productive space for construction of the nation. Taking up Benedict Anderson's notion of the imagined community, Mitra argues that diasporans use the internet to imagine themselves as a unified group via identification with a specific (national) homeland. As she reveals in her study, to foster this identification individuals reconstruct India online through comments, questions, and news stories circulated within discussion groups on the web. Together, these items constitute a distinct representation of India, which is then engaged by Indian diasporans to "re-create a sense of virtual community through a rediscovery of their commonality" (678).

In a similar manner, Kwasi and Ofori-Mensah also produce a distinct image of Ghana through OMG! Ghana's articles, photos, music, videos, comments, events, and advertisements. Much like Achille Mbembe approaches Africa in his postcolonial theoretical project *On the Postcolony*, on this website Kwasi and Ofori-Mensah construct Ghana by considering the nation for what it *is*, rather than attempting to prove what it is not. Significantly, this frees OMG! Ghana from the restrictive attitudes of representational discourse aimed at refuting the African Savage and dissolves the false binary between African traditional culture and its engagement with modernity. As a result, OMG! Ghana presents an image of the nation as connected to rather than separate from the West, and one that engages critically with its challenges just as readily as it celebrates its successes.

Within the Modern World

As Mbembe outlines in his interrogation of postcolonial Africa, one of the primary historical functions of Western discourse has been to situate Africa as incongruous with (Western) modernity. However, as he and others have clearly demonstrated, the African experience is fundamentally linked to modernity, and in many ways even precedes its development in the West.[4] On OMG! Ghana this connection to modernity

is achieved through the use of remix to present Ghanaian experiences as global, which is achieved by presenting these experiences alongside a wide range of others from around the world, including many from the West. In addition, OMG! Ghana also posits a Ghanaian connection to modernity via the articles featuring Ghanaian life, which reveal these experiences of life as modern. Yet, at the same time many of these stories also demonstrate the ongoing presence of traditional Ghanaian culture in contemporary life, thus deconstructing the false binary between tradition and modernity promoted by Western discourse.

OMG! Ghana's news coverage clearly illustrates the use of remix in constructing the nation as modern. Although the stories within the News section are separated into regional categories, the mere inclusion of topics occurring outside of Ghana—and outside of Africa in particular—on this website work to articulate the country as a nation within the modern world. Just as with Western news coverage on CNN, the BBC, or other media outlets recognized for their "global" perspective, many of the stories included here on OMG! Ghana are not directly tied to the country, yet still ultimately reflect some connection to Ghanaian interests. As a result, these stories help to clarify the conceptualization of Ghana promoted through this website, and also how its position is imagined in relation to the rest of the world. Furthermore, by clicking on the News tab from OMG! Ghana's homepage rather than selecting a region from the dropdown menu, users are able to view headlines from all of the most recent news stories regardless of region. In this manner, OMG! Ghana visitors are able to decide for themselves how they would like the nation to be presented on the website, and in doing so perform their own (albeit somewhat limited) act of remix.

The use of remix to situate Ghana within the modern world is also evident in a similar fashion in the coverage of entertainment news on OMG! Ghana. Much as with political news, the entertainment section on this website is divided up into several subcategories, including "Music," "TV/Movies," "Watch Ghana TV," Hollywood," "Interviews, " and "Events/Gigs." Here again, some of these spaces, such as the "Ghana TV" and the "Hollywood" tabs work to reproduce certain nations online (in these cases both Ghana and the United States respectively). However, just as with the news section, by clicking the entertainment tab instead of choosing a subcategory, all of the content is presented together. In this way, Ghana and other African countries are presented alongside those in the West rather than as separate or removed from it. This presentation

thus challenges the assumption of Western discourse that maintains a binary opposition between Africa and the West, which is often articulated as "primitive" and "modern."

Modernity is also articulated through the content of many of the articles themselves. For example, within the news section, stories address contemporary issues and modern concerns, such as the construction of a new shopping mall and the launch of a new website.[5] The modern experience of Ghanaian life is also evident in many of the entertainment articles, which reveal big name rappers journeying to Ghana to perform in concerts (Felix 6 October 2013), concerns about the conduct of the nation's union for musicians (Felix 20 September 2013), and a vibrant local hip hop scene. However, at the same time, these stories are juxtaposed with others reflecting the continued significance of traditional culture in everyday life, such as in recent concerns over a river demon in a town near Accra (Administrator 17 April 2013). As a result, contemporary Ghanaian experiences are represented in relation to both tradition and modernity.

Because of technology's close association with both modernity and the West, the "Technology" tab on OMG! Ghana also strongly contributes to the website's construction of the nation as modern. As Lisa Nakamura notes in her analysis of race in cyberspace, in dominant Western discourse Africans and African-descended people are presented as exotic Others whose use of technology is both inept and uncanny. In contrast, the content in OMG! Ghana's "Technology" section demonstrates significant evidence of knowledge of, access to, and integration with technology in Ghanaian life. For example, "how to" instructional articles are peppered throughout this section, providing a variety of valuable information to readers ranging from how to revert back to an earlier version of iOS (OmgGhana 20 September 2013), to procedures for reducing the number of social networking pages and profiles one has online (OmgGhana 12 September 2013). Not only do these types of articles demonstrate the technological literacy of the authors, but their frequency in this section also suggests this information is useful to a significant portion of OMG! Ghana's readership. In a similar manner, news pertaining to cell phones and cell phone technology is highly emphasized in this section, indicating the central position this technology holds in the lives of Ghanaians.[6]

Ghana As It Is

As independence has continued to mature on the African continent, new challenges have shifted some of the focus away from Africa's relationship with the West. One of the most prominent of these developments has been the increased stratification of African societies, which has resulted in visible tensions along both class and ethnic lines. Just as Frantz Fanon predicted in his final monograph *Wretched of the Earth*, the small cadres of African elites cultivated through the colonial system frequently abuse their positions of power in pursuit of personal gains. As a result, political corruption has become a prominent feature in contemporary discourse surrounding Africa and produced by Africans, despite the possibility that such criticism could be construed as supporting Western charges of African ignorance. Similarly, the rise in ethnic tensions and violence such as those associated with the disputes in Rwanda and Darfur has also been articulated as a prominent concern, despite its possible association with Western stereotypes of African brutality and animalistic violence. Thus, whereas previously representations of Africa and of African descended people *by* African descended people had been firmly and, I argue, *primarily* engaged in a dialogue with the West (namely by challenging the problematic representations promulgated in its discourse), as a result of ongoing changes, these representations are now more centrally engaged with new relations and figures of power.

OMG! Ghana's construction of the nation as it is (rather than as it is *not*) can be traced throughout the website. In particular, content under the "News" section reveals an open engagement with a wide range of topics that offer a complex reality of Ghanaian political and cultural life. Within this section news stories are divided up into four categories, including "World News," "Africa," "Local News," and "Election 2012." The "Local News" tab, which is also labeled elsewhere as "Ghana News," is the most pronounced space on the website where this nation is reproduced. This section features stories from in and around the country, focusing particularly on Accra, which is not only the national capital and most populous city, but also the current residence of site co-founder Paa Kwasi.

Within this tab, evidence of the shift in concerns over representation can be seen most clearly through OMG! Ghana's willingness to engage in topics that might be interpreted as supporting Western stereotypes of the African Savage. In particular, as Mbembe delineates in his work, acts of violence and corruption continue to challenge much of the African continent. Thus, discussion of contemporary circumstances and

experiences in Africa must take these into consideration, despite any association they might have with Western-produced stereotypes. Through OMG! Ghana's coverage in the "Local News" section, it is made plain that this site supports such an approach. In addition to celebrations of cultural events and personal interest stories, headlines describe acts of violence in a wide variety of contexts, ranging from child abuse to armed robbery to political conflict. In close association with this last point, charges of political corruption are also featured prominently, in spite of the use of African political corruption within Western discourse as "proof" of the supposed inherent ignorance of African people and their inability to self-govern. Significantly, this diverse blend of content can also be found in coverage of other national and international news stories located elsewhere on the site, which will be discussed in greater detail below as they pertain to situating Ghana within the modern world.

As outlined above, sex and sexuality among African people has also been engaged by the West to support its stereotype of the African Savage. However, as with discussions of violence and corruption, this association has not led OMG! Ghana to avoid such topics. On the contrary, issues pertaining to sex and sexuality among Ghanaians is discussed openly throughout much of the website, including in stories under the "Local News" tab. Although these stories comprise a much smaller portion of the news covered here (centered mainly on a few sensationalized stories of incest and queer sexualities[3]), they are nevertheless a significant inclusion in this section because of their overwhelmingly negative connotations. In contrast, it is also worth noting that sex and sexuality is articulated quite differently elsewhere on the site, such as in OMG! Ghana's Lifestyle section where it is presented as commonplace and mundane. However, in both cases these inclusions suggest a growing apathy toward the Savage stereotype within African discourse.

Conclusion

Ultimately, through these and other deliberate efforts made on Kwasi and Ofori-Mensah's website, Ghana does indeed "meet the world." However, as I have attempted to demonstrate through this analysis, neither Ghana nor any other part of Africa has ever been truly separate from the world. Rather, the illusion of separation, and in many cases outright opposition, between these two entities was the invention of the West to justify its exploitation of the continent and its people. To encourage acceptance of

this false binary Western discourse developed the stereotype of the African Savage, which has continued to evolve based on the changing needs and position of Western society. In response, efforts to refute this stereotype have also evolved, and have recently begun to reveal a third phase in representation that is less concerned with Western discourse. Instead, representations in this new phase have begun to focus more heavily on internal challenges and structures of power that are not tied to the West.

As a website consciously articulated as a representation of an African nation, OMG! Ghana embodies this third phase by both situating the country within modernity through a process of remixing objects of popular and political culture, and also presenting Ghana as it is. However, perhaps the strongest evidence of this shift is revealed through a consideration of who OMG! Ghana is actually presenting the nation to. According to Kwasi, Ghanaians themselves comprise the primary audience for OMG! Ghana, the largest percentage being those who are currently residing in the country, followed by Ghanaians in diaspora. By conceptualizing the world in this manner, Kwasi and Ofori-Mensah are not denying the continued significance of the West, as it is still clearly visible in much of the content on the website. Rather, OMG! Ghana presents an image of the world where Ghana itself is at the center, thus unseating the West from its position of power and forcing a shift in the ongoing struggle for self-representation in minority group politics.

Notes

1. Terms like *West* and *Western* are admittedly (and often intentionally) quite vague. Throughout this essay I engage these terms primarily in reference to the countries of Western Europe and the United States. However, because this designation, like most group identities, describes a community that is imagined, it is important to acknowledge that what ultimately constitutes "the West" is highly fluid and dynamic.

2. Many scholars have written extensively on the relationship between violence and colonization. For example, Amie Césaire argues that the use of violence in European colonies was directly tied to the rise of Hitler in Nazi Germany and the subsequent violence inflicted upon Jewish people during the Holocaust (35–46). Building on this argument, Fanon insists that violence is the only language spoken by the colonizer. Showing the effects of this violence on the colonial subject, Fanon argues that the colonized must therefore be willing to engage violence as a tool to gain independence (1–62).

3. For example, please see Quaci Kyei, "What!!! Man Bonks Sister, Marries Her and They Have a Child Together," 18 April 2013, *OMG! Ghana*, 2012,

BiGx LLC, 19 April 2013 and Joenas N, "OWASS Sacks 19 'Homosexual' Students," 16 Apr. 2013, *OMG! Ghana*, 2012, BiGx LLC, 19 Apr. 2013.

4. For example, please see Cedric Robinson, *Black Marxism: The Making of the Black Radical Tradition* (London: Zed, 1983).

5. Please see Nsiah Asante, "Tanokrom to Get a $100m Shopping Mall," 15 Apr. 2013, *OMG! Ghana*, 2012, BiGx LLC, 21 Apr. 2013 and Administrator, "Introducing Varimor.com, To Make Your Shopping Life More Easier," 15 Apr. 2013, *OMG! Ghana*, 2012, BiGx LLC, 21 April 2013 respectively.

6. For example, in the month of July over one third of all articles (31 of 85), featured in the technology section dealt specifically with cell phone or cell phone technology.

Works Cited

Administrator, "Accra: River Demons to be Arrested." *OMG! Ghana*. BiGx LLC, 17 Apr. 2013. Web. 21 Apr. 2013

Césaire, Aimé. *Discourse on Colonialism*. New York: Monthly Review Press, 2000. Print.

Fanon, Frantz. *The Wretched of the Earth*. New York: Grove, 1968. Print.

Felix, Zion, "Akon Storms Ghana." *OMG! Ghana.com*. BiGx Media, 6 Oct. 2013. Web. 6 Oct. 2013

Felix, Zion, "Ghost Names on MUSIGA Payroll." *OMG! Ghana.com*. BiGx Media, 20 Sept. 2013. Web. 6 Oct. 2013

Hall, Stuart. "New Ethnicities." *Stuart Hall: Critical Dialogues in Cultural Studies*. Ed. David Morley and Kuan-Hsing Chen. London: Routledge, 1996. Print.

Kwasi, Paa. Email interview. 25 July 2012.

—. Skype interview. 25 September 2012.

Mbembe, Achille. *On the Postcolony*. Berkeley: U of California P, 2001. Print.

Mitra, Anada. "Virtual Commonality: Looking for India on the Internet." *The Cybercultures Reader*. London: Routledge, 2000. 676–94. Print.

Mudimbe, V. Y. *The Invention of Africa: Gnosis, Philosophy, and the Order of Knowledge*. Bloomington: Indiana UP, 1988. Print.

Nakamura, Lisa. *Cybertypes: Race, Ethnicity, and Identity on the Internet*. New York: Routledge, 2002. Print.

"Didn't Like iOS 7? Here's How To Revert." *OMG! Ghana.com*. BiGx Media, 20 Sept. 2013. Web. 4 Oct. 2013

"How to Erase Yourself From The Internet." *OMG! Ghana.com*. BiGx Media, 12 Sept. 2013. Web. 4 Oct. 2013

OMG! Ghana. BiGx LLC, 2012 Web. 9 Feb 2013

Pieterse, Jan Nederveen. *White on Black: Images of Africa and Blacks in Western Popular Culture*. New Haven: Yale UP, 1992. Print.

Robinson, Cedric. *Black Marxism: The Making of the Black Radical Tradition*. London: Zed, 1983. Print.

Part 2: Feminist Disruptions of Gender and Narrative Codes

When *Variety* reported that the summer box office numbers for 2014 were down for the first time in a decade, and down fifteen percent from 2013, a wave of anxiety rippled through Hollywood. A few months prior, the *New York Times* reported that the ratio between speaking roles for male versus female characters in all Oscar nominated films was more than two to one. Indeed, an extensive study commissioned by the Geena Davis Institute for Gender and carried out by a team at the USC Annenberg School of Communication and Journalism reported the same gender, as well as racial, imbalance in the top ten box office markets globally. Clearly, these things are complexly interrelated. Given the relationship between filmic media and identity formation in today's scopic regime, how tenable is a film and television industry that consistently offers its audience such contradictory images of their realities? And to what extent do these depictions perpetuate further power imbalances in the world off screen?

Not only are the representations of female characters problematic in their scarcity and one dimensionality, feminist critics have long pointed to the classical linear narrative form organized around the codes of the male gaze—the foundation of most popular media—as instrumental in limiting female agency and identity. These limitations occur in the very form of the medium itself, at least in its conventional structures.

The authors of this section map new opportunities for feminist engagement with the emergence of a diverse set of hybrid forms that disrupt traditional narrative forms and visual codes, as they set the stage for alternative writings based on the possibilities of gender identity within popular culture. While the hybrid form does not in itself easily or resolutely dislodge past hegemonic visual or narrative forms, it creates new "writing" spaces to reimagine gender identity.

Works Cited

Lang, Brent. *Variety Magazine.* "Box Office Down 15% in Hollywood's Worst Summer in Nearly a Decade." 28 Aug. 2014. Web. 20 Sept. 2014.

USC Annenberg Staff. "Gender stereotypes persist in films on a worldwide scale." *USC News.* U of Southern California, 22 Sept. 2013. Web. 30 Sept. 2014.

Lee, Kevin. "The Gender Gap in Screen Time." *The New York Times.* 27 Feb. 2014. Web. 4 Mar. 2014.

7 Adapting Lisbeth for Hollywood: The Politics and Franchising Practices behind Sony's *GWTDT* Reboot

Courtney Brannon Donoghue

Introduction

One of the most controversial female characters in contemporary popular culture, Lisbeth Salander has been called an anti-heroine, pop-punk icon, and misogynist's fantasy. This tattooed, pierced computer hacker with a photographic memory and rather antisocial tendencies sits at the center of Stieg Larsson's globally successful literary franchise, *Män som hatar kvinnor* (*Men Who Hate Women*, 2009, dir. Niels Arden Oplev) and its two sequels. At once empowered and vulnerable, mysterious and open, the abused and the avenger, Lisbeth sparks debates regarding femininity and agency in these stories. Published in Sweden in 2005, and later released in English as *The Girl with the Dragon Tattoo*, the first book sold over fifty million copies worldwide (Parks). Due to its popularity, the book series was adapted into a Swedish-language miniseries, *Millennium*, broadcast across Europe in 2010, and released theatrically worldwide. The following year, Sony Pictures produced and released its own English-language film version of the first book. Under heavy marketing and media fanfare, the $90 million *The Girl With The Dragon Tattoo* starring Rooney Mara and Daniel Craig and directed by David Fincher offers a Hollywood blockbuster spin on the globally successful Swedish franchise.

While this rapid succession of film and broadcast adaptations raises questions about the nature of cross-cultural adaptations and blockbuster novels, I intend to set aside older adaptation debates of fidelity, quality, or origin addressed thoroughly in earlier work of Robert Stam.[1] Instead, this essay explores the circulation and translation of *The Girl with the Dragon Tattoo* (*GWTDT*), primarily the striking process of adapting Lisbeth for an English-language blockbuster. The inherent politics and practices—both industrial and ideological—circulate within the conglomerate Hollywood reboot. In remaking the Swedish franchise for a vast global audience, representational and industrial tensions emerge around the film's narrative, marketing, and promotional materials.

Media industry studies frames the post-1980s period as Conglomerate Hollywood, a transitional moment where larger policy, economic, and technological forces have reshaped industrial and institutional structures, strategies, and culture. Namely, the conglomeration of diverse media companies under a handful of diverse parent companies, emergence of digital technologies, and increased flow of global finances, products, professionals, and ideas have altered the way films are made, circulated, and consumed (Holt and Perren; Havens, Lotz, and Tinic; Schatz). In his seminal work, *Convergence Culture*, Henry Jenkins acknowledges how this industrial transition has led to a practice of expanding film products across potential markets and moving content across different media platforms (home video, broadcast, tablets, online streaming, etc.). A key production strategy to emerge in this convergence era—franchising—intends to extend the life of a film or media product. Jenkins defines franchises as the "coordinated efforts to brand and market fictional content under new conditions" (19). The expansion may occur through sequels, reboots, or spin-offs but also through newer distribution models and ancillary markets.

While a remake generically describes a film remade within a new industrial, cultural, or linguistic context, the reboot is a fairly new concept emerging during the conglomerate period. The practice should be understood within the logic, practices, and production cultures of contemporary media conglomerates Sony, Warner Bros., Fox, etc. Specifically, industry professionals and critics classify a reboot as a media franchise or property reimagined through rebranding to capture a new audience and reignite the fan base. A reboot may encompass an entirely new visual story world and tone, as was the case with Christopher Nolan's *Dark Knight* films for Warner Bros. Or, a media property may be reimag-

ined across different media platforms within the same parent company, such as HBO's *Sex and the City* reimagined as a teen drama on the CW network.

In the case of *The Girl With The Dragon Tattoo*, the book trilogy expanded transnationally into two different film series operating within different industrial models and logic. While the Swedish and Hollywood film versions have two different journeys across different media platforms, I am interested primarily in how the various *GWTDT* iterations either challenge or uphold changing production and distribution models. In the case of Sony's film, specific franchising practices shape the film as a large-scale blockbuster aimed at a wide global audience. Based on an analysis of industry trade publications, marketing campaigns, online critical press, and both film versions, the circulation of this film franchise from Europe to Hollywood reveals shifting approaches to traditional distribution platforms, current reboot discourses, and representations of a complex heroine. In the first section, *GWTDT*'s transnational journey represents current industry practices and debates surrounding distribution platforms and remaking or rebooting content. I examine the franchise as a film reboot, primarily as an industrial practice, and its discursive limitations. The relationship between the two iterations reveals the limited scope of contemporary reboot debates that framed Sony's film. Instead, I build off Derek Johnson's work on media franchising to emphasize how industry production logic and representational practices offer a new perspective on Hollywood's *GWTDT*. The remainder of the essay considers Lisbeth's circulation or representation within current Hollywood practices. Namely, Sony's *hollywoodization* of the franchise results in the "softening" and "sexualization" of a powerful and provocative female heroine. I look at three elements of Lisbeth's transformation—*pornification, commodification,* and *hollywoodization*. In general, the English-language film reveals how the character's translation and marketing function as part of a global blockbuster logic driven by franchising and reboot practices. Lisbeth's Hollywood journey is informed by specific industry gender norms and constructions that work to simplify and contain this complex heroine.

Circulation of Media Texts Across Borders and Platforms

The franchise's journey from one industrial context to another is relatively short, yet fraught with disputes over rights, originality, and the contemporary Hollywood reboot strategy. Before transitioning into a discussion of *The Girl With The Dragon Tattoo*'s transcultural and industrial journey, it is necessary to understand the film within the context of contemporary production strategies—franchising, remakes, and reboots.

A wave of mergers and acquisitions since the 1980s restructured the industry. Larger, diverse media conglomerates (Sony, Time Warner, NewsCorp) grew from merging and acquiring Hollywood film and television studios (Columbia Pictures, Warner Bros., Fox, etc.). In addition to increased concentration of ownership, digital media technologies, and increasingly globalized production, distribution and consumption patterns have reshaped filmmaking practices, and in turn, the Hollywood product itself (Schatz; Balio). Higher risks, increased cross-company and media convergence, and more diverse audiences continue to impact production models. An increasingly important, but not new, strategy to emerge has been the film franchise. Derek Johnson defines franchising as the "multiplication and replication of these media properties over time . . . an industrially driven process perceived as unchecked expansion and assimilation across cultural contexts" (2). As a series of related films or other media texts, franchises rely heavily on the ability to flow across media platforms to expand a story universe across various divisions of the parent company. The reboot has emerged since the 2000s as a practice for refreshing a film franchise or property for a new generation, as in the case of Sony's 2012 *The Amazing Spider-Man* or Paramount's 2009 *Star Trek*. William Proctor describes a reboot as "a process of regeneration, of resurrection and rebirth. It allows tired brands, exhausted properties, the luxury of rebirth and the chance to remain vital and relevant whilst providing a stable source of material that does not rely on original untested sources" (7). Although remakes also rely on tested source material, the reboot today is a central strategy for Hollywood studios that is deeply entrenched in contemporary production culture, licensing rights, and distribution platforms. Considering *GWTDT* operating within this industrial logic and mode of production, this section explores both the distribution history of the Swedish and Sony versions in relation to aca-

demic and industrial debates surrounding remaking or rebooting film franchises.

After the worldwide success of Larsson's three novels, Sweden's Yellow Bird Film and Germany's ZDF Enterprises adapted the series into three feature films for theatrical release. Distributed across Europe between February and November 2009, the Swedish-language film stars Noomi Rapace as Lisbeth Salander and Michael Nyqvist as Mikael Blomkvist, the disgraced journalist who partners with her to solve the story's central crime and occasionally partners with her in the bedroom. Known as *The Girl with the Dragon Tattoo* in English, this $13 million Swedish-German-Norwegian co-production was shot primarily in Sweden. Yellow Bird Film and its partners expanded and recut the trilogy into a nine-hour mini-series, *Millennium*, for the Swedish broadcaster, Sveriges Television (SVT) in March 2010. The film's successful European release led to limited theatrical distribution worldwide, including Music Box Films acquiring US rights to release all three films between March and October 2010. Music Box Films released the theatrical versions in a limited two hundred screen run, which is a standard theatrical releasing model for independent and foreign-language films in the US. For example, indie powerhouse distributor Sony Pictures Classics releases its films anywhere from 20–300 screens domestically. Yet, in challenging a staggered distribution practice that move downstream from theatrical to home entertainment, the film was available simultaneously through video-on-demand providers like Netflix.

This distribution history of the Swedish-language version is significant for two reasons. First, the release of the film series theatrically in one region, and later through broadcast television is an illustration of the extended shelf life, or "legs," of this particular franchise. Second, both the film's transition to television and its US release disrupted traditional distribution models for film franchises, since Hollywood studios typically allow for longer breaks between sequels in a franchise. For example, Warner Bros. waited one year between releasing the first and second *Harry Potter* films (2001 and 2002) while Sony had a two-year gap between the first and second Sam Raimi *Spider-Man* films (2002 and 2004). Much of this delay may be related to production and distribution scheduling, yet it still serves as an industry standard even for mid-range budget franchises like *Sex and the City* or *The Hangover*. The 2009 *The Girl with The Dragon Tattoo* and its sequels also challenged the pacing of downstream distribution windows. A film's theatrical release is typically

followed six months later in a staggered sequence of video-on-demand, DVD, rental services, premium cable, broadcast cable, etc (Drake). However, the simultaneous availability of US-based audiences for theatrical and streaming access reflects independent and international models that seek smaller, more focused audiences instead of the broad, global audience that Hollywood studios court through a more controlled, wide saturation release.

Significantly, as the final Swedish film was released across Europe and Music Box Films distributed the Swedish trilogy in the US the following year, American producer Scott Rudin and Sony Pictures also acquired rights to produce English-language versions of Larsson's series. Sony's efforts did experience a few challenges due to a dispute between Larsson's partner and estranged family over the literary estate after his unexpected death delayed the studio's acquisition process. Furthermore, Rudin and the studio experienced some backlash due to the quick turnaround between the Swedish films and the pre-production of Sony's version. When Swedish director, Niels Arden Oplev, was asked in an interview whether anyone involved in the newer version contacted him, he replied:

> No. I know [David Fincher's] seen my film but I don't know anything besides that. The only thing that's annoying to me is that the Sony PR machine is trying to make their Lisbeth Salander the lead Lisbeth Salander . . . Even in Hollywood there seems to be a kind of anger about the remake, like, 'Why would they remake something when they can just go see the original? (Spines)

From interview and trade press accounts of the Sony version, producer Rudin and director Fincher had zero communication or collaboration with the Swedish producers and their partners. In his work on media franchises, Derek Johnson discusses how multiple sites of franchise production can lead to "efficient, coordinated use of franchise resources" in the case of the *Battlestar Galactica* reboot. Yet, in the case of *GWTDT*, simultaneous sites of production result in tensions and "competitive—even resentful—desires for differentiation" between iterations of the same franchise (Johnson 132). As emphasized in my analysis, the resentment or "desire for differentiation" among audiences as well as cultural workers like Oplev or Fincher are tied to slippery notions of originality and origin.

I will note that whether Sony's *GWTDT* should be categorized as a remake or reboot is not the issue here, particularly if the relatively short time span between film versions is a factor. Instead, I am interested in how key remake/reboot critiques circulated heavily around the film during its production and distribution, serving as a site of contention and tension between the two franchise iterations. Oplev's response implicitly connects to and parallels industrial and academic debates regarding the current state of franchising and Hollywood reboots. Namely, whether Hollywood repurposes a popular franchise from an international film series or local studio fare, critical discourses circulate around major studios remaking a beloved film franchise. Many times, these discourses rely on questions of originality, profitability, and appropriate time span. Critical and industrial backlash or resentments emerged during the 2000s around the recent wave of remakes and reboots (Gray; Levin). Bloggers, critics, and creative professionals openly claim Hollywood has run out of ideas.[2] A film blogger for *Slashfilm* bemoans how "only two of the top 30 grossing films of the 2000s was original," while a writer for the *Los Angeles Times* wonders if the cycle of "culturally backward-looking" remakes is "spinning out of control"? (Sciretta; Goldstein). Reboot discourses debate the "authentic originality" of a film property within a Conglomerate Hollywood context. Specifically, the "tentpole" blockbuster strategy can refresh a property or franchise for Time Warner or Sony and utilize its "brand value" for additional revenue streams across different platforms or local markets (Goldstein).

In recent years, the time span or window between remaking or expanding a franchise property like *Spider-Man* (five years), The *Bourne* series (two to five years), or *GWTDT* (a matter of months). Time between iterations is a contentious issue. A post on Cracked.com notes, "the period between the final movie in a franchise and the reboot has been shrinking at an alarming rate." The site's infographic, "Movie Reboot: Mourning Period," touches on a common critique of "too soon" that grounds audience reactions in a wave of nostalgia or "retromania" for older versions ("Movie Reboot Mourning Period"; Goldstein). Typically, these debates rely on understanding a beloved film series within the restrictions of audience memory or its place of origin (especially for international remakes). Similar discussions surrounded Sony's *GWTDT* as reflected in Oplev's comments and how dozens of comments in online forums (IMDB.com, latimes.com, etc.) call for protecting the "original"

Swedish films. This perspective ignores the flexible and mobile nature of franchising in the Conglomerate era (Johnson 157).

Despite the popular and critical backlash, this is not a reason to dismiss *GWTDT* or any other international franchise remake. As Johnson suggests, the process of franchising is more powerful and complex than profit motives or questions of corporate dominance, instead: "it is the creative culture of franchising—meaningful relations, identifications, and differences—that are so important both to uncovering the greater complexities of this industrial production logic and to critiquing that system properly" (236). Moving beyond a criticism of Hollywood's hunger for profits or lack of originality in the case of franchising allows a better look at the "Sony machine" and how the studio's *GWTDT* operates within larger industry-specific production and distribution cultures. The following section traces Lisbeth's translation or reboot through Sony's marketing campaign, star promotion, and the film's narrative. By looking at three aspects of how this heroine circulates within the Sony 2011 film—pornification, commodification, and hollywoodization—I illustrate how Sony transformed a globally popular blockbuster book series and European film series into a successful franchise shaped by Hollywood logic and practices.

Lisbeth's Journey

In addition to popular reboot discourses circulating around the Sony film, many film critics and audiences viewed this international film remake through a process of localization or Hollywood's adaptation of a foreign language or culture. Similar to discussions surrounding Hollywood remakes of Sweden's *Let The Right One In* (2008, dir. Tomas Alfredson) or Korea's *OldBoy* (2003, dir. Chan-wook Park), the critique commonly traces the difficulties of changing a geographical setting, language and accents, or any culturally specific markers from one local context to another. For example, much attention was paid to Fincher and his colleagues' decision to shoot their *The Girl with The Dragon Tattoo* in Sweden using a handful of Swedish and international actors. In some ways, the characters speaking in English with a variety of "Swedish accents" or the toning down of local references and cultural markers fostered a backlash over the film as "lost in translation" (Zeitchik). Combined with reboot discourses of originality and origin, this argument views the Sony film from a place of loss and inadequacy. Aside from the

creative and performative differences between Noomi Rapace to Rooney Mara, most critics distinguished the later by her soft, curvy figure, more communicative relationship with Daniel Craig's character, and romantic aspirations in the final act.

However, scholarly discussions of international television formats theorize the remake process through the travel of a series or format as an industry strategy. Specifically, Timothy Havens suggests how TV producers and programmers imagine the format business as a "cultural journey" that moves across international borders. This "journey" is a productive way of understanding certain industry practices and logic. Likewise, I view the English-language franchise not as "lost" but its journey of being repurposed or localized within different industry logic, specifically franchising practices. Instead of a place of deficiency or loss, this section considers the process of localizing or translating Lisbeth to Hollywood narrative conventions, marketing campaigns, and promotional strategies in order to appeal a global mainstream audience.

Pornification

Borrowed from Melissa Silverstein's *IndieWire* post, one of the most striking aspects of Sony's marketing campaign is the "pornification" of Lisbeth Salander (Silverstein). For high-concept style blockbuster marketing, a simplification of plot and imagery for print ads reduces the female heroine to a two-dimensional sexualized object for global consumption (Wyatt). Sony began their official six-month marketing blitz with an "illegal" red band trailer that went viral during the summer of 2011. Seen as a studio publicity stunt, the trailer features a succession of rapid fire dizzying shots of the large cast of characters in key locations and story events. While a handful of these shots introduce Lisbeth, it is never clear who she is or her significance as the "girl" in the narrative. Only after the print posters emerged in June and July 2011 did Lisbeth become a key emphasis of the film's marketing.

Actress Rooney Mara's body emerges as a central promotional site in print, online, theatrical promos, and merchandise tie-ins. Throughout the books and film versions, Lisbeth's body is a contested place of pleasure, suffering, and resistance. On the one hand, she is featured in casual sexual exchanges with a woman she encounters at a bar and later while working closely with Blomkvist. On the other hand, in the film's most graphic scene, Lisbeth is beaten, gagged, and raped by her state-appoint-

ed legal guardian. While she eventually uses footage of this assault to threaten the man and regain control of the guardian/ward dynamic, Lisbeth is physically degraded. Her slender frame carries the physical and emotional trauma of this incident as highlighted in a shower scene showing her crouching body covered in bruises and blood. Although I will not dispute that actress Mara by and large does fall under the male cinematic gaze throughout the film, the controversial Sony marketing campaign attempts to sell only one aspect of her character as sexual object.

From the film to Sony's marketing campaign, Lisbeth's body is transformed from a complicated site of abuse and agency to a titillatingly topless figure clutched by Daniel Craig's Blomkvist in an embrace. A comparison of the Swedish and Sony print campaigns reveals a stark difference in how this female heroine is imagined within two different industrial contexts. The Swedish poster features the two protagonists sitting in front of a roaring fireplace. Noomi Rapace's Lisbeth Salander sits cross-legged and hunched over in the foreground. Dressed in a black leather jacket and pants, a partially hidden face peers from under a dark hoodie and hair. Michael Nyqvist's Blomkvist sits casually in an armchair in the middle ground of the image. His posture appears open and relaxed in contrast to Lisbeth's guarded and crouched frame. A picture of the missing girl hangs above the large fireplace. The poster introduces key characters and plot points—the dark, complicated central character, the disgraced journalist, and their search for the young woman who disappeared in the 1960s. In addition to the two actors' names listed at the top of the poster, the credits prominently highlight Larsson's name and the film's title.

While the Swedish poster clearly highlights a major plot point and its infamous characters, the Sony version sells a different experience. In a more minimalist style, the 2011 poster portrays two key characters in a black and white medium long shot. Craig's Blomkvist stands in the sparse shadowed background dressed in a dark sweater and a sinister glare as he possessively clutches Lisbeth's tiny frame in his left arm. Directly in front of him, Mara's Lisbeth is topless, wearing only a pair of low cut dark pants. Along with her pronounced dark eye makeup, Mara's thin, pale, pierced and tattooed chest and torso emerge as the focal point. The physically powerful and guarded heroine appears naked and vulnerable in the possessive arms of her male lead.[3] Reminiscent of one of Craig's steely-eyed James Bond posters or a 1990s Calvin Klein cologne ad of waifish models, the poster was labeled "Not Suitable For

Work" and received a wave of backlash from bloggers and critics. *IndieWire*'s Silverstein labeled the campaign the "pornification" of a strong female character. She argued "[Lisbeth] doesn't play by the rules . . . now we have a poster that puts her right back into *that* girl box" (Silverstein). Arguably, Lisbeth's primary value in this context stems from her femininity and desirability in the arms of her male counterpart.

Mara's sexualized body extends into other print campaigns, most notably the *W* magazine layout and an accompanying promotional piece. The actress portraying Lisbeth covers the issue dressed in her signature black leather jacket, piercings, short black hair, and dark eye makeup. Her "bloodied" red fingers pull open the jacket partially exposing her breasts and a large "Salander" tattoo. Photo after photo feature a half-clothed, listless, and inactive Mara dressed as Lisbeth. The layout includes pictures of Mara hugging her topless chest against a snowy, desolate landscape as well as the visibly unfazed young actor with pants pulled down during a tattoo session on her backside. Her body becomes less an extension of personal power or control within her environment and instead emerges as an object on display or an invitation to be looked at within these male dominated spaces. Significantly, Mara spoke out on the backlash of the NSFW poster in an *Entertainment Weekly* interview:

> People have a hard time with strong females and with nudity. But I think had I been doing something incredibly violent on the poster, people wouldn't have had a problem with it. That sort of says a lot about the world that we live in. It's just a teaser poster. I think it did just that. It teased people (Brunner).

Whether or not the print campaign's intention was to illicit the reaction of potential viewers is not the question here. Instead, what emerges is how or why Lisbeth as the female heroine symbolizes desirability and what this reveals about the gendered quality of Hollywood blockbuster and franchising practices.

As suggested by Derek Johnson, media franchising has the potential to raise questions surrounding identity, representation, and industry logic. As a way to think beyond popular and industry criticism regarding the reboot or remake, he contends that "intriguing possibilities mark the regulation and reproduction of identity as a productive angle from which to sustain the examination of franchising" (Johnson 241-2). Johnson outlines the transformation of Rainbow Brite from her introduction in the 1980s and reintroduction in 2000s. He identifies Rainbow Brite's

twenty-first century reimagining from "cherub-faced" little girl to tall, lanky, and "sexualized tween." The reimagining of Lisbeth within the Hollywood industrial logic of franchising and high-concept blockbuster aims to transform and expand this property for a mass, global audience. Yet this transformation relies heavily on selling a single dimension of Lisbeth's sexualized body as a desirable object and less on the cache of the franchise or multi-faceted story.

COMMODIFICATION

From prayer scarves sold to promote the Sony Julia Roberts's vehicle *Eat, Pray, Love* (2010) to the endless *The Amazing Spider-Man* (2012) toys and merchandise, movie tie-ins are a major part of promoting big budget studio productions (and producing additional revenue). During the months leading up to *The Girl with the Dragon Tattoo*'s December 2011 release, a number of product tie-ins emerged seamlessly alongside Sony's official marketing campaign. Many of these merchandising efforts attempted to reproduce one specific visual element of the film for audience consumption—Lisbeth Salander's style. Two key members of the production crew created a fashion line and makeup tips inspired by Lisbeth's distinct style. If the print campaign worked to make the character sexually desirable, then the tie-ins offer access to this character through consumer products.

Trish Summerville, celebrity stylist and *GWTDT*'s costume designer, developed a line of clothing with the Swedish clothing chain H&M based on Lisbeth's character. Her thirty-piece collection included dark hoodies, black leather jackets, dark jean vests, combat boots, knitted snoods, and distressed jeans (Han). H&M's designer Anna Norling described the line "as a 'feminized' take on the character's assassin chic." To promote the collection's international release in over 180 stores, H&M circulated publicity photos featuring the petite punky designer standing with a group of pale, tall, and waifish models adorned in the Lisbeth-inspired outfits. A *Rolling Stone* article celebrated the clothes as representing: "a female with a hard-as-nails persona and ensembles to match. [Lisbeth's] tomboy-meets-cyberpunk style reflects her uncompromising worldview" (Nika). The motorcycle jacket and "fierce" accessories operate as an extension of her character for female audience members to try on and casually appropriate. The promotional language circulating around the clothing line emphasized the notion of fashion as empower-

ment. This presumes that dressing like the heroine helps an individual express her "authentic self" but, more specifically, that it is a way for consumers to experience and play with Lisbeth's exotic identity and fictional worldview. In an interview, Summerville connected the fashion line to the character's inner state: "Salander's look is very real and very lived in, with pieces that her character has worn for a long time, like her jackets that act as her armor to shield her from the world. I wanted the collection to have the essence and strength of Salander, with a fashion edge" (Swash). In other words, anyone can inhabit Lisbeth's experiences and world by adopting her dark and resistant style. Through a process of gendered commodification, a complex female character is essentialized and limited to a handful of mass manufactured and disposable trends.

Released a week before the film's Christmas opening, the H&M collection stirred controversy across the US and Europe. Denounced for exploiting one female's traumatic experience to sell and market ready-to-wear designs, one of the loudest critiques came from journalist and blogger Natalie Kardeef. In a post, later featured in the *Huffington Post*, Kardeef called out H&M: "you glamorize [rape], putting a glossy, trendy finish on the face of sexual violence and the rage and fear it leaves behind" (Karneef). By reducing Lisbeth's character and experiences to a fashion commodity, H&M reinterprets her narrative arc as a punk chic fashion icon and leaves the messy emotional trauma and personal history behind. Furthermore, *Teen Vogue* ran a *GWTDT* themed article in the August 2012 issue called, "Tough Love: Super-Edgy Makeup." Jane Shin Park interviews the film's makeup designer, Pat McGrath, and offers tips on how to achieve the Salander style, aka the "ultimate in subversive chic." The author instructs readers to snap on magnetic piercings, don charcoaled eyes, and embrace a vibrant lip color since Lisbeth's "super-edgy makeup" is "more wearable than you'd think" (Park).

Lisbeth's character is mobilized to sell not only hip Swedish clothes and makeup tips, but Hollywood sells her consumable image to expand the franchise's story universe. These strategies reveal a number of assumptions and industry practices regarding franchising and gender. These promotional tie-ins extend Sony's *GWTDT* film into other platforms and into legitimate feminine spaces. Wearing her signature jacket or emulating her charcoaled eye makeup offers a way to access and participate in her world through play. Yet, this access is limited to the gendered boundaries of what is acceptable to or expected from female audiences both as consumers and movie-goers.

Hollywoodization/Romanticization

A striking element of the franchise's Hollywood expansion is how a variety of industry practices operate and work to reform Lisbeth as more feminine and relatable. Classical Hollywood narrative conventions and gender expectations operate both inside and outside of the film's text to romanticize and contain the female lead. Primarily, the film's emphasis on romantic coupling (or Lisbeth's inability to couple) results in a more serialized, open ending. This device not only reimagines her central goal but also reflects the industrial logic of franchising. From the drive for romantic-narrative closure to the actor's star image, the hollywoodization of Mara and her character reveal larger limitations for the female heroine in contemporary blockbusters.

Narrative closure operates uniquely in both film versions and offers a different outcomes and outlooks for Lisbeth in each context. According to a *New Yorker* article on the film's adaptation, the Swedish version "got rid of a lot of the clutter and scrubbed off the sugar coating that Larsson put on the relationship between Mikael and Lisbeth" (Acocella). The Swedish theatrical version of *GWTDT* minimizes their romantic relationship to a few physical or sexual encounters. Instead, after the mystery of the missing girl is solved, the remainder of the narrative focuses on Lisbeth's successful heist of a corrupt businessman's embezzled money. On the one hand, since she takes the funds to exact revenge on this man who framed Blomkvist, this directly relates to their relationship. Yet, on the other hand, this plot point is more about Lisbeth's actions and Blomkvist's reaction than what it means for the two characters. The audience learns of Lisbeth's trip to the Cayman Islands to steal the dirty money via surveillance footage on a news show as Blomkvist watches. The 2009 film closes with a sunny scene in the Cayman Islands. A final shot of the female character walking down the boardwalk triumphantly disguised in expensive business attire.

The Sony version reimagines Lisbeth's character trajectory and attachment to Blomkvist, whereas their relationship emerges as a central concern and motivation in the last 20–30 minutes. As many film critics describe it, she is "softened" and transformed in the end by developing a more intimate relationship with the journalist (Bartyzel). In their sexual interactions and a scene discussing her family's past, Lisbeth opens up and becomes romantically attached to Blomkvist. Final scenes show her hanging around his magazine office and telling her former guardian about her happiness in finding a new friend. Although more scene-

time is devoted to her preparation process before and during the heist, the film does not end with a triumphant Lisbeth successfully using her hacking capabilities to exact revenge. Instead, the concluding scene follows her arriving at Blomkvist's office with an expensive leather jacket. Her romantic hopes are crushed quickly. After seeing him embracing his colleague and lover, whose polyamorous relationship is missing completely from the Sony film, she throws the gift in the trash. In a much darker, and unrequited moment, a visibly upset Salander gets on her bike and rides away.

Lisbeth's failed romantic gesture is important for a few reasons. First, this scene should be understood within the historical context of classical Hollywood cinema. From screwball comedies of the 1930s to contemporary action films, romantic coupling with the possibility of marriage serves as a device to denote narrative closure. A central ideology interwoven into the Hollywood narrative champions the transformative power of love. Or more specifically, female characters and their agency have been tightly bound within heteronormative limits. A woman's action, motivation, and function many times will revolve around a romantic relationship. This *GWTDT* version condenses a complicated character, primarily focusing on Lisbeth's romantic transformation and desire to couple. By the end, Sony's Lisbeth is reduced to a young woman who just wants to connect and be loved; a character that clearly operates within a long industrial history of baggage and audience expectations. The emphasis on her failure to successfully couple in the final scene becomes a failure on the part of the female protagonist to conclude the narrative. Second, this open-ended film leaves the audience wondering whether or not they will end up together. Since coupling is not achieved, the story cannot be contained in one feature film. By serializing their relationship (will they or won't they?), the story must spill over into subsequent film sequels, thus reinforcing the franchising logic of extending the story into sequels and extratextual content.

The need to contain Lisbeth within a romantic narrative mirrors Mara's star text and the promotional discourses surrounding the film. Unlike the previous promotional examples where Mara is in Lisbeth character, a number of interviews and photo spreads feature the actor posing as herself. Even before the film's production began, the unknown actor was a visible figure. After a highly publicized casting process, Fincher and his creative team chose Rooney Mara for the lead role. During the production process, early discussions surrounding the film and

Mara's interpretation of the character involved her physical transformation into the "edgy" and dark character.

Yet, a few months prior to the release, and simultaneous to the print campaign discussed earlier, the focus shifts in order to distinguish Mara's star image from the infamous role. Specifically, a stream of interviews, new stories, and magazine spreads began to describe Mara as "soft," "glam," "haunting," and "feminine," contrasting her image from the "hard" or "extreme" and "edgy" as Lisbeth. The popular and critical emphasis on the actor's acceptable feminine and alluring qualities reveal the function of star promotion—the process of constructing a star image that is accessible and desirable. Critic Monika Bartyzel argues: "There seems to be a [critical] relief that Mara's Salander is a more relatable person, that classic 'female' tropes like softness and vulnerability are visible. It speaks to society's overwhelming discomfort with the unclassifiable." The film's romanticization of Lisbeth attempts to contain and simplify a complex female character who does not fit within the limited models for female characters in blockbusters.

Conclusion

Sony's 2011 *Girl with the Dragon Tattoo* provides an illustrative case study for one type of contemporary production and distribution practice. While the 2009 Swedish version challenged traditional film distribution models by incorporating alternative streaming and broadcasting platforms, the Hollywood version reflects current production practices that rely on franchising and reboots. The Fincher production represents how popular and critical debates regarding the rising importance of remakes and reboots for Hollywood studios typically are limited by claims of originality and origin. In moving beyond those critiques of sameness, *GWTDT* offers a multi-faceted space to examine the interaction between franchising logic and female representation in the Hollywood blockbuster.

Ultimately, Sony's version reveals the continued gendered logic inherent in the Hollywood blockbuster, its female heroines, and female audiences. Within the narrative and marketing campaigns, Lisbeth must operate on multiple levels. She appears as the desirable and accessible object in traditional print marketing aimed toward male audiences. Yet, selling Lisbeth's clothing and makeup style promotes the film to female audiences by transforming her into a relatable and accessible character.

The aim of this essay was not to recycle reboot critiques focusing on how Sony watered down or reduced the essence of Lisbeth Salander as imagined by Stieg Larsson and the Swedish film. Instead, I argue that examining Mara's Lisbeth as operating within contemporary franchising logic and practices of Conglomerate Hollywood reveals more about the complex and contradictory processes between gender, global audiences, and Sony's promotional efforts. This process reveals the tensions among sexual desirability, a commodified experience, and efforts to minimize and contain Salander's sexual, aggressive, and intellectual excess. In an age of wider releases and globally targeted audiences, Lisbeth Salander's franchised journey allows her the flexibility and resources to be everything to everyone as she constantly is in the process of being made and remade across shifting industrial contexts.

Notes

1. In a discussion of film adaptations, Stam argues the need to move away from literary hierarchies invested in claims of authenticity and fidelity to the source material. Instead, he suggests intertexuality as a framework since "do no adaptations 'adapt to' changing environments and changing tastes, as well as to a new medium, with its distinct industrial demands, commercial pressures, censorship taboos, and aesthetic norms?" (3).

2. This claim appears shortsighted historically. Remakes and adaptations have been a staple for Hollywood producers, especially the major studios from the studio era to today.

3. The poster design varies on the local market. For examples, Sony's marketing templates are designed in its California and New York offices. They are then sent to local distribution offices where local managers will adapt them slightly for the Spanish, Japanese, or Brazilian markets. This is why East Asian markets featured only the release date for the *GWTDT* poster and other European markets included the film's title.

Works Cited

Acocella, Joan. "Man of Mystery." *The New Yorker*. 10 Jan. 2011. Web. 7 Dec. 2012.

Balio, Tino. "'A Major Presence in All the World's Important Markets': The Globalization of Hollywood in the 1990s." *Contemporary Hollywood Cinema*. Ed. Steve Neale and Murray Smith. London: Routledge, 1998. 58–77. Print.

Bartyzel, Monika. "Girls on Film: Softening and Sexualizing Lisbeth Salander." *Movies.com*. Fandango Movies, 22 Dec. 2011. Web. 7 Dec. 2012.
Brunner, Rob. "*The Girl With the Dragon Tattoo* star Rooney Mara talks about the rape scene, the NSFW poster, and more." *Entertainment Weekly*. Entertainment Weekly Inc., 11 Aug. 2011. Web. 7 Dec. 2012.
Drake, Phillip. "Distribution and Marketing in Contemporary Hollywood." *The Contemporary Hollywood Film Industry*. Ed. Paul McDonald and Janet Wasko. Malden, MA: Blackwell, 2008. 63-82. Print.
Goldstein, Patrick. "Is Hollywood's Mania for Remakes Spinning Out of Control." *Los Angeles Times*. Los Angeles Times, 14 Oct. 2011. Web. 7 Dec. 2012.
Gray, Brandon. "2011 Preview: Sequels Now, More than Ever." *Box Office Mojo*. IMDB.com, Inc, 28 Jan. 2011. Web. 7 Dec. 2012.
Han, Angie. "H&M and *Dragon Tattoo* Costume Designer Team for Salander-Inspired Fashion Line." *SlashFilm*. /Film, Inc, 26 Oct. 2011. Web. 7 Dec. 2012.
Havens, Timothy, Amanda D. Lotz, and Serra Tinic. "Critical Media Industry Studies: A Research Approach." *Communication, Culture & Critique* 2 (2009). 234–53. Print.
Holt, Jennifer and Alisa Perren. "Introduction: Does the World Really Need One More Field of Study?" *Media Industries: History, Theory, and Method*. Ed. Jennifer Holt and Alisa Perren. Malden, MA: Wiley-Blackwell, 2009. 1-16. Print.
Jenkins, Henry. *Convergence Culture: Where Old and New Media Collide*. New York: NYU P, 2008. Print.
Johnson, Derek. *Media Franchising: Creative License and Collaboration in the Culture Industries*. New York: NYU P, manuscript. Print.
Karneef, Natalie. "An Open Letter to H&M from a Rape Survivor." *NatalieKarneef.com*. Natalie Karneef, 25 Nov. 2011. Web. 17 Dec. 2012.
Levin, Jonathan. "Next Summer's Blockbusters: 'Marmaduke' and a 'Footloose' for the New Millennium." *Slate*. The Slate Group, 8 Jan. 2011. Web. 7 Dec. 2012.
"Movie Reboot Mourning Period" *Cracked*. N.p., n.d. Web. 7 Dec. 2012.
Nika, Colleen. "See H&M's 'Girl With The Dragon Tattoo'-Inspired Collection From No Doubt, Janet Jackson Designer." *Rolling Stone*. Rolling Stone, 1 Nov. 2011. Web. 7 Dec. 2012.
Park, Jane Shin. "Tough Love: Super Edgy Makeup." *Teen Vogue*. Conde Nast, Aug. 2011. Web. 7 Jan. 2012.
Parks, Tim. "The Moralist." *The New York Review of Books*. NYREV, 9 June 2011. Web. 15 Jan. 2012.
Proctor, William. "Beginning Again: The Reboot Phenomenon in Comic Books and Film." *SCAN Journal of Media Arts Culture*. Macquarie U, n.d. Web. 1 Dec. 2012.

Schatz, Thomas. "The Studio System and Conglomerate Hollywood." *The Contemporary Hollywood Film Industry*. Ed. Paul McDonald and Janet Wasko. Malden, MA: Blackwell, 2008. 25–7. Print.

Sciretta, Peter. "Only Two of the Top 30 Grossing Films of This Decade Are Original." *SlashFilm*. /Film, 16 Nov. 2009. Web. 7 Jan. 2012.

Silverstein, Melissa."The Pornification of Lisbeth Salander." *IndieWire*. IndieWire.com, 8 June 2011. Web. 29 June 2012.

Spines, Christine. "Girl with the Dragon Tattoo." *Word & Film*. 5 Nov. 2010. Web. 7 Jan. 2012.

Stam, Robert. *Literature Through Film: Realism, Magic, and the Art of Adaptation*. Malden, MA: Wiley-Blackwell, 2004. Print.

Stam, Robert. "Introduction: The Theory and Practice of Adaptation." *Literature and Film: Theory and Practice of Film Adaptation*. Ed. Robert Stam and Alessandra Raengo. Malden, MA: Blackwell, 2005. 1-52. Print.

Swash, Rosie. "H&M launch *The Girl with the Dragon Tattoo* clothing range." *The Guardian*. Guardian News and Media Ltd., 26 Oct. 2011. Web. 15 June 2012.

Wyatt, Justin. *High Concept: Movies and Marketing in Hollywood*. Austin, TX: U of Texas P, 1994. Print.

Zeitchik, Steve. "*Dragon Tattoo*: Why do so many foreign remakes struggle?" *Los Angeles Times*. Los Angeles Times, 27 Dec. 2011. Web. 7 Jan. 2012.

8 Recasting *The Best Years of Our Lives*: Gender, Revision, and Military Women in the Veteran's Homecoming Film

Anna Froula

Stretching from antiquity to the US's current wars, the narrative of the veteran's homecoming has relied on the nurturing devotion of the woman waiting patiently at home to soothe the warrior's trauma and help him reintegrate into society during peacetime. Like other genres of war narratives, the homecoming story has historically been structured along gendered binaries: active/passive, masculine/feminine, warrior/nurturer, violent/peaceful, and "over there"/home. In this genre, women do not always fulfill the role of the "right woman to come home to" as one World War II-era *Ladies' Home Journal* article anxiously characterized, gender roles and expectations of women have historically been clear (Gardner).[1] Military women, however, complicate these traditional frameworks and notions of feminine restoration of wounded masculinity. As I have argued elsewhere, while women have traditionally represented "home" to fighting men they have also engendered uncanny experiences when they don the masculinized military uniform (Froula). As television series such as *China Beach* (ABC, 1988-91), more recent popular texts about women soldiers, such as F/X's short-lived *Over There* (2005), and testimonies from current veterans, suggest, the military woman's return disrupts the conventions of the homecoming genre even if she returns with similar needs and issues as military men.

This essay reads the female soldier homecoming narratives in three fictional films: *Home of the Brave* (Irwin Winkler, 2006), *The Lucky Ones* (Neil Burger, 2008), and *Return* (Liza Johnson, 2011) as postfemi-

nist texts: they depict the military woman not as a disruptive agent but as "just one of the guys" in an imagined culture where obstacles to women's military status have disappeared and women have the same problems re-adjusting to life in the US as men. Using *The Best Years of Our Lives* (William Wyler, 1949) as the seminal text that explicates how women should (and should not) manage their traumatized veterans, I argue that these three homecoming films about military women struggle to ground themselves because, for them, masculinity does not need to be restored. Moreover, in two of the films, the women's return to the combat zone pre-empts a consideration of how the outcome of the war influences their attempts to reintegrate into civilian America. In them, there is a going home but not a staying there: in the age of stop-loss, the touchstones of the homecoming genre cannot be fully articulated.

By way of Amanda Lotz's taxonomy of what attributes constitute postfeminist texts and clarification of what postfeminism(s) even mean, I argue that these films about returning women veterans "*deconstruct binary categories of gender and sexuality, instead viewing these categories as flexible and indistinct*" (116, emphasis original). They reflect such concepts as Tania Modleski's sense "that postfeminism assumes the goals of feminism have been attained" and Bonnie J. Dow's articulation that "power differences between the sexes . . . have been discarded as irrelevant or threatening" (cited in Lotz 112). The Department of Defense has essentially gone postfeminist, lifting the longstanding ban on women in combat in January 2013, a change that both prevents a return to the draft to support its unending wars and ostensibly reflects an understanding that women are just as capable as men in the combat conditions of the frontless wars in Iraq and Afghanistan. Allowing women in combat roles creates the perception that most of the US military branches themselves have at least officially deconstructed the binary of the violent soldier male and the peaceful domestic woman. Yet troubling gender distinctions remain. As Kirby Dick's 2012 Oscar-nominated documentary *Invisible War* testifies, women are overwhelmingly more likely to be sexually assaulted by their brothers in arms than killed by the enemy. Moreover, the Service Women's Action Network (SWAN) reported in 2012 that women are "up to four times more likely to be homeless compared to non-veteran women and veteran men" ("Homeless Women Veterans"). Homeless women veterans are also at risk for higher incidences of "severe forms of mental illness" and less likely to seek help from the Veterans' Administrative services and other outreach services for PTSD,

due to feelings of shame, fear of losing custody of children, and "the perceived male-bias of VA services" ("Homeless Women Veterans"). Even if much of military service has been stripped of prohibitive gender biases, what often happens during and after the tour of duty reflects gender differences.

Reassimilation in the Model Homecoming Narrative

While *Return* focuses on just one female veteran's struggles, both *Home of the Brave* and *The Lucky Ones* attempt to update *The Best Years of Our Lives* by narrating the returns of a few soldiers traveling home together. Before exploring the ways in which these films depict the women's return, I first demonstrate why *The Best Years of Our Lives* endures as a model homecoming narrative. While it is certainly not the first homecoming film, its tropes and significance bear out in later homecoming films, such as the Korean War's *The Men* (Fred Zinneman, 1950), in which Marlon Brando's paralyzed veteran relies on the patient ministrations of Teresa Wright's Ellen, and Vietnam's *Coming Home* (Hal Ashby, 1978), in which Sally Hyde's (Jane Fonda) sexual and personal liberation depend on the resexualization and emotional breakthroughs of the paralyzed and impotent veteran Luke (Jon Voight). The reliance on the trope of the woman healer is such that when women are absent from the homecoming narrative, as in *First Blood* (Ted Kotcheff, 1982), it is difficult, if not impossible, for the veteran to reintegrate into peacetime society.

Homecoming stories in the World War II film exclude experiences of military women, thus grounding this genre in the struggles of male veterans. Just as World War II sets the moral standard of and historical template for subsequent American wars, so too does the "good" woman of World War II become the model of idealized womanhood on the homefront. Outlining the challenges that women face in *remasculinizing* their veterans, to borrow Susan Jefford's term, reintegration films have historically promoted not only welcoming home the ex-servicemen and assisting them in defining their peacetime roles, but also helping women redomesticate themselves from their wartime independence, financially and socially (xii). Wyler's instantly popular *The Best Years of Our Lives*, winner of seven Academy Awards, provided a prescriptive manual designed to restore the veteran's masculinity in postwar America. While the reintegration film often relies on formulaic happy endings, *The Best Years of our Lives*' subtle attention to the complexities of postwar trauma

in domestic settings suggest that the film's hopeful ending is more ambiguous than certain.

The Best Years of Our Lives takes as its subject three combat veterans: Captain Fred Derry (Dana Andrews), a highly decorated bombardier and peacetime soda jerk; Al Stephenson (Fredric March), infantry sergeant and former banker; and Homer Parrish (Harold Russell), an amputee sailor whose prosthetic hooks starkly emphasize the loss of his hands. Fred, who struggles with trauma and the stress of finding a vocation, must first exhaust and end his whirlwind marriage to Marie (Virginia Mayo), who only wants to party with her trophy war hero husband, before claiming happy future with a good woman, Al's daughter Peggy (Teresa Wright). Al initially drowns his combat trauma in alcohol and struggles to synthesize wartime survival skills with peacetime banking with the help of his patient wife, Milly (Myrna Loy). All palpably nervous about the idea of re-entering their pre-war lives, the veterans meet on the flight home and share a cab to Boone City. The camera repeatedly returns to frame the new veterans as tiny figures in the cab's rear-view mirror, a visual metaphor for their anxiety about feeling out of place in a society that progressed without them. As the mirror confirms the "pastness" of their wartime lives, their reluctance to leave the cab indicates how unprepared they are to enter the present of postwar America. While both Fred's and Al's reintegration dramas are compelling, I will focus here on Homer, who most directly resonates with the characters in the postfeminist films I discuss below.

When the cab pulls up in front of Homer's house, he nervously suggests they go to his uncle's bar, Butch's Place, to have a few beers to brace them for their families. Unable to convince his brothers-in-arms, Homer slowly approaches the house as his little sister Luella (Marlene Ames) announces his return. Smiling, Fred and Al witness the exuberant reunion, but when Homer regretfully waves off the cab, his mother chokes back a noisy sob at her first glimpse of his hooks: from the outset, his mother is not the woman needed for his reassimilation. Observing Homer's girlfriend Wilma (Cathy O'Donnell) eagerly embrace Homer, Al despondently notes that although the Navy's training in artificial limb usage will serve Homer well—he can "drive a car, open a beer, put a nickel in a jukebox [. . .] they couldn't train him how to put his arms around his girl [or] to stroke her hair." Homer's sweetheart, then, the literal "girl next door," must restore the masculinity of this broken warrior, one who cannot even return to menial labor, much less bread-winner status.

The film's initial scenes, depicting the demobilization of wounded American servicemen, signal the horrors of combat before positing the proper female response. When Wilma reassures Homer that she will gladly wed the man whose injuries have left him, as he says, "as helpless as a baby," the narrative essentially supplants the memories of his trauma, his prior conception of masculinity, with the impetus of postwar reconciliation. Homer spends much of the film resisting Wilma's entreaties and trying to establish his independence. Even though he feels like a "freak," his injuries nevertheless serve to familiarize Americans with the startling view of men without limbs and thus begins to articulate an alternative masculinity that differed from the strong, whole-bodied image of Uncle Sam.

In one scene, Wilma visits Homer, who is practicing shooting his rifle for purposes of hunting, an activity that would reconnect him with the lineage of American warrior males as it simultaneously reveals the anxieties regarding his lack. "Of course it isn't loaded," he retorts to Wilma's gentle queries, "don't you think I know how to handle a gun?" With the use of his hooks Homer can grasp the phallic rifle to assert that he maintains his masculinity despite the symbolic castration of his missing limbs (Figure 1).

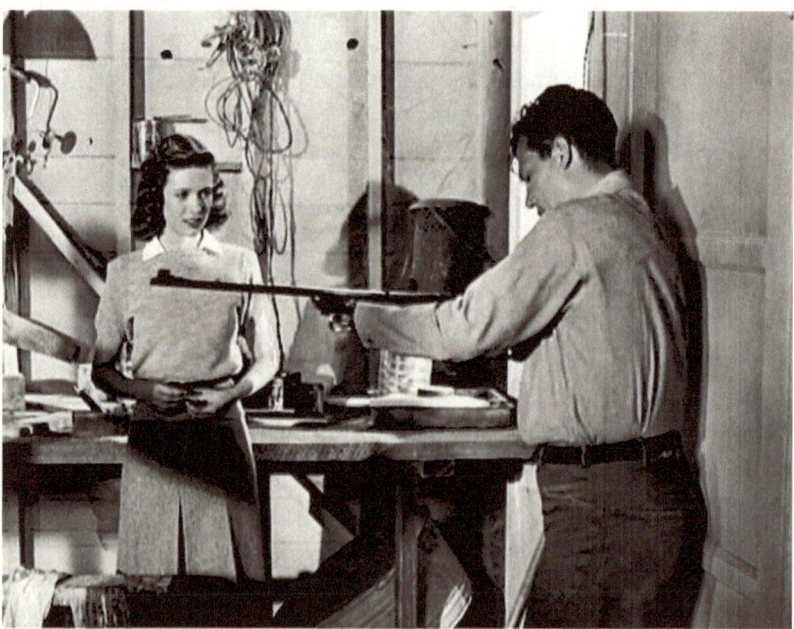

Figure 1. *The Best Years of Our Lives* © 1946. Samuel Goldwyn Company.

However, Homer knows well that the hooks are mere prosthetic surrogates that rudimentarily function like hands but cannot ensure his independence. Without them, Homer is completely emasculated; he cannot put them on independently nor survive. The returning warrior is incapable of taking care of himself, much less of caring for and protecting the woman he loves.

After patiently enduring Homer's shamed rejections, Wilma finally convinces him that he is enough of a man to marry her in a tender bedtime scene. When Wilma appears in his kitchen with the news that her parents want her to leave town and forget about him, Homer finally allows his girlfriend to see him "naked," without his hooks. Participating in Homer's bedtime ritual, as we have seen his father do, she helps him into his pajamas and thus signals her maternal capabilities (Michel 265). "This is when I know I'm helpless," explains Homer. "My hands are down there on the bed. I can't put them on again without calling to somebody for help [. . .] I'm as dependent as a baby." Kneeling before him as he sits on his single bed, Wilma pledges herself to take the place of his arms and hands. "I know what to say, Homer," she reassures. "I love you, and I'm never going to leave you." Finally responding to her desires, Homer tenderly embraces her with his stumps for the first time. As she leaves, turning out the lamp and leaving the door cracked just so, the camera returns to a close-up of Homer's reaction to Wilma's bedside manner; he gazes at his bedroom ceiling, and a tear trickles down his cheek.

The tear suggests Homer's ambivalence about coming to terms with his sense of emasculation from his lost limbs as it opens this late-night moment into a tableau of the rest of his nights. Even as Wilma restores Homer's belief in and dedication to their marital commitment, she can never restore him to his pre-war identity, the high school athlete whose trophies fill his small room. Still, the suggestive posture she assumes while kneeling before him indicates that, for all of Homer's social and economic emasculation and despite her earlier questions about his loaded rifle, she recognizes that he remains a sexually functioning male. Not only did Wilma wait faithfully while Homer was gone, she proved steadfast when Homer took off the proud marker of the veteran—the uniform—thereby validating the marker of his debilitation—the hooks—as honorable.

The meanings of war wounds, in Elaine Scarry's estimation, are predicated on the outcome of the war. The stories Homer's wounds tell both

implicate him in his consent of participation in the war and objectify him as a victim *of* the war, of its often-suppressed goal of out-injuring the enemy (63). The visual confirmation of the bodily damage of a war in which the US was victorious, then, cracks the façade of a national image of victory. Homer's handicap embodies the nation's weaknesses and its significant losses, its inability either to return its warriors intact to faithful Penelopes or to consecrate the soil of enemy nations with the blood of patriotic warriors. Homer's eventual capacity to overcome self-pity and return Wilma's affection effectually absolves the nation from potential criticism. Though her fidelity to her prewar pledge to marry him re-sexes and remasculates the permanently injured veteran as she performs the work of the military and of the nation. She has treated the veteran's pain and restored him to postwar America.

Contemporary American popular culture remains at odds with the visible reminders of the realities of war-damaged and broken male bodies that defy assimilation into its exceptional mythology of masculine warriors returning whole in body and spirit. Wyler's ground-breaking choice to develop a narrative around a double amputee, who in real life accidentally injured himself during a Naval demolitions training exercise, confronts myth with the reality of war's material impact. Homer's hooks rupture the popular template of the returning war hero, the collective national memory of ticker-tape parades and ecstatic Americans filling the streets on V-E Day. His struggles to accept his physical limitations—especially his inability to put the hooks on by himself—only ease when Wilma restores his masculinity by declaring her love for him despite the haunting absence of his hands. Thus the narrative of *The Best Years of Our Lives* relies on the restorative scene of Wilma making Homer whole again in ways his prosthetic limbs fail to do.

In the final scene, the striking composition of the bride and groom saying their vows offers assurance in a restorative vision of postwar America, a vision achieved by an ambiguous adherence to female sacrifice and the erasures of male trauma. On one side stands the redemptive promise of the healing veteran, the newly married Homer and Wilma. The backbone of the enduring nuclear family, Al and Millie, stand together slightly off center, and Fred and Peggy stand on a perpendicular axis at either side of the bridal couple, eyes interlocked (Figure 2).

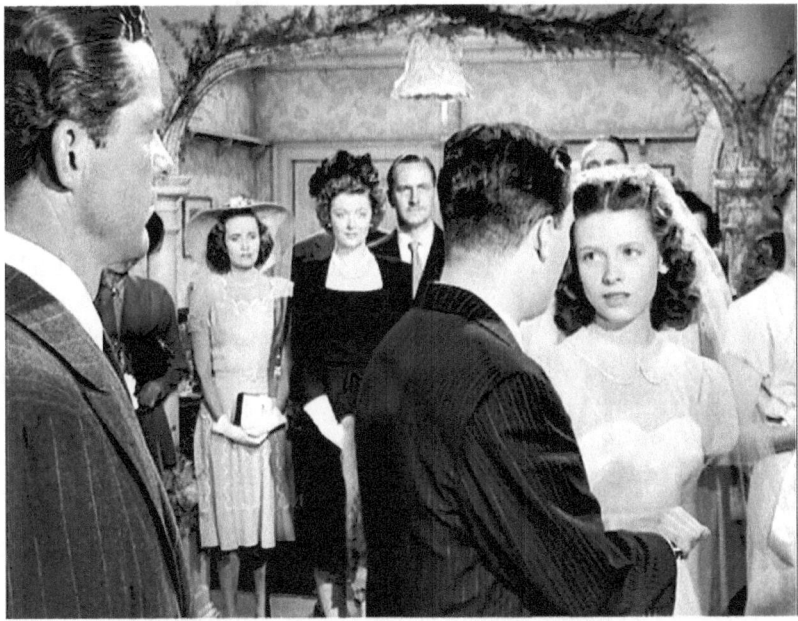

Figure 2. *The Best Years of Our Lives* © 1946 Samuel Goldwyn Company.

With Gregg Toland's deep focus, this shot frames past, present, and future visions of the American family—white, middle class, faithfully dedicated, and hard-working couples healing from the largely unmentionable horrors of the war. Charting the shifting rationales for American women to move from supporting the war effort to restoring their men, *The Best Years of Our Lives*' portrayals reinsert the woman in the home to produce their veterans' mythological happy ending.

Postfeminist Texts and the Homecoming Genre

Of the three women's homecoming films under consideration, only *Home of the Brave* attempts something close to a happy ending for its female veteran, and it is one that hinges on finding the right man. In contrast, the women soldiers in *The Lucky Ones* and *The Return* are sent back to Iraq, and the final shots in both films depict them in uniform at the airport, their final homecomings deferred and uncertain as the end of the war itself.[2] The three films' depictions of the women are similar in that they trace an outline of the female combat and homecoming experience, but their characters seem suspended in gender roles too fluid to

articulate very clearly how warfare and the return still remain gendered.[3] Rather, without either the need for women to recuperate masculinity and sexual prowess, which is a reliable staple in the male soldier homecoming genre, or hegemonic gender binaries in place, the experiences of the female veterans seem, for the most part, gender neutral with some exceptions that I discuss below. Women have had to prove that they are capable of doing the military work that they have been doing for years and for which they still experience political, cultural, and social backlash. Cinematic portrayals of military women, such as Demi Moore's Jordan O'Neill in *G.I. Jane* (Ridley Scott, 1997) and Meg Ryan's Karen Walden in *Courage Under Fire* (Edward Zwick, 1996), have shown them proving that they "can take it like a man," though neither film depicts them returning home. Like the men, the women in the three more recent films struggle with civilian employment, romantic relationships, and uncontrollable violence and aggression, as well as with childcare responsibilities. Like men, they also struggle with translating their war memories into conversation and, thus, something that can be worked through.

Home of the Brave, *The Lucky Ones*, and *Return*'s treatments of military women suggest the postfeminist phenomenon Angela McRobbie describes as when "feminism is 'taken into account,' but only to be shown to be no longer necessary" (259). In other words, the films universalize the women's experience of trauma and repatriation (even when temporary) as genderless, white, heteronormative, and apolitical. They downplay the challenges women have historically faced, not only in gaining access to and acceptance in military roles but also in receiving recognition for their achievements and for the reality of their participation in past and contemporary warzones. All three films *note* gender, though obliquely, since there is little reason within the narratives for the women to recuperate femininity. Therefore, the presence of military women in these postfeminist texts appear to be more tokenist than an index of how far military women have come. Women are part of the story, but the films do not explicitly explore female experiences of war; rather, they more readily equate them to male experiences with PTSD.

One exception occurs in *Return*, when Kelli (Linda Cardellini), who has deemed her pre-war factory job to be "pointless" and, after discovering that her husband Mike (Michael Shannon) has had an affair in her absence, forgets to pick up her daughter from cheer practice. After accusing her of walking around like a "zombie," Mike demands that she "act like a goddamn mother." Since Kelli received a DUI the night

she confirmed her suspicions of Michael's affair, her skills as nurturer and heart of the household are called into question, and she spends the rest of the film trying to get more custody rights over her daughters by attending Alcoholics Anonymous (AA) meetings. Though the film underscores her devotion to the girls—to avoid going back to Iraq, she disguises and drives them toward Canada, though she ultimately brings them back—she functions more as the troubled veteran and is unable to embed herself into domestic family life. Having internalized her experience and rebuffed her friends and husband's frequent offers to talk about it, saying, "nothing happened to me," Kelli is moody and listless. As she points out, she didn't get "raped in a porta potty, I didn't have to fucking carry a dead body, and I didn't get blown up by an IED, so I consider myself pretty lucky." Yet, her mention that rape is "what happens over there" sets *Return* apart from *Home of the Brave* and *The Lucky Ones* for even acknowledging this systemic problem in the US military.

Further calling her mothering abilities into question, Kelli's attempted pregnancy becomes another futile attempt to avoid the Army's remobilization of her unit back to Iraq before her custody hearing. After she receives her orders, she sleeps with two men to try to get pregnant. Another disaffected veteran Bud (John Slattery), whom she meets at AA, understands "it must suck comin' home with all these fuckin' Oprah assholes up your ass." Narratives about military women's returns often employ an older male veteran like Bud to authenticate their service and provide some solace and understanding, as we also see in *Home of the Brave* and *The Lucky Ones*. After their sexual encounter, in which she convinces him to come inside her, her first pregnancy test is negative, which prompts her to sleep with a former work colleague to try again. Here, pregnancy stands in for other apocryphal self-inflicted injuries intentionally committed by male soldiers in war stories in order to evade combat. Failing a second test, she dismantles the guttering and copper pipes in her house to sell for funds to skip town with her daughters before eventually resigning herself to her military duty and returning to Iraq. She is a soldier first and must honor her military contract over her children. Motherhood, previously considered a deterrent to women's military service, if not an outright reason for forbidding women from serving at all, is figured in this postfeminist moment as on similar footing as fatherhood has been for male soldiers, as only one aspect that defines Kelli. The film ends with her alone in the airport in her military

fatigues, gazing at nothing with the "thousand-yard stare" so characteristic of the hardened military veteran (Figure 3).

Figure 3. *The Lucky Ones* © 2008 Lionsgate.

While *The Return* maintains its focus on one woman, both *Home of the Brave* and *The Lucky Ones* more closely model *The Best Years of Our Lives* by following the return of four and three veterans, respectively. As Homer Parrish's female counterpart, *Home of the Brave*'s Vanessa Price (Jessica Biel) and her one amputated hand suggest different possibilities of cultural meanings when a woman loses a limb in combat. The recasting of the disabled veteran into a woman reworks the sexual politics and symbolism of war injuries, yet the postfeminist approach minimizes how these differences play out. Vanessa's plight is not rendered so clearly as Homer's because *Home of the Brave* evades the prospect that she might experience amputation differently than a man.

In the film's introduction, single mother Vanessa plays a pick-up game of basketball with other female soldiers on a military base in Iraq. This scene of strong women competing in physical activity is crosscut with a nearby group of male soldiers playing football and joking about sex, drinking, smoking pot, and prostitutes, but only out of earshot of their female comrades. The gendered contrast suggests that treating Vanessa like one of the guys is more complicated than the movie is willing to entertain: her male colleagues do not talk about these topics in her presence. Also a picture of heteronormativity, she refers to her "sweetheart" Ray and her son in conversation, and we know she is a good mother because while on the phone she worriedly asks her own mother to make

sure he eats a vegetable. Such details work to offset lingering anxiety over the idea that military service overmasculinizes women.

One cultural risk that the movie does take is in its initial depiction of her combat wound. As Helen Benedict argues, the Pentagon has used notions of a social abhorrence toward femininity in combat: "American society, its policy statement says [. . .] will not tolerate the killing and mutilation of its mothers and daughters. Likewise, it argues, soldiers are more troubled by the sight of women being wounded and killed than of men, so they will put themselves at extra risk trying to protect women in battle." During a humanitarian supply run, locals attack Vanessa's convoy, kill the officer she drives, and severely wound her right hand. Samuel L. Jackson's medic neither pays her more attention than the wounded men, nor do the men appear more troubled by her blood than by others', but the camera lavishes attention on her bloody screams. While gore is standard in contemporary depictions of males' war wounds, repeated shots of Vanessa's bloody face, arm, and torso confront the viewer with the reality that women are fighting and dying overseas. This is a departure from previous fictional representations of women soldiers' combat wounds that are primarily characterized as emotional (e.g., Davey Davidson [Claudette Colbert] in *So Proudly We Hail* [Marc Sandrich, 1943] or Dana Delaney in *China Beach*) or as the result of "friendly fire" (e.g., Karen Walden in *Courage Under Fire*, Jordan O'Neill in *G.I. Jane*).

But *Home of the Brave*'s single battle scene—Winkler's attempt to normalize the female soldier and the anxiety she has historically inspired—gives way to the attempt to normalize the combat amputee. When Vanessa goes to Walter Reed Hospital for her prosthetic hand, however, the anonymity of the other veterans—including one other woman—and Vanessa's flashback to the firefight anchor her PTSD into a neutered gender zone. In her hospital gown she joins a long line of amputees that she joins via a tracking shot that offers a muted look into the US's growing number of wounded warriors. She is just another patient from another explosion in another country. After Walter Reed, Vanessa returns to the arms of friends and family, including Ray (James McDonald) and her son, both of whom she tearfully embraces in the airport in a moment that emphasizes her femininity against the typical homecoming portrayals of stoic men. The cinematography hides her prosthesis, keeping her in a tight, medium-close shot throughout—a stark contrast to the initial sight of Homer's hooks bringing his mother to tears in a long shot in *The Best Years of Our Lives*. Later at home, the welcoming

party celebrates downstairs while Vanessa hides in her bedroom and unsuccessfully attempts to unbutton her dress uniform with her prosthesis. Overwhelmed, she slides to the floor and fights back tears, evoking Homer in his bedroom. However, unlike Wilma, no one comes to her aid or helps explicate her specific fears. Like the male characters who return with her (and whom she occasionally sees and commiserates with), she is alone with her PTSD.

While being treated at the VA for phantom pains, Vanessa is the picture of the uncanny violent female as the raging mother. Her physician shows her a brochure of prosthetic attachments created for sports—swimming, baseball, and a fishing rod and reel—then assures her that the Army will pay for her to be able to do these activities with her "boyfriend or husband . . . to help [her] pass the time." Vanessa asks if there is one

> to give people the finger? Or maybe a flat palm with a spike in it? You know, for when I smack my kid around. Because when I really put my shoulder into this, this thing just goes flying across the room. It's kind of getting to be a little bit of a problem, Doc . . . because if I could just keep my kid in line and not have to go digging for this thing, then maybe I'd have some time for some flyfishing.

As a single, working mother who must redomesticate herself by necessity, she hardly has the time to engage in these traditionally masculine leisure activities.

The project of universalizing her trauma, of staging an amputee's struggles as genderless, coupled with Winkler's lack of exposition, renders her motivations and emotions vague. We don't know *why* she has been pushing Ray aside or what makes him the "wrong" man to help her feel whole. Her prosthesis even becomes the scapegoat in the relationship's final demise, as the rejected Ray angrily tells her, "I guess it only takes one good hand to push someone away!" In contrast, Cary (Jeff Nordling) her colleague at work and the *right* man is revealed to her simply by asking what happened to her hand, changing the subject to how he finds her beautiful, and then kissing her one "bad" hand. Her final scene in the film revisits her bedroom, this time with Cary laughing with her about the challenges her prosthesis creates for him undressing her. Winkler does not suggest that she is unsexed by her amputation to the same degree as Homer—this is Jessica Biel, after all—however, the

movie does emphasize this new union as crucial to her coping with her return, simply by ending her story there.

In general, these three films avoid the complexity of sex and sexuality in the US military and mediating the ways that US rape culture intersects with US military culture, a subject that is outside of this essay's scope. But as Alyssa Rosenberg points out, Hollywood's fictional war film output about the longest wars in US history tells us more about weary American attitudes toward the war than about the wars themselves and their complex politics, gender issues, protests, etc. With the exception of *Home of the Brave*'s introduction and of *Return*'s inclusion of Kelli's sexual encounter with Bud, fictional homecoming films about women veterans downplay the complicated sexual politics of a gender-integrated military. Yet, *The Lucky Ones* opens with a gesture toward the trope of women endangering warriors as TK (Michael Peña) instructs the other men in his Humvee how to properly sexually excite a woman by going down on her. Refocusing the soldiers on the mission at hand, he warns that obsessing too much about "pussy" can "get us killed . . . and I'm not gonna let pussy get us killed." Immediately afterward, the vehicle takes fire, and as the men collect themselves, another soldier notices the blood leaking from TK's crotch. Much of TK's thread in the interwoven story about three soldiers taking an unexpected road trip together focuses on his anxiety about being able to have an erection by the time he reunites with his girlfriend, which slightly aligns him with Homer in *The Best Years of Our Lives*. Yet his traveling companions—Colee (Rachel McAdams) and Cheaver (Tim Robbins)—who band together and share the last available rental car after an electrical blackout results in all connecting flights out of NYC being cancelled, are also injured. Cheaver sits on a hemorrhoid pillow because he was injured when "a port-a-John fell on" him, an injury that prevented him from being sent with his unit to Mosul and "getting shot to pieces." Colee walks with a limp because she was shot in the leg. Having met on the flight to New York, the trio drives first to St. Louis, where Cheaver's wife unceremoniously breaks up with him, and then onto Las Vegas. Colee and TK are on thirty-day leaves, while Cheaver is returning home to stay—that is, until his son's acceptance into Stanford motivates him to re-enlist to earn the bonus needed for the down payment.

Like Kelli, Colee's return is temporary, and thus the movie does not need to recuperate her and her experiences into domestic life. Unlike Kelli and Vanessa, however, Colee's countrified, happy-go-lucky nature

does not seem compromised by her war experience, and the film does depict her return as somewhat differentiated from TK and Cheaver. For one, she insists that TK pull over to let her use the restroom rather than do what he suggests, which is squat outside the car. Then they enter a bar of young men and women transfixed by a reality TV show, and when Colee approaches three young women to make conversation, she experiences a *Mean Girls* (Mark Waters, 2004) reaction from them, only this time Rachel McAdams's character is slighted by the college-age women who mock her ignorance of the show as well as her limp. When she sees them laughing and faux-limping in a mirror, she returns to inform them that she limps because she got shot in Iraq. "That wasn't very smart, was it," jeers one, prompting Colee to shove her and punch the men who try to restrain her before Cheaver and TK join her, forming the center of a circle of onlookers and potential combatants. Colee celebrates their victory when they return to the car and muses that she is "just glad I didn't have my weapon." Scenes of male veterans having violent outbursts in bars are staples in reintegration films, particularly from Vietnam forward; thus Colee's brawl is another postfeminist move, emphasizing that she is "just one of the guys."

For Colee's part, she is traveling to Las Vegas to visit the family of Randy, a fellow soldier who died saving her life when she was shot, and return his guitar, which she learns is worth about twenty thousand dollars. Though she remains tightlipped about the nature of their relationship, she confesses that she hopes to stay with his family for the duration of her furlough. Yet after meeting Randy's family, who welcomes her, she learns that he has lied to her, keeping secret a child and a girlfriend at home. Rather than return the guitar to Randy's father, who, it turns out, does not play (contra Randy's story), she keeps it and becomes Cheaver's unlikely benefactor. However, Cheaver's decision to turn down her money—thereby relieving her from the duty of ensuring his reassimilation—and return to war for the cash bonus reflects the ongoing financial burden of multiple tours of duty for military personnel and their families.

Colee's gender portrayal is more nuanced as her relationship with TK emphasizes her femininity. Before she visits Randy's family, Colee sobs in the car after TK insults Randy and her intelligence. To get her to stop crying, Cheaver and TK humor her by stopping for a picnic in the beautiful weather. They stop at a campsite, where Colee befriends three young prostitutes and introduces them to TK, who has expressed inter-

est in visiting sex workers to help him get his erection back before facing his girlfriend. Colee thus attempts to play an unlikely pimp by securing a "military discount" for TK. His nerves get the best of him, and he insists that he and Colee go on an electrolyte run so he can properly hydrate before attempting the task.

Ultimately, TK does not need the assistance from the professionals because encountering a freak storm with Colee proves to be the solution in a specifically gendered way. When a tornado approaches them, she insists that they get out of the car and seek shelter. As they huddle together in a drainage tunnel, Colee, who detects TK's fear about the storm, wraps her arms around him and whispers in his ears. After the tornado passes, TK awkwardly tells her that "it's working"—she has healed his erectile dysfunction. Later, he co-opts a story she told about Randy allegedly holding up a casino—another lie—and confesses to the crime to avoid being returned to Iraq before the police tell him that the particular casino he claims to have victimized has never been robbed. As the three soldiers initially part ways, TK kisses Colee on the lips, prompting her to glare at him and call him "forward." Her rebuff solidifies her portrayal as a "good woman to come home to," if only she were to remain home. Yet this scene also takes on the contours of more traditional homecoming tropes because she functions as Wilma to TK's emasculated Homer and because women have historically been considered prizes for victorious warriors. Instead of staying with Randy's family, she heads home to work out her issues with her mother for the rest of her stay, which suggests that even she needs a woman's touch to help her reassimilate, if only temporarily. After the rest of their leaves, which the film omits, they reunite at the airport and join an endless line of soldiers boarding a commercial jet that takes off into the sunset, an ellipsis on the question of whether they will ever finally reintegrate home (Figure 4).

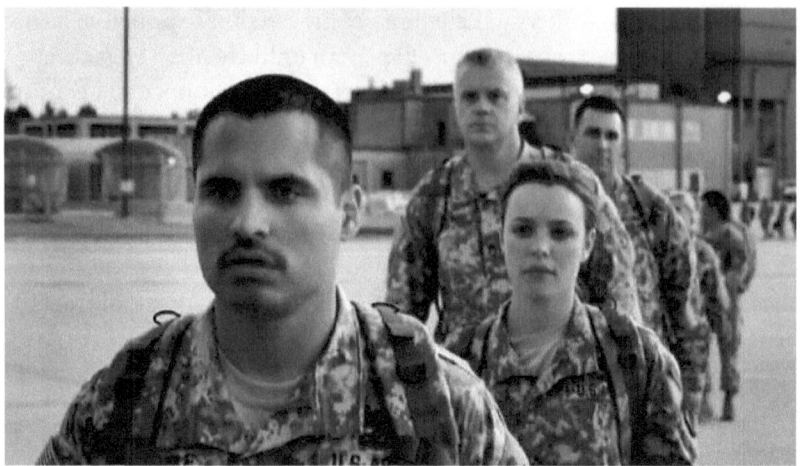

Figure 4. *The Lucky Ones* © 2008 Lionsgate.

These are not the best years of our lives. Culturally, we need new ways of telling soldiers' stories and accounting for their experiences in popular and public culture. Contemporary documentaries are initiating critical explorations into the issue of women's war experiences that counter and complicate these postfeminist stories. Yet relatively weak receptions of war films about Iraq and Afghanistan suggest that war-weary movie audiences are not yet up to the task of entertaining more complex notions of gender, sexuality, war, and trauma—or feminist texts that explore women's experiences of war more explicitly. The era of stop-loss negates full reintegration of veterans and normalizes their liminal status of existing betwixt and between combat and civilian life, and these postfeminist attempts capture the female soldiers in similarly liminal states between gender roles and expectations that often seem more muddled than liberating.

Notes:

1. See also Susan M. Hartmann, "Prescriptions for Penelope: Literature on Women's Obligations to Returning World War II Veterans," *Women's Studies* 5 (1978): 223–39.

2. Many thanks go to Anthony Grajeda for helping me think through this section with his thought-provoking and insightful work on the area. Anthony Grajeda, "From the Frontlines to the Homefront: Female Soldiers, Gendered

Trauma, and the Melodrama of (Post)War," Society for Cinema and Media Studies. Drake Hotel, Chicago, IL. 7 Mar. 2013.

3. Masculinity needs to be recuperated for male characters in these films, but that issue is beyond the scope of this essay.

WORKS CITED

Benedict, Helen. "The Plight of Women Soldiers." *The Nation*. The Nation, 6 May 2009. Web. 4 Oct. 2012.

The Best Years of Our Lives. Dir. William Wyler. Perf. Harold Russell, Cathy O'Donnell. RKO, 1946. DVD.

Froula, Anna. "'Free a Man to Fight: The Figure of the Female Soldier in World War II Popular Culture." *Journal of War and Culture Studies* 2.2 (2009): 153–65. Print.

Gardner, Mona. "Has Your Husband Come Home to the Right Woman?" *Ladies' Home Journal*. Dec. 1945. Print.

Home of the Brave. Dir. Irwin Winkler. Perf. Jessica Biel. MGM, 2006. DVD.

Jeffords, Susan, *The Remasculinization of America: Gender and the Vietnam War*. Bloomington: Indiana UP, 1989. Print.

Lotz, Amanda. "Postfeminist Television Criticism: Rehabilitating Critical Terms and Identifying Postfeminist Attributes." *Feminist Media Studies* 1.1 (2001): 105–21. Print.

The Lucky Ones. Dir. Neil Berger. Perf. Rachel McAdams, Tim Robbins, Michael Peña. Lionsgate, 2008. DVD.

McRobbie, Angela. "Post-Feminism and Popular Culture." *Feminist Media Studies* 4.3 (2004): 255–64. Print.

Return. Dir. Liza Johnson. Perf. Linda Cardellini, Michael Shannon, and John Slattery. 2.1 Films, 2011. DVD.

Rosenberg, Alyssa. "How Iraq Changed Everything: From *The Hurt Locker* to *The Marine*, the Rise of Soldiers in Pop Culture." *Think Progress*. N.p., 19 Mar. 2013. Web. 25 July 2014.

Scarry, Elaine. *The Body in Pain: The Making and Unmaking of the World*. Oxford: Oxford UP, 1987. Print.

Service Women's Action Network. "Homeless Women Veterans: The Facts." VAWnet.org. National Online Resource for Violence Against Women. 4 October 2012. Web. 25 July 2015.

9 Television's Queer Future? The Possibilities and Limitations of Web Series, Digital Distribution, and LGBT Representation in *Husbands*

Melanie E. S. Kohnen

> It [Husbands] feels like you're peeking at a future—of TV, of America—that's just barely coming into existence.
> —Ira Glass, October 2011

HUSBANDS is a web-based sitcom that explores the fallout from an accidental marriage that happens during a drunk weekend in Las Vegas. The twist? It involves two men. Created in 2011, *Husbands* situates itself in a near future in which same-sex marriage has been legalized nationwide in the United States, thus allowing for the trope of accidental same-sex marriage between protagonists Brady and Cheeks. In addition to projecting an almost-tangible future of nationwide same-sex marriage, *Husbands* also lays claim to the future in other ways: producers Jane Espenson and Brad Bell consider the portrayal of Brady and Cheeks as forward-looking alternatives to gay and lesbian representations on network television and emphasize web-based distribution and transmedia extensions as the future of television. While *Husbands* imagines itself as creating a future text distributed through an alternative medium outside of TV's usual channels, the televisual past lingers in *Husbands*' narrative and distribution, and the series' break with television's norms is not as thorough as the producers like to imagine.

In this essay, I explore *Husbands*' conflicted position between television's past and future. In the first section, I investigate the creation of *Husbands* and its complicated relationship to network television. I consider the ways in which Espenson and Bell continuously frame *Husbands* as legacy to classic network sitcoms while also positioning the series as an alternative to network TV. While this positioning might seem contradictory at first, the important takeaway is the realization that *Husbands* sees itself primarily in conversation with television and not with web-based video. In particular, I argue that it is important to understand *Husbands* as television in order to grasp the series' intervention in televisual LGBT representation and in television distribution. At the same time, I address the blindspots in imagining *Husbands* exclusively in televisual terms through a comparison of the series to queer web-based video projects and the larger context of user-generated online content. In the second section, I focus on *Husbands*' challenge to current modes of representing gay and lesbian characters on network sitcoms, particularly regarding the desexualization of gay and lesbian couples on contemporary programs such as *Modern Family* and *The New Normal*. I argue that *Husbands* issues challenges to network norms both through an overt address of LGBT tropes in the second season's narrative arc, which places Brady and Cheeks at odds with the media, and through staging, which consistently underlines the sexual dimensions of Brady and Cheeks's marriage. Even though *Husbands* offers a counterpoint to network sitcoms' trope of desexualization, I demonstrate in the essay's final section that the series does not escape the larger framework of LGBT representation on TV. As a white, professional couple in a committed relationship, Brady and Cheeks echo the norms for representing gay relationships that have emerged on television over the past two decades. In my concluding remarks, I consider whether or not *Husbands*' move to the CW's digital distribution platform for the third season constitutes a return to the fold of traditional television.

Origin Stories

Husbands is a collaborative project envisioned by established television writer Jane Espenson and online celebrity Brad Bell. Espenson brings her experience of writing for series such as *Buffy the Vampire Slayer* and *Battlestar Galactica* to *Husbands* while Brad Bell contributes his knowledge of producing short, successful videos for YouTube (his YouTube

channel has over ten thousand subscribers). Together, they financed, wrote, and shot the first season of *Husbands* during the summer of 2011. Consisting of eleven episodes that run between two and three minutes, *Husbands*' first season adds up to the length of a standard sitcom episode on network television. While Espenson and Bell had hoped for a possible pick-up by a television network, the success of the first web-based season convinced them to stick to the internet as *Husbands*' home (Jusino). *Husbands*' initial success crucially depended on the producers' active social media presence, especially on Twitter, where both Espenson and Bell promoted the series and frequently interacted with fans. Due to Espenson's established name in the television industry, the first season also received mainstream press coverage in both digital and print publications, including *The Huffington Post*, *Tubefilter*, *The Advocate*, and *The New Yorker*, to name only a few.

Inspired by the success of the first season, Espenson and Bell announced a second season of *Husbands* for the summer of 2012. Mobilizing their increasing number of fans, Espenson and Bell managed to raise $50,000 through a Kickstarter campaign. With a higher budget at their disposal and more confidence in *Husbands*' appeal, Espenson and Bell took a bolder approach to the second season's production and narrative. For example, season two was shot in a rented luxury home in the Hollywood Hills rather than at a friend's house, it features cameos by a number of cult television celebrities including Felicia Day and Tricia Helfer, and it overtly addresses network television's frequently problematic LGBT representations. Season two premiered in August of 2012 and included three ten-minute episodes. Once again, viewers and critics embraced the series, which inspired Espenson and Bell to broaden the *Husbands* universe into a series of graphic novels and to appear frequently at fan conventions, such as San Diego Comic-Con. *Husbands*' third season was distributed online in August 2013, but not on YouTube. Instead, Espenson and Bell made a deal with CW Seed, the expanding digital distribution platform of TV network The CW, and granted exclusive streaming rights to the new platform (Marechal).

The changes *Husbands* underwent from its first to second season speak to the series' complicated relationship to television, and, indeed, to recent changes to television as a medium. From the outset, *Husbands* has imagined itself both as a future of and alternative to network television. Through its portrayal of a near future in which same-sex marriage is legal, *Husbands* tries to envision alternative representations of gay men.

Likewise, through its online distribution, the series seeks an alternative way of distributing programming—one that does not rely on a big studio or network/channel (and not even one of the emerging big players in online distribution, such as Netflix, Hulu, My Damn Channel, etc). Consider the following statement by Jane Espenson, in which she links the possibility of alternative LGBT representations to alternative online distribution methods:

> Boy, I gotta think that online is where the future of the new wave of content is going to come from. And because you don't have to be a broadcaster, you don't have to appeal to everyone in every demographic, you can take risks, you can do a show like ours with this young sexy married couple. TV will put gay marrieds on TV, but they generally won't make them sexual, they will do everything to desexualize them, they cast a straight actor as one of the guys, or they give them babies, or something. (AtGoogleTalks)

Espenson directly critiques the desexualization of gay men in successful network programs like *Modern Family*. She also emphasizes that *Husbands'* more overtly sexualized portrayal of Brady and Cheeks is enabled by the supposed creative freedom of the web. From the perspective of Espenson and others involved in *Husbands'* production, alternative visions of LGBT representations thus go hand-in-hand with online distribution and the absence of network notes on self-publishing platforms such as YouTube.

However, I want to make it clear that *Husbands* imagines itself very much as *television*, and not as web-based video. As the previously cited statements indicate, Jane Espenson and Brad Bell see *Husbands* in a conversation with television, especially network television, even if the series also takes format cues from YouTube videos. As Espenson stated in March 2013, "We consider *Husbands* television. It's just television that arrives in a different box" (Belonsky). Regarding Espenson and Bell's projection of *Husbands* as the future of television (the kind that comes in "a different box"), it is important to understand that they position *Husbands* as the latest incarnation of domestic sitcoms. Specifically, they imagine *Husbands* as the latest in a long line of sitcoms in which the humor derives mostly from tensions and misunderstandings in the main couple's relationship. For example, in the behind-the-scenes documentary for season two, Bell and Espenson discuss the influence of *I Love Lucy*

on their portrayal of Brady and Cheeks's relationship, and Espenson has also referred to Husbands as "Mad About You with guys" (Jusino).

Indeed, Espenson and Bell consider the preservation of the classic sitcom format as part of how *Husbands* redefines and challenges mainstream television. Considering that Espenson and Bell want to offer an alternative vision of television, one might think that they would seek a definite break with TV's past. Instead, they lay claim to this past and insist on being a legacy of television's most successful sitcoms. By placing a gay couple at the center of a traditional domestic sitcom, they encourage an examination of the genre's rather heterosexual past and try to show how the sitcom can move beyond that limited view of love and marriage. In addition to broadening the sitcom genre, Espenson and Bell's goal is to demonstrate that audiences embrace domestic sitcoms featuring a gay couple (Jusino). The success of *Husbands* affirms Espenson and Bell's belief. Interestingly, while there was no comparable sitcom on network TV during *Husbands*' first season—leaving aside *Modern Family*, which features a gay couple as part of an ensemble—NBC launched the sitcom *The New Normal* around the time of *Husbands*' season two premiere. *The New Normal* depicts the life of an affluent white gay couple, who have a baby with the help of a surrogate.

While Espenson and Bell embrace the classic domestic sitcom, they also understand *Husbands* to be a direct response to network television's engagement with and representation of gays and lesbians. Particularly during its second season, *Husbands* explicitly addresses flaws in television's portrayal of gay and lesbian characters and tries to offer an alternative way of representing gay men. For example, *Husbands* calls out network TV's failure to show physical and emotional intimacy between gay couples through dialog and staging that highlights the sexual aspects of Brady and Cheeks's relationship. It is important to understand *Husbands* in this specific context of televisual LGBT representation, especially in comparison to other gay, lesbian, and queer web series. Other web series may understand themselves as challenges to problematic aspects of queer and heteronormative culture, but they do not position themselves as overt challenges to network TV.

For example, the web series *It Gets Betterish* addresses, as the title suggests, the It Gets Better project, a YouTube-based video collection aimed at preventing suicide among LGBT youth. While the It Gets Better project has received a lot of support, its core narrative of assuring queer youth that a better future awaits them if they can just "tough it out," has come

under critique for shifting a resolution to anti-gay bullying from the present to an unknowable future.[1] In addition, the projected future in It Gets Better videos frequently consists of a committed relationship, children, and professional success. In contrast to the homonormative narrative of the It Gets Better project, *It Gets Betterish* tells stories about a diverse group of gay men in New York City that are often uncomfortable and unflattering. In the episode "HIV AIDS Test," Brent worries about exposure to HIV when he comes across a video on an amateur porn website that features a man with whom he had a casual and unprotected sexual encounter the previous week. The episode depicts Brent's anxiety about getting tested for HIV and a conversation with a doctor about casual sex and STDs, but it does not include a moralizing lesson about the dangers of unsafe sex. Rather, the assumption underlying the episode's plot is that gay men are aware of the risks involved in unprotected sex, but that this knowledge may conflict with affective situations or desires that momentarily outweigh that knowledge. *It Gets Betterish* tells queer stories; in other words, its depiction of gays and lesbians resists normative discourses of sexuality. *Husbands*, on the other hand, can hardly be called queer—as I will show in the next section, its portrayal of Brady and Cheeks may be more complex than what current network television sitcoms offer, but it is still firmly rooted in TV's basic parameters of LGBT representation. Understanding *Husbands* as television, and not as web video, is crucial to evaluating *Husbands* as the future of television's take on gay, lesbian, and queer representation. Web series such as *It Gets Betterish* introduce queer visions that offer alternatives to television's representational flaws. But they are not (and do not understand themselves as) television, and they often are not nearly as successful as *Husbands*.

Understanding *Husbands* as television is also important to evaluating its distribution via YouTube and Blip.tv. Discussing the initial conceptualization of *Husbands* as a web series, Jane Espenson explains, "This was a comedy. I really wanted to do it the way that we wanted it done, and we decided that the best way to do it, the quickest, most efficient way was to do it on the web" (Plesser). For TV industry professionals like Jane Espenson, the possibility of controlling a television series from inception to distribution constitutes a major incentive to turn to the web. Not incidentally, the idea of web-based television gathered widespread support during the 2007 Writers Strike, an event that was a particularly stark reminder of the uneven power balance between producers and writers.[2] At the heart of the strike were writers and producers' divergent interpre-

tations of the increasing expansion of television onto the internet via tie-in "webisodes" or online repeats on networks' websites, neither of which resulted in residuals for writers. Producers argued that online TV content merely constituted "promotional" material, even when writers wrote new content for webisodes (Giannini). Even though the strike resulted in marginal increases of residuals for writers, the months-long struggle reaffirmed writers' impressions that the traditional organization of the industry does not grant them control over the products of their creative labor. Well-known TV showrunners such as Joss Whedon turned to web series as a circumvention of traditional distribution models in the hope that online TV would allow for more direct creative and monetary control (Whedon). Whedon's online musical *Doctor Horrible* (2008) became a financial success and was even broadcast on the CW in November 2012. While this turn to the web proved successful for Whedon, Espenson, and others who had already made a name for themselves in the TV industry, other writers who start out on the web find this new world of web-based TV less welcoming.[3]

The split between success for some and disappointment for many points to another context for web series in general and *Husbands* in particular. While web-based distribution might constitute an escape from the confines of traditional TV, it places web series into the industrial context of social media platforms. Espenson and Bell mainly use YouTube to distribute *Husbands*—a platform that, like Facebook, Twitter, or Instagram, promises users control over their creative products. Consider how this promise is communicated in, for example, YouTube's slogan "Broadcast Yourself" or Google Chrome's 2011 advertising campaign motto "The web is what you make of it." It was this same seductive promise of creative freedom that prompted *Husbands*' producers to declare the web as a better alternative to network television.

At first glance, the interface of YouTube and other social media platforms fulfills this promise. It is easy to upload and distribute video via YouTube. However, once one looks beyond what Felix Stalder has called the "front end" of social media and considers the "back end" or infrastructure, a different perspective opens up (242). The front- and back-end of platforms like YouTube exist in tension: the front-end is user-friendly, cheap, and flexible; the back-end is, in Stalder's words, "centralized, based on long-term planning, very expensive, difficult to run, corporate, and opaque" (248). Put differently, the promise of creative freedom on sites like YouTube arises out of principles that are neither cre-

ative nor free, but rather are strictly regulated and focused on profit. As a consequence, creative freedom on the front-end is only granted as long as it does not interfere with the economic interests on the back-end. For example, remixers often discover that their projects interfere with the corporate interests woven into YouTube's infrastructure. YouTube's automated content identification system frequently tags and removes remixes in a defense of (corporate) intellectual property even when remix projects fulfill fair use guidelines. Instead of allowing users to broadcast themselves in any way they want, the creativity offered by, e.g., YouTube, resembles a paint-by-numbers game: you are tolerated as long as you paint within the lines. *Husbands* certainly does; it is profitable, offers original content not in conflict with copyright law, and adheres to YouTube's "community standards" that state, "YouTube is not for pornography or sexually explicit content." But one has to wonder if Espenson and Bell are aware of provisions in YouTube's Terms of Service agreement that declares "[y]ou hereby grant YouTube a worldwide, non-exclusive, royalty-free, sublicenseable and transferable license to use, reproduce, distribute, prepare derivative works of, display, and perform the Content in connection with the Service and YouTube's (and its successors' and affiliates') business." Considering that Espenson and Bell's main motivation for turning to the web is the retention of creative control over their ideas and labor, this provision would (or should) not be agreeable to them.

The contradictions in *Husbands*' distribution discourse, which arise out of the tensions between the front- and back-end of social media platforms, also linger in the representational politics of *Husbands*. On the one hand, *Husbands* offers an intervention in television's problems with LGBT characters and storylines by, for example, not shying away from displays of affection between Brady and Cheeks. On the other hand, the homonormative framework that structures TV's LGBT representations remains in place on *Husbands*.

"Acceptable Gays are Overweight, Over Forty, Overly Professional with Their Lovers in Public": Negotiating Television's LGBT Codes and Norms

Husbands' critique of gay and lesbian characters on network television is facilitated by a glimpse into Brady and Cheeks's negotiations of the private and public consequences of their accidental marriage. The first season of *Husbands* focuses on the private consequences—viewers witness Brady and Cheeks making the decision to stay married, telling a good

friend about their marriage, and moving in together. The second season shifts to the public consequences, particularly the impact of Cheeks's tendency to document intimate moments via social media on Brady's public image as a star athlete. Concerns for Brady's reputation lead his agent to force Brady and Cheeks into a live television interview, during which the couple has to decide how they will relate to the public. In the end, Brady and Cheeks reject the mandate to be "overly professional" with each other in public and share a passionate kiss on live TV after explaining how they fell in love. In this shift from highlighting Brady and Cheek's private identities in season one to their public lives in season two, the mode of critique also changes: it moves from an implicit/private to an explicit/public attack on the television's attempt to normalize LGBT characters and storylines. Yet, in both seasons, the most salient feature of LGBT representation on network TV also appears on *Husbands*, namely the reduction of queer media visibility to a wealthy white gay couple in a committed relationship.

In the first season, *Husbands*' approach to offering an alternative way of representing gay couples on TV follows a "show, not tell" model: different facets of gay male identity are shown through Brady and Cheek's negotiations of how to integrate their lives, but there is no overt discussion of how the media represents gay male identities. Perhaps as a consequence of the short episodes, much of Brady and Cheeks's negotiations take the form of banter and witty one-liners about their different attitudes toward marriage and domesticity. Nevertheless, serious critique emerges briefly, for example when Brady declares himself "the patriarch of this marriage," a comment which Cheeks does not take well at all and rejects with a pointed reminder about marriage being constituted of two equal partners, regardless of gender ("Return of the Zebra").

Husbands' second season is much more overt in promoting its alternative vision of gay couples on TV. Showing and telling frequently complement each other as modes of critique—in fact, the media-oriented plot of the season constitutes a meta commentary on the state of LGBT representation on television. Espenson and Bell take on a number of gay tropes and critique them on the level of dialog (Brady, Cheeks, and other characters discuss what "appropriate" gay media representations are) and on the level of performance (there are overt displays of affection throughout the season). The season opens with a scene that shows Brady and Cheeks waking up together, which in and of itself is a challenge to network TV's hesitancy to portray the more intimate aspects of gay relationships.

Figure 1. Brady and Cheeks's controversial kiss. Cheeks posts a photo of their first kiss of the day, which kicks off the media frenzy that eventually leads Brady and Cheeks to take a firm stance on the publicness of their relationship. *Husbands* © 2011–2013 Scriptacular Productions.

The question of how Brady and Cheeks should present their marriage to the public and to the media dominates the conversations in most scenes. When Brady's agent Wes calls to discuss the media's reaction to Cheeks's photo, he summarizes the supposed problem with Cheeks's behavior: "He is unacceptably sexy and that terrifies America. Acceptable gays are overweight, over forty, overly professional with their lovers in public" ("Appropriate Is Not the Word"). Via Wes's comment, *Husbands* spells out the supposed reasoning behind network TV's reluctance to show gay couples in intimate settings, namely that the mass audience sought by networks can only accept gay couples as long as the sexual aspects of their relationships remains off-screen. This critique expands in a later conversation between Brady and Cheeks, in which they discuss Wes's admonishment to make Cheeks appear "less gay" to avoid harm to Brady's baseball career. Brady observes that "TV gays sing about acceptance, host daytime talk shows, and adopt babies from exotic locations," to which Cheeks replies, "That is so not me" (ibid). Brady's observations include thinly veiled allusions to *Glee*, Fox's successful musical drama about a high school glee club that prominently includes gay characters; *Ellen*, the afternoon talk show hosted by Ellen DeGeneres; and *Modern Family*, the ABC sitcom featuring a gay couple that adopts a child from

Vietnam. *Husbands*, via Cheeks's rebuttal, rejects these prominent ways of rendering gay and lesbian identities and lives visible on TV.

Throughout the second season, *Husbands* outlines the constraints placed on LGBT representations on network TV, especially those in programs like *Glee* or *Modern Family*, which the popular press often lauds as progressive (but which are also the subject of critique for their reluctant portrayals of affection and intimacy between gay characters, especially by scholars and fans).[4] Integrating a discussion of LGBT media representations into the narrative of a TV series is relatively rare, especially in recent years when gay and lesbian characters have become a common aspect of many programs.[5] *Husbands* thus makes it very clear which mode of LGBT representation it opposes, and it shows, via the portrayal of Brady and Cheeks's relationship, what an alternative vision might look like.

Most significantly, *Husbands* does not shy away from discussing or offering glimpses of Brady and Cheeks's sex life. One scene shows Brady trying to seduce Cheeks to "relieve some tension" before their big interview, but Cheeks keeps rebuffing Brady by reaching for his retainer (to keep his teeth "nice and straight-acting") and by asking for a tension-relieving foot massage (instead of sex). When Brady asks Cheeks what is going on, he replies, "This is me, less gay" ("The Straightening"). While no sex takes place in this scene, Brady and Cheeks appear in bed in nothing but tight underwear, and they share a number of glances, touches, and near-kisses that are definitely intimate.

Figure 2: Brady and Cheeks share intimate moments in bed. *Husbands* © 2011–2013 Scriptacular Productions.

Husbands thus makes a point about the constant evasion of gay sexuality on television by contrasting dialogue and performance: Cheeks talks about being "appropriately" gay—as per Brady's agent's instructions—while he and Brady act in a way that could count as "inappropriate" by many network TV standards. Regarding the contrast between what the characters say and what they do in this scene, Brad Bell observes, "It's making a point that gays aren't allowed to be sexy, but they're being sexy" (*Husbands: Behind the Scenes*). In other words, Cheeks (and *Husbands*) is making a point about the desexualization of gay men on TV by seemingly adhering to expectations of propriety via his refusal to have sex with Brady; yet this refusal plays out in a deliberately erotic way and is thus deliberately "inappropriate."

The "inappropriateness" of this scene becomes particularly apparent in comparison to *Modern Family* and *The New Normal*, two network sitcoms that prominently feature gay couples. Both programs appear to set some new standards for the inclusion of gay relationships in TV sitcoms. The programs' desire to set themselves apart is already apparent in the sitcoms' titles. The title *Modern Family* emphasizes that its vision of family, which includes an interracial marriage and a gay partnership as a matter of course, embodies the cutting edge of American familial life. Along the same lines, *The New Normal* suggests that a gay couple wishing to have a baby is no longer an extraordinary event, but rather a commonplace reality for many. But the hesitancy with which both *Modern Family* and *The New Normal* approach intimacy between gay men makes any claims to their progressive advocacy questionable.

The portrayal of Cameron and Mitchell on *Modern Family* and of Bryan and David on *The New Normal* shies away from what one might expect of programs that position themselves so boldly, namely depictions of gay relationships that run the gamut from everyday squabbles to sexual intimacy. As Alexander Doty has observed, Cameron and Mitchell seem equal to the straight couples on *Modern Family* "in every way *except* for showing physical affection and desire for his partner (oh, and except for being married)" (emphasis original). It took over a season for Cameron and Mitchell to share a kiss in the season two episode titled "The Kiss," and this kiss only came about after growing protests from fans (Doty). The lack of affection and intimacy between Cameron and Mitchell was conveniently explained by *Modern Family*'s mockumentary format. If everything we see on *Modern Family* is the result of a camera crew documenting characters' lives, and Mitchell does not like

public displays of affection (as viewers learn in "The Kiss"), then even supposedly private moments are public due to the presence of cameras. Considering that *Modern Family* only borrows stylistic devices from the mockumentary and does not integrate the supposed presence of a camera crew into the diegesis in any meaningful way, this explanation comes across as half-hearted at best. In "The Kiss," televisual style restricts intimacy between Cameron and Mitchell in even more deliberate ways. Cameron and Mitchell's kiss takes place at the same time as a father-daughter kiss between Jay and Claire.

Figure 3: Cameron and Mitchell's fleeting kiss in Season 2. *Husbands* © 2011–2013 Scriptacular Productions.

Cameron and Mitchell are placed in the background while Jay and Claire are situated in the foreground. The focus is thus on Jay and Claire's moment of familial bonding while same-sex affection is relegated to the margins of the televisual image. As Alfred J. Martin has argued, in the rare moments that depict same-sex affection on network TV sitcoms, stylistic devices like longshots or over-the-shoulder shots are frequently used to distance the viewer from the display of intimacy ("It's Not").

While *The New Normal* does not use stylistic devices to distance the viewer from same-sex affection, it nevertheless evades any sexually charged portrayals of Bryan and David's relationship. The frequent depiction of Bryan and David in their bed makes for a particularly apt comparison to *Husbands*' critique of desexualized gay men on network sitcoms. While *Husbands* leaves no doubt about sex as common occur-

rence in Brady and Cheeks's bed, the regular viewer of *The New Normal* knows that everything aside from sex happens in Bryan and David's bed. Nearly every episode features a scene set in Bryan and David's bedroom and often shows one or both of them in bed. In these scenes, Bryan and David tend to discuss the main conflict of the episode, which often revolves around their impending parenthood. While these conversations can be intimate on an emotional level (and even include the occasional chaste kiss), there is no suggestion of sexual intimacy. To borrow Brady's agent's words, Bryan and David remain "overly professional" with each other in the bedroom and thus fit into the parameters of appropriate behavior for gay men according to network TV's standards.[6]

In terms of representing intimacy in gay relationships, *Husbands* portrays Brady and Cheeks differently from Mitch and Cameron or David and Bryan. But like the couples on *Modern Family* and *The New Normal*, Brady and Cheeks are affluent white successful professionals in a stable relationship. If *Modern Family* and *The New Normal* outline a "new normal" for gay men on TV and offer a perspective on why gay couples should be accepted as "normal" in the current moment, then Brady and Cheeks's America of the near future does not entirely break with these norms.

THE PERSISTENCE OF WHITENESS

Husbands' contradictory position of signaling both TV's future and its past becomes particularly obvious when considering how far the series continues the persistence of whiteness that has characterized LGBT representations on network TV over the past fifteen years. During that time, the inclusion of LGBT characters in mainstream television has become normalized. In other words, the appearance of gay and lesbian characters has become a normal occurrence, and their presence is now an unremarkable and quotidian feature of television.[7] Consider, for example, that the simultaneous coming out of Ellen DeGeneres and her character Ellen Morgan triggered a media frenzy that lasted for months in 1997; in contrast, the appearance of gay and lesbian characters on current programs is rarely discussed or remarked upon outside of LGBT publications. While the media may not comment on LGBT representations any longer because they have become a routine feature of the televisual landscape, it is worth considering how this normalization has come about. A closer look at many gay and lesbian characters on network TV reveals that they fit into tightly defined cultural norms: for the most

part, they are white, wealthy, professional, and in monogamous, committed relationships. Both processes go hand-in-hand: gay and lesbian characters have become unremarkable because they fit mainstream cultural and televisual norms.

The representation of Brady and Cheeks as newlywed gay couple on *Husbands* fits into this trajectory of gay and lesbian normalization on network TV. In *Husbands'* diegesis, same-sex marriage is legal throughout the United States and thus has become an unremarkable aspect of everyday life. Aside from taking a clear pro-gay marriage stance, *Husbands* does not offer a further engagement with the issue; rather, we follow Brady and Cheeks's deliberations of staying married, redefining their relationship, and managing their domestic and public life. Within *Husbands'* diegesis, Brady and Cheeks's marriage also remains unremarkable. It is not their marriage that is scandalous, but rather it is Cheeks's overtly "gay" behavior in public. *Husbands* continues a specific portrayal of a gay couple established in recent TV series: Brady and Cheeks are white, out-and-proud professionals in a committed relationship. As such, they inhabit exactly the type of queer visibility that television has promoted as default mode of representation for LGBT Americans for the past fifteen years. In this respect, Brady and Cheeks are not really any different from gay couples on network sitcoms like *Modern Family* or *The New Normal*. Even though *Husbands* does overtly challenge a few tropes of representing gay relationships, its overall framework for depicting gay life and marriage does not break with the conventions of LGBT representation on mainstream TV.

Importantly, all gay couples in the aforementioned TV shows are white. Their whiteness appears unremarkable—it is certainly not a matter of much discussion in popular critiques of *Modern Family*, *The New Normal*, or *Husbands*. If whiteness does come up, it is part of a familiar discourse critiquing the lack of diversity in television. While the lack of meaningful diversity is certainly an important topic, it does not fully address the structural function of how whiteness enables the normalization of gay and lesbian characters on television. It is this structural function of whiteness in LGBT representation that deserves further consideration. Specifically, I argue that whiteness is central to the normalized and normative articulation of queer visibility on contemporary network television and in web series like *Husbands*. Whiteness connotes an "unremarkable" default position in American culture, and on television, it works in conjunction with other cultural norms, like class status

and committed partnerships, to integrate gay and lesbian characters into televisual everyday life. In programs like *Husbands*, *Modern Family*, and *The New Normal*, whiteness thus crucially shapes our perception of gay characters as normal and normalized.

THE FUTURE OF TELEVISION?

In April 2013, Jane Espenson and Brad Bell announced that the third season of *Husbands* would be distributed exclusively through CW Seed, the digital studio founded by the CW in 2012. *Husbands*' affiliation with an established television network might appear straightforward, namely as a return to the traditional TV fold. However, the complex implications of this move become apparent when read against the facets of *Husbands* that I have outlined in this essay.

First of all, *Husbands* remains a web series. Presumably, Espenson and Bell retain full creative control over the series, a factor that has been their main motivation for producing *Husbands* for online distribution. Despite *Husbands*' success, the series' continued financing remained uncertain before the decision to partner with CW Seed. As I explained, many web series ultimately fail because they cannot sustain the necessary financial support to continue production. From this point of view, it makes sense that Espenson and Bell would trade exclusive distribution rights for a guaranteed source of financing. CW Seed has promised *Husbands* forty-four more minutes worth of episodes, which comprises as much "air time" as the series has had in its first two seasons ("Interview with Brad Bell and Jane Espenson"). Entering into a stable partnership with a large distributor is not uncommon in web series production. For example, the long-running web series *The Guild* (2007-present), which centers on a group of gamers, entered into a similar agreement with Microsoft and is distributed exclusively through Xbox Live before becoming available more widely online (Ellcessor, 47). Beyond recognizing the financial security for *Husbands* that comes with CW Seed's corporate resources, my discussion of the front- vs. the back-end of social media platforms serves as a reminder that the supposed creative freedom on YouTube, *Husbands*' previous home, only goes so far. In fact, considering YouTube's Terms of Service and their claims to any content uploaded on the site, the lines of control over content and distribution might be more clearly drawn at CW Seed, which is a smaller company than YouTube and has an investment in television as a medium.

Even if *Husbands* remains a web series, it is debatable whether or not the distribution via CW Seed constitutes a return to television. An alignment with a television network certainly brings *Husbands* closer to traditional TV than it has been before. Yet, one has to consider that while CW Seed is a branch of the CW, its online series exist at the margins of television. Network television is still centered on a broadcasting schedule and its established patterns of ratings and advertising revenue. In a way, *Husbands* has moved from a center of the web, i.e. YouTube, to the margins of television (the digital branch of a so-called "netlet," or a minor TV network). From this point of view, *Husbands*' online distribution still appears as something that is ahead of the network television game, and the CW has certainly recognized this. Specifically, the CW seems intent on bringing web-based and traditional broadcast TV into a closer exchange, which becomes obvious in statements such as the following by Rick Haskins, the CW's executive VP of marketing and digital programs. He observes, "'Husbands' has been a critically-acclaimed, user-friendly YouTube series for two seasons . . . By bringing that to the CW, we hope to bring new fans over to the network and to CW broadcast shows as well" (Marechal). It appears that one of the CW's main motives for recruiting *Husbands* was to guide a considerable fanbase from web-based TV to traditional TV. There might even be a chance for *Husbands* to cross over into the CW's regular broadcast schedule (ibid). Considering that Espenson and Bell have always understood *Husbands* as television and have positioned the series as being in conversation with network sitcoms, especially their modes of representing LGBT characters and storylines, it would not be a surprise if they embraced a chance to see *Husbands* on the CW's broadcast schedule.

This brings me to the third point I want to consider in relation to *Husbands'* move to CW Seed, namely the series' overt challenge of LGBT representations on sitcoms such as *Modern Family* and *The New Normal*. Espenson and Bell have stated that CW Seed would not interfere in the content shown on *Husbands* (Galante). One might have expected that the third season would continue *Husbands'* mission of featuring Brady and Cheeks as a married couple that defies many of television's established tropes of LGBT representation. Unfortunately, this is not the case. The third season focuses on Brady and Cheek's decision to have a real wedding and the appearance of Brady's ex-fiancee at said wedding. This plot constitutes a return to the private dimensions of Brady and Cheeks's marriage rather than a continuation of the more public aspects

that formed the focus of season two. However, *Husbands*' effort to revise tropes of LGBT representation continues in the graphic novel that appeared during the hiatus between seasons two and three. In the six stories that make up the volume, Brady and Cheeks are transported into settings that evoke classic genres, including film noir, science fiction, action, mystery, etc. For example, Brady and Cheeks appear in a *Sherlock Holmes* scenario that transforms the homoerotic dimensions of Holmes and Watson's relationship into a denotative gay relationship. Discussing the *Husbands* graphic novel, Bell stated in a column for *The Huffington Post*, "Let's imagine that Sherlock and Watson are gay (because, hello, they totally are) and living in an accepting society. What, then, becomes the obstacle to their love? In a James Bond scenario, who's Bond? Who's 'the girl'? Does it have to be strictly defined, or can it be kind of gray?" (np). By inserting Brady and Cheeks into familiar genres, their heteronormative conventions are rendered apparent and simultaneously challenged. Similar to how *Husbands* challenges the heterosexual couple at the center of the classic domestic sitcom, *Husbands: The Graphic Novel* dislodges heterosexuality from a wide variety of genres. The *Husbands* comics thus insert gay heroes into genres in which traditional film and TV hesitate to place gay men. While this provides interesting commentary on sexuality and gender norms (Brady and Cheeks switch off being rescued, etc.), the graphic novel features mostly white characters. As in the web series, whiteness remains a persistent and uninterrogated feature both of how *Husbands* stages its intervention in LGBT tropes and the tropes themselves. The overall framework of LGBT representations on television and off with its emphasis on committed, professional, and white gay couples thus remains in place even as the diegetic universe of *Husbands* expands.

Overall, *Husbands*' move to the CW Seed confirms rather than changes the series' complicated relationship to television. The series is still at home on the web, and thus occupies a space that has been hailed as the future of television, but it also finds itself in the margins of network television and thus tethered to TV's past. Likewise, *Husbands* often succeeds in offering an alternative vision to network TV's limited picture of gay married couples, but has not dismantled the more fundamental structures that mold queer media visibility. Jane Espenson and Brad Bell certainly have the desire to push *Husbands* further; after all, as they have emphasized many times, "*Husbands* is, all at once, a dream for the future and a dream come true" (Espenson and Bell). Like many future texts,

Husbands projects a vision of the future while also representing the possibilities and limitations of the present media landscape.

Notes:

1. Dan Savage, founder of the It Gets Better project, created his own video, in which he and his husband advise LGBT youth to "tough it out" and get through the bullying in their teenage years to reach adulthood and live fulfilling, productive lives.

2. The history of web-based television programming begins before 2007, however. For an overview of this history, see Aymar Jean Christian, "The Web as Television Reimagined? Online Networks and The Pursuit of Legacy Media."

3. For an examination of the difficulty of monetizing original TV content on sites like YouTube, see Aymar Jean Christian, "The Problem of YouTube."

4. For positive press reports on *Glee*, see, for example, *Entertainment Weekly*'s "special report" on gay teens on television, subtitled, "How a bold class of young gay characters on shows like Glee is changing hearts, minds, & Hollywood" from January 26, 2011. Critiques of *Glee*'s handling of its gay and lesbian characters can be found in fan-run projects such as The Glee Equality Project, which demonstrates the uneven distribution of moments featuring affection and intimacy among the program's gay and straight couples. For academic commentary on *Glee*, see Alexander Doty's contributions to *Flow*; on *Modern Family*, see Steven Edward Doran and Peter C. Kunze's essays in *Queer Love in Film and Television*.

5. An older example of such meta-commentary is the *Will & Grace* episode "Acting Out", in which Will and Jack protest NBC for its failure to air a kiss between two gay characters on a soap opera.

6. There are explicit portrayals of gay sexuality on cable and premium cable, but since *Husbands* sees itself as legacy to and critiques specifically network TV sitcoms, I will leave those portrayals aside.

7. It is important to recognize that denotative or overt depictions of gay and lesbian characters are not the only ways in which identities and practices that reside outside of heterosexuality become visible on television. In other words, queer visibility in the media comprises a much wider array of characters, stories, and styles than characters that are deliberately identified as gay or lesbian in the diegesis. For example, a number of connotative queer signs have been part of television and film since the Hollywood Production Code came into existence in the 1930s. and they continue to be part of these media in the present. My discussion here focuses specifically on denotative gay and lesbian characters because that is the mode of queer visibility at work in *Husbands* and other network sitcoms. For a discussion of queer media visibility at large that includes queer connotative signs, see Glyn Davis and Gary Needham's anthol-

ogy *Queer TV*, Alexander Doty's *Flaming Classics*, Richard Dyer's *The Matter of Images*, Melanie E.S. Kohnen's forthcoming *Queer Representation, Visibility, and Race in American Film and Television*, Vito Russo's *The Celluloid Closet*, and Patricia White's *UnInvited*.

Works Cited

"Acting Out." *Will & Grace*. NBC, 22 February 2000. Television.
"Appropriate Is Not the Word." *Husbands*. Online video clip. *YouTube*. YouTube, 15 Aug. 2012. Web. 11 Feb. 2013.
Armstrong, Jennifer, Archana Ram, Tim Stack, and Tanner Stransky. "Gay Teens on TV." *Entertainment Weekly*, Issue 1139, January 28, 2011: 34–41. Print.
AtGoogleTalks. "Talks at Google Presents: Jane Espenson." Online video clip. *YouTube*. YouTube, 13 Apr. 2012. Web. 15 July 2012.
Bell, Brad. "You're Just Like a Million Others, Snowflake." *The Huffington Post*. TheHuffingtonPost.com, Inc., 12 Dec. 2012. Web. 6 Aug. 2013.
Belonsky, Andrew. "Gay Web Dramas Flourish as TV Networks Cling to Satus Quo." *The Guardian*. Guardian News and Media Ltd., 8 Mar. 2013. Web. 19 Mar. 2013.
Christian, Aymar Jean. "The Web as Television Reimagined? Online Networks and The Pursuit of Legacy Media." *Journal of Communication Inquiry* 36.4 (Fall 2012): 340–356. Print.
—. "The Problem of YouTube." *Flow* 13.08 (February 2011): n. pag. Web. 24 Feb. 2013.
"Community Guidelines." *YouTube*. YouTube, 2013. Web. 6 Feb. 2013.
Davis, Glyn, and Gary Needham, eds. *Queer TV: Theories, Histories, Politics*. London and New York: Routledge, 2009. Print.
Doran, Steven Edward. "Housebroken: Homodomesticity and the Normalization of Queerness in *Modern Family*." *Queer Love in Film and Television*. Ed. Pamela Demory and Christopher Pullen. Basingstoke, Hampshire: Palgrave-Macmillan, 2013. 95-104. Print.
Doty, Alexander. "*Modern Family*, *Glee*, and the Limits of TV Liberalism." *Flow* 12.09 (Sept. 2010): n. pag. Web. 24 Feb. 2013.
—. *Flaming Classics: Queering the Film Canon*. New York: Routledge, 2000. Print.
Dyer, Richard. *The Matter of Images: Essays on Represenation*. New York: Routledge, 1993. Print.
Espenson, Jane, and Brad Bell. "For the Boy in Heart-Shaped Glasses." *Televisual*, 3 Apr. 2013. Web. 4 Apr. 2013.
Ellcessor, Elizabeth. "Tweeting @feliciaday: Online Social Media, Convergence, and Subcultural Stardom." *Cinema Journal* 51:2 (Winter 2012): 46–66. Print.

Galante, Amy. "Web Series 'Husbands' Kicks Off Book Tour and Inks Deal with CW Digital." *Examiner.com*. Examiner.com Entertainment, 9 Apr. 2013. Web. 14 Apr. 2013.

Giannini, E. "Fan Support and Its Effect (Or the Lack Thereof) on the Strike." *Flow* 7.15 (2008): n. pag. Web. 24 Feb. 2013.

Glass, Ira. "Sitcom From an America That Is Just Starting to Exist." *This American Life Blog*. Chicago Public Media, 25 Oct. 25, 2011. Web. 14 Apr. 2013.

"HIV AIDS Test." *It Gets Betterish*. Online video clip. *YouTube*. YouTube, 29 Nov. 2011. Web. 10 Mar. 2013.

Husbands: Behind the Scenes. Dir. Scott Perlman. Prod. Streamin' Garage. Aug. 2012. Web. 31 Mar. 2013.

"Interview with Brad Bell and Jane Espenson." *The Frank DeCaro Show*. SiriusXM Satellite Radio. 9 Apr. 2013. Web. 13 Apr. 2013.

Jusino, Teresa. "Jane Espenson and Cheeks discuss writing Husbands." *Tor.com*. Macmillan 13 Sept. 2011. Web. 25 Mar. 2013.

"The Kiss." *Modern Family*. ABC, 29 Sept. 2010. Television.

Kohnen, Melanie E.S. *Queer Representation, Visibility, and Race in American Film and Television: Screening the Closet*. Book Manuscript.

Kunze, Peter C. "Family Guys: Same-Sex Parenting and Masculinity in *Modern Family*." *Queer Love in Film and Television*. Ed. Pamela Demory and Christopher Pullen. Basingstoke, Hampshire: Palgrave-Macmillan, 2013. 105-16. Print.

Marechal, AJ. "CW Offers 'Husbands,' More Web Fare from Digital Studio." *Variety*, 27 Mar. 2013. Web. 7 Apr. 2013.

Martin, Alfred J. "It's Not in His Kiss: Gay Kisses, Narrative Strategies, and Cameronera Angles in Post-Network Television Comedy." *Flow*, 16.07 (Sept. 2012): n. pag. Web. 19 Mar. 2013.

Plesser, Andy. "Veteran television writer Jane Espenson producing gay marriage sitcom." *The Huffington Post*. TheHuffingtonPost.com, Inc., 3 Oct. 2011. Web. 10 Feb. 2013.

"Return of the Zebra." *Husbands*. BlipTV, 11 Oct. 2011. Web. 11 Feb. 2013.

Russo, Vito. *The Celluloid Closet: Homosexuality in the Movies*. Revised Ed. New York: Harper and Row, 1987. Print.

Stalder, Felix. "Between Democracy and Spectacle: The Front-End and Back-End of the Social Web." *The Social Media Reader*. Ed. Michael Mandiberg. New York: NYU P, 2012. 242–56. Print.

"Terms of Service." *YouTube*. YouTube, 2013. Web. 6 Feb. 2013.

"The Straightening." *Husbands*. Online video clip. *YouTube*. YouTube, 29 Aug. 2012. Web. 11 Feb. 2013.

Whedon, Joss. "A Message From Creator Joss Whedon." *Doctor Horrible Net*, 2008. Web. 17 Feb. 2013.

White, Patricia. *UnInvited: Classical Hollywood Cinema and Lesbian Representability*. Bloomington: Indiana UP, 1999. Print.

10 *Sucker Punch* and the Aesthetics of Denial: Future Perfect Tense

Virginia Kuhn

The theatrical release of *Sucker Punch* was met with virulent criticism from mainstream and alternative critics alike. Director Zach Snyder was accused of narrative incoherence and letting special effects trump story, while he was simultaneously indicted for creating characters who were faux feminist, an affront somehow worse than bold-faced misogyny. Reviewers from *Variety* to *The New York Times*, from *Rolling Stone* to *The Onion* and everything in between judged it to be a train wreck of a film; Leonard Maltin called it the "strangest" film he had seen in a long time and Quentin Tarantino named it one of the ten worst of 2011. The reviews became so brutal that one critic, the author of the single astute review at the time, called *Sucker Punch* the most widely misunderstood film in recent history.[1]

It seems that Zach Snyder had the audacity to reveal in film—big box office film, no less—what Laura Mulvey argued more than thirty years prior in her highly influential essay, "Visual Pleasure and Narrative Cinema,"—namely that the cinematic male gaze structures female subjectivity. Indeed, this notion is enacted throughout *Sucker Punch* in sometimes startling ways as the five young female leads must fight their way out of a mental hospital. I suspect, however, that this is *not* a message people are prepared to hear from the likes of Snyder, the director of the very commercial *300* and *Watchmen*, a privileged white male who is squarely implicated in the system he condemns. Thus the venomous critique.

If gauged by its relative degree of "empowerment" (the measure often used to gauge a feminist text), then *Sucker Punch* proves problematic, not because of its misogyny, but rather due to its ultimate dystopian

bent. But as a "future text" on which this collection is themed, a text that "imagines new pathways through the forms and formats used to express contemporary questions of race, gender, and identity," it is a perfect model (introduction, ix). *Sucker Punch* is an amalgamation of popular culture with all its racial and gender stereotypes and cultural clichés. It inhabits the realm of hybridity and pastiche via the highly stylized and heavily sampled worlds one finds within. Further, by destabilizing the narrative structure at key moments, *Sucker Punch* becomes a craftily feminist text, one that is all the more compelling in its potential to attract the very audience (e.g., fanboys and gamers) who might benefit most from seeing it. Moreover, this film makes use of the big screen while anticipating the potential for repeated viewing that is made possible by small screens, and this lends a certain democratizing force to its analysis, destabilizing the authority of the film critic.

Given the multidimensionality of *Sucker Punch*—it is part action film, part video game, part anime, and part music video—it is difficult to do it service in a conventionally formatted linear essay. To mitigate this difficulty and enact its key ideas, this essay's structure invokes the concept of layering: Using three levels that mirror the type of *leveling up* one does in video games, each layer attempts to add depth and nuance to the larger concepts. The risk is one of necessary repetition as various aspects of the film are revisited in each layer, and rather than independent or discrete arguments, this structure is additive in nature (i.e. not hierarchical).

Level One: The Surface

Initially, the storyline of *Sucker Punch* feels like an all too familiar adaptation of a Marvel comic book story. The opening action is cartoonish in nature (Figure 1) and centers on a young girl named Babydoll, played by Emily Browning, whose mother dies, leaving her and her little sister in the hands of their evil stepfather. Having been left out of the will, the drunk and enraged stepfather approaches Babydoll's bedroom with an appropriately menacing look but she fends him off, only to have him approach her sister's room. Babydoll then attempts to rescue her younger sister and in the ensuing scuffle, the sister is killed, and Babydoll is committed to the "Lennox Home for the Criminally Insane," where the bulk of the film takes place.

Figure 1. Opening image of Babydoll in faux theatre setting. *Sucker Punch* © 2011 Warner Brothers.

Babydoll retreats to an alternate reality, ostensibly as a coping strategy, and the institution becomes a brothel, the hospital staff its management. Scantily dressed girls populate this world and their time is spent either doing household chores or in rehearsals with Dr. Gorski, their therapist cum dance mistress (cum Madam). Babydoll's appearance is the epitome of a manga or anime character with her huge eyes, blond pigtails and skimpy schoolgirl clothes. (Figure 2) She is simultaneously victimized and liberated vis-à-vis the intrusion of fantasy game sequences in the narrative, which come when she must "dance for her dinner," as it were. When forced to perform, Babydoll's physical body complies, but only as she mentally transports herself to a fantastic world of quests, a world in which she and four of her inmate sisters prevail in the face of incredible odds. A game master/sensei character, played by Scott Glenn, guides the missions *Charlie's Angels*-style as he takes them through the steps required to achieve freedom through specific quests. The men of the brothel/asylum become transfixed when Babydoll dances and the girls make strategic use of her stupor-inducing performance in order to hide their acquisition of the items needed for their escape: a key, a map, a lighter, and a knife. The element of time that is so common to the structure of games is introduced through Babydoll's impending lobotomy at the hands of the visiting specialist, played by Jon Hamm. They must complete the quests before his visit. Ultimately, Babydoll is lobotomized, and all the girls are killed trying to escape, with the one exception of Sweet Pea, played by Abbie Cornish. Babydoll distracts the guards, sacrificing herself, in order to let Sweet Pea escape. Sweet Pea

then boards a bus whose driver is none other than the Wise Man/Scott Glenn character.

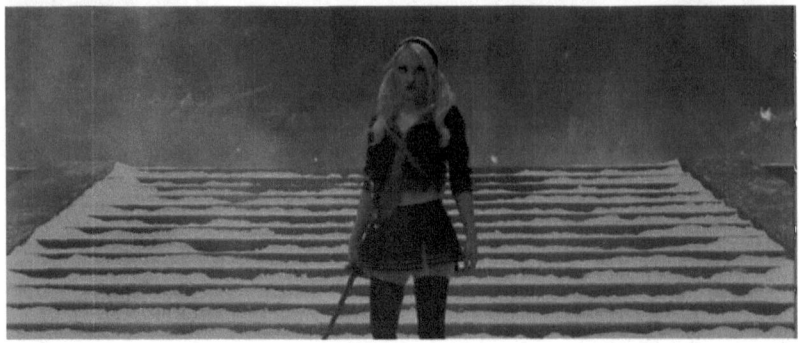

Figure 2. Babydoll in the gameworld. *Sucker Punch* © 2011 Warner Brothers.

Reading the film at this level, we might say its formal qualities are the most interesting, if the most confounding aspect: The game sequences—there are three of them throughout the film—are simultaneous with the dance, and they begin as Babydoll starts to dance, closing her eyes as the camera pans around her head to signal the interiorization of the images. In the game world of her mind, we see the girls face off against a giant samurai, steampunk Nazi zombies, and finally dragons. These quests are replete with all of the densely packed action sequences and special effects for which Snyder is known from films like *Watchmen* and *300* that blend live action footage with digital effects to create a hybrid type of hyper-real visual palette. We are only returned to the outer world—the asylum/brothel at the end of the dance (which also marks the end of the quest), to see the face of the breathless, sweat-browed Babydoll, before the shot cuts to the men in the room who are slowly coming out of the spell they have been under. In this way, the film simultaneously raises and dashes the voyeuristic promise of her objectification, and we, the film's audience, cannot see what Babydoll's audience sees. It is an odd moment of spectatorship and a fairly ingenious way in which we are both implicated in this act, but frustratingly blind to it. This simultaneous action not only defiles the narrative structure of the film, it also subverts the first person position of a game mechanic, denying the player rewards on both fronts. Moreover, this device essentially forces the viewer to take on the role of a young woman, one who is mercilessly subjected to the lascivious male gaze.

Does this dramatic device function only as an alibi for basking in the violence of video games and the sexual objectification of women? Are the skimpy outfits and action sequences merely an extension of the ubersexualized dancers in many music videos? Certainly, there is a long history of this trend in the arts, particularly those issuing from patriarchal cultures. Oil paintings of the European Renaissance, for instance, commonly depicted nude female figures for disingenuous purposes. As renowned cultural critic John Berger argues, the women in these paintings are always passive, always on display, whether in mythological scenes depicting sexual conquests by the gods or in didactic illustrations of the perils of sin. Berger reveals the disingenuousness of these pictures, which reinforced the status quo:

> You painted a naked woman because you enjoyed looking at her, you put a mirror in her hand and called the painting *Vanity*, thus morally condemning the woman whose nakedness you had depicted for your own pleasure (51).

Does the bordello of *Sucker Punch* do similar cultural work? Certainly Snyder was accused of being masturbatory in his approach. However, he has been quite vocal about the many women in his life who influence him and for whom this film advocates—not only is his wife his producer, he also has several daughters. And while authorial intentions are not the only gauge of a work, film reviews have added almost nothing insightful to the conversation.

For the most part, critics have had little idea what to make of the film and especially the narrative cutaway during the dance sequences. Peter Travers, film critic for *Rolling Stone*, said that it "comes off as a tease that cops out on its shoddy but kinky premise," adding that at the "first sign of nudity, the censor-friendly camera cuts to dream scenes of the girls in warrior drag . . ." (Par 3). The implication that the dramatic device serves only to avoid an R rating seems utterly wrongheaded for a variety of reasons. Conceptually, it's key. But even pragmatically, it makes no sense. Snyder is not oblivious to the implications of ratings. In fact, he turned down the chance to direct *S.W.A.T.,* which would have been his first feature, because it would *not* be rated R. He has said that the film was always intended to be PG-13, and so it seems highly unlikely that this device is the result of a lack of forethought or merely an evasive maneuver.[3]

Similarly, the stereotyping of the girls is clearly self-conscious if dismally ironic: the Korean-American Jamie Chung's character is named Amber while the dark-complexioned Vanessa Hudgens's character's name is Blondie. Whether playing on the "yellow" skin of Chung/Amber or playing against the non-blondness of Hudgens/Blondie, these names cum adjectives call attention to their own constructedness. It is difficult to believe this is *not* a commentary on the act of stereotyping and the way that such superficial categorizations are essentializing and sometimes simply wrong. Moreover, the clichés that make up the film, from the typified quests to the girls' skimpy clothes to the hackneyed lines used by the sensei character before each quest, are so numerous they can hardly be arbitrary or accidental. Thus, I contend, the film comments on generic conventions without necessarily being bound by them, disrupting and problematizing narrative as a basic filmic structure.

Level Two: Back to the Beginning, the Structural Male Gaze

If the storyline of *Sucker Punch* is hauntingly familiar, it is actually the first of Snyder's features to be based on his original material; he wrote the screenplay with Steven Shibuya over a period of several years. Its familiarity is that of its genre: the action film, and it is a stunning example of what Jean Baudrillard advances as a *third order simulacrum*: a copy without an original (6). According to Baudrillard, in contemporary culture we are bombarded with semiotic systems and these signs become more real than the things they once represented. Paired with the mechanical reproducibility brought about by technical and technological evolution, we find ourselves in a sort of hyperreality, one which is no longer tethered to the material world. *Sucker Punch* feels exactly like a copy without an original: an adaptation of a Marvel comic that never was, a hero's journey without a stable protagonist, a spoof that does more than simply call attention to the generic conventions it parodies, a musical whose interludes are action sequences set to eclectic remakes of musical hits. Moreover, the film includes several elements that function as metonyms to other genres: the indeterminancy of a video game, the throbbing soundtrack of a music video, the special effects of a contemporary film, the 1950s era setting of a period film.

But insofar as its constituent parts are familiar, the structural whole of *Sucker Punch* is quite new, and this is where its potential for inter-

vention lies. Indeed, a sustained examination calls the main storyline into question and casts doubt on the identity of the protagonist as well as the real-fantasy binary. The opening sequence is revealed exclusively through images and includes no character dialogue whatsoever. Indeed, Emily Browning's Babydoll is the lead character, but she utters not a single line of dialogue until eighteen minutes into the film, which provides one clue to her actual status. In addition, the opening sequence includes a narration that begins with these lines:

> Everyone has an angel
> A guardian who watches over us
> We can't know what form they'll take
> One day, old man
> Next day, little girl
> But don't let appearances fool you
> They can be as fierce as any dragon

At the very end, however, we see that Sweet Pea is, perhaps, the main character. Of the five girls, three are killed while gathering the materials of their escape. Babydoll then sacrifices herself so that Sweet Pea can escape and, as Sweet Pea rides off in a bus driven by the Sensei/Scott Glen character, the opening narrative voice reemerges, picking up the introductory thread with the following queries:

> Who honors those we love with the very life we live?
> Who sends monsters to kill us and at the same time sings that we'll never die?
> Who teaches us what's real and how to laugh at lies?
> Who decides why we live and what we'll die to defend?
> Who chains us and who holds the key that can set us free?

After these rhetorical questions and a dramatic pause, the narrator ends the film with: "It's you. You have all the weapons you need. Now fight." In this final moment then, the very structure of the film shifts as we discover that Babydoll is an avatar for Sweet Pea's trapped persona, and rather than a happy ending, we have a call to action. This shift has been foreshadowed early on when Babydoll enters the asylum and her stepfather is given a tour, starting with the theatre where the manager/pimp explains that Dr. Gorski has them reenact their trauma as a form of therapy (9:12). In the first rehearsal, which is also the first fantasy sequence,

we see Sweet Pea dressed like Babydoll, platinum blond pig-tailed wig and all, in the midst of a pantomimed lobotomy. (Figures 3 and 4)

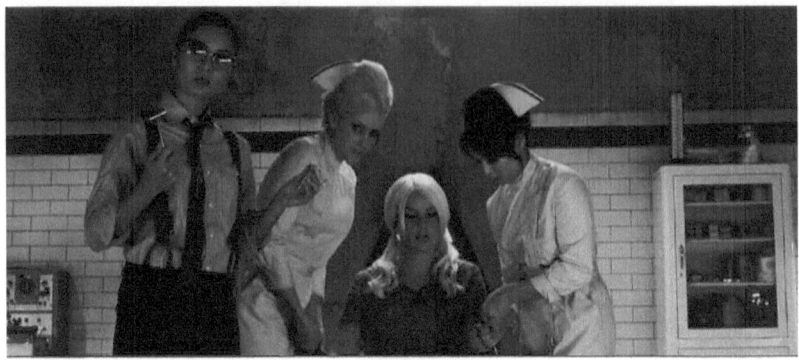

Figure 3. Babydoll being prepped for her lobotomy. *Sucker Punch* © 2011 Warner Brothers.

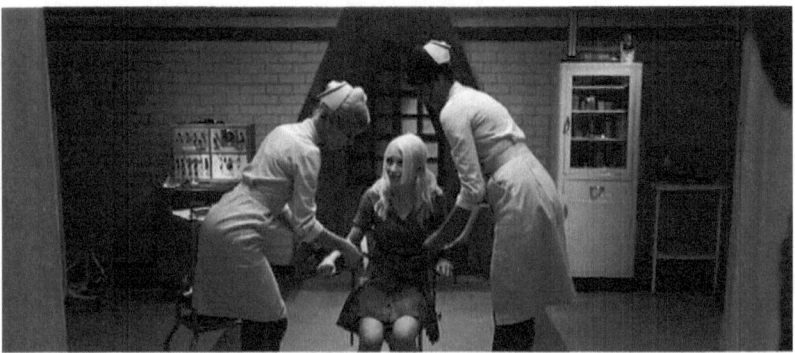

Figure 4. Sweet Pea enacting Babydoll's lobotomy scene. *Sucker Punch* © 2011 Warner Brothers.

When Sweet Pea objects to this scene, she tells Dr. Gorski that it must be fixed since, as she continues, "You gotta help me. I'm the star of the show, remember?" (13:26). This last statement is accompanied by a sarcastic gesture, calling the veracity of her words into question (Figure 5). The visual syntax here is complex and nuanced. Similarly, the camera briefly focuses on each of the items needed for escape in a montage of asylum life that comes just before this rehearsal scene (10:50–11:30). One would be hard pressed to make these connections, however, within

the space of a single viewing, and indeed these structural deviations of *Sucker Punch* anticipate such repeated views.

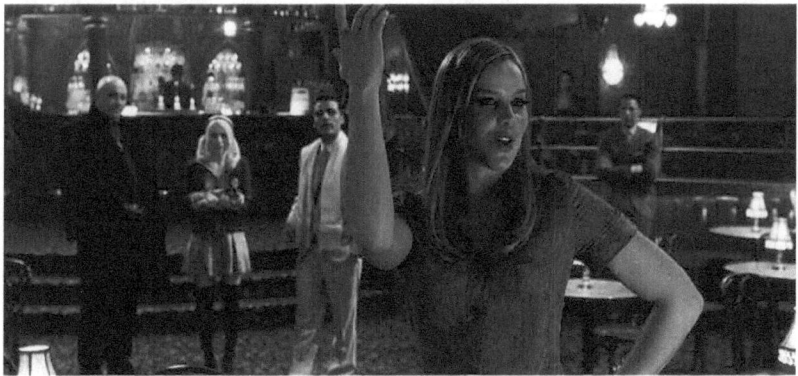

Figure 5. Sweet Pea gestures to her starring role. *Sucker Punch* © 2011 Warner Brothers.

Just as Laura Mulvey has updated her earlier thinking about the structural aspects of narrative cinema and the male gaze, so too *Sucker Punch* offers an approach to filmmaking that acknowledges its own participation in a system that it both critiques and attempts to disrupt. Mulvey recently launched a critique of the old-new binary that informs most of the conversation around film and new media. Digitizing can breathe new life into film, even as it allows the viewer to deconstruct narrative time by manipulating (stopping, starting, backing up, moving forward) the film itself. However, as she herself reflexively notes, this critique has inadvertently erected a new binary that pits "the material and indexical" in opposition to "narrative and illusion," and this, she notes, "resurrects the old opposition between avant-garde materialism and the illusion of fiction, with an implicit validation of avant-garde practice, stripping away the mask of narrative to reveal the material presence of celluloid and the cinematic apparatus" (77). This approach, she admits, informed her thinking about film in the 1970s, though she has recently revised her stance. The relationship between old and new media, she argues, offers the chance to break down that binary, "most particularly through an investigation of the complex temporalities of film that are now becoming visible and available to theory" (*Ibid*).

Indeed, digital tools have rendered films "available to theory," and this opens up possibilities for structural intervention, particularly with regard to narrative time. For Mulvey, this takes the form of an "aesthet-

ics of delay" that is, in part, influenced by the increasing prevalence of stills within films. She cites Raymond Bellour's meditation on photograms (or, in this case, freeze frames) that disrupt narrative time, suspending it for moments and calling attention to the construction of narrative. In other words, the aesthetics of delay, while not confined to digital media, is made possible by emergent technologies as analogue films become digitized.

Rather than an aesthetics of delay, I contend that *Sucker Punch* advances an "aesthetics of denial." This denial runs throughout: We are denied a happy ending. We are denied a heroine. We are denied even that which the diegetic audience is granted—a woman dancing for our enjoyment. When the dance sequences are suspended via the game sequences, they are not merely delayed, they are completely absent, leaving the viewer to write in her own anxieties. We see only the impact of Babydoll's dance on her audience, while we, theatrical viewers, are denied the voyeuristic pleasure of this spectacle. But this denial also indicts the audience, who is necessarily complicit in both the film's oppression—we are visually marked as the viewer early and often—as well as that of the larger Hollywood machine, which, after all, is often framed as giving consumers what they want. In this aesthetics of denial then, we may find a space for intervention, taking to heart the final words: *It's you. You have all the tools you need. Now fight.* Certainly the conversation around gender inequity in Hollywood has been reinvigorated over the few years since the film's 2011 release, and while it would be imprudent to assign a causal relationship between *Sucker Punch* and this dialogue, one can at least say the film is timely and has sparked discussion.

Perhaps the key question to consider becomes: *If the male gaze of narrative cinema structures female subjectivity, can a shift in its formal qualities prove liberatory?*

LEVEL THREE: CONTEXT, CRITICS AND CULTURE

Sucker Punch is the fifth feature film directed by Snyder, who made music videos and television commercials for a decade before his first feature film in 2004. It is also the first feature that is *not* based on older material—a remake or an adaptation—although, in many ways, it is a remix of pop culture iconography and aesthetics. The copious visual effects, Snyder has said, answers one motive of the film—to give audiences a reason to come back to the theatre now that they have more sophisticated con-

sumer grade devices at home (IMDB interview). Snyder has also said the film is a commentary on the status of women in Hollywood, which is similar to a brothel.[4] (Figure 6) Are these two impulses mutually exclusive? Can a film be both entertaining and subversive or is this the same old misogyny repackaged for the twenty-first century? Most critics have suggested the latter, but there has been little real textual evidence offered and few have addressed the film on the basis of its complex visual syntax.

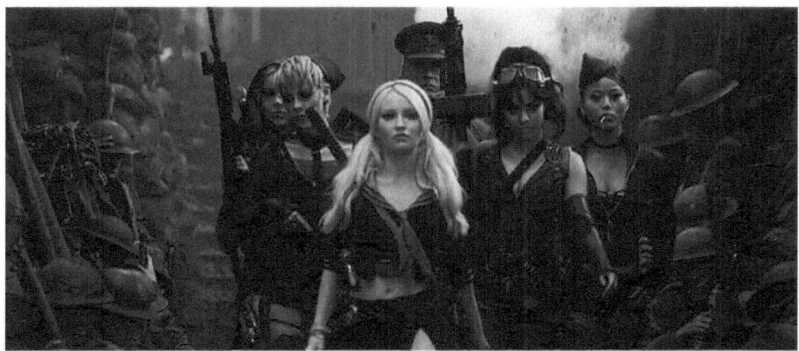

Figure 6. The lead girls in battle. *Sucker Punch* © 2011 Warner Brothers.

Debates about the loss of the experience of the big screen given the onslaught of small screens notwithstanding, it is undeniable that digital technologies have endowed moving image media with the sort of "infinite patience" of a book, opening up the potential of the small screen for enhanced critical response.[4] As I have argued elsewhere, the ease with which filmic media—once ephemeral—is now able to be pinned down and subjected to sustained analysis cannot be overstated. Heretofore, critics could offer a reading of a film without backing these claims with textual evidence, and since they've had privileged access to the films themselves, it was difficult to debate them. Now that the average viewer has access to the filmic texts and can analyze the film in a more sustained way, the situation is rapidly changing. When *Rolling Stone*'s Peter Travers says on camera that the film is "a piece of caca" adding "that's what we say in critic terminology," one can almost see his obsolescence solidify.[5] Moreover, given the contemporary climate of user reviews and trusted friend recommendations, one wonders if today's movie-going public is receptive to such posturing couched as use of the vernacular.

Feminist film critics were equally dismissive of *Sucker Punch* without offering textual evidence, and sometimes even invoking evidence that isn't there. For instance, Monika Bartyzel, Moviefone's feminist blog-

ger for its "Girls on Film" column called the film "faux feminism" noting that "[i]nstead of empowering their female brethren, the women of 'Sucker Punch' work as warriors protecting the male gaze and male authority." This is partly true of course, in that the male gaze is acknowledged, and yet Bartyzel seems not to notice that the dance sequences are missing, writing as though she has seen them. She writes, "[t]hough her female counterparts see her dancing as nothing special, her hypnotic hip thrusts and gyrations put every man into a catatonic daze . . ." (Par 4). Firstly, the other girls actually do think Babydoll's dancing is extraordinary as all but Sweet Pea clamor around her after the first dance, Rocket asking, "What *was* that?" (21:34). But perhaps more profoundly, we never see any part of Babydoll's body moving, although we do hear Sweet Pea lamenting the dance based on "all those gyrations and moaning" (23:06). The fact that this blogger refers to "hip thrusting and gyration," must surely be due to the convincing nature of the cutaway sequences—upon first viewing, you might actually think you've seen her dance. However, in reviewing the film, there is zero evidence for this. These absences then, in the aesthetics of denial, become blank spaces on which the viewer may write her own anxieties, and this is where the film's formal elements prove most intriguing.

If most reviews do not offer textual evidence for their claims, the notoriously ironic paper *The Onion* is perhaps the perfect place for a review that considers form as well as content. Indeed, *The Onion*'s AV Club critic Nathan Rabin, after admitting that he has to give the film a second look, writes, "[d]eep down, *Sucker Punch* is a silent movie with a talking problem; Snyder does not like or trust words, so he tells his story in images that are as striking as they are derivative" (Par 3). While I would argue the point in reverse—it is not so much that words are disliked, rather that images and music are glorified—Snyder's use of images as communication is one of the film's strengths. It lends a type of complexity and nuance that exceeds the words of the script, sometimes reinforcing them, sometimes calling them into question. The images are not simply illustrations of the verbal, and they sometimes function independently, as when they highlight the items needed for escape in an early montage. If we view this film as visual communication, then the word "derivative" is meaningless: communication depends on a shared lexicon.

Part of that visual communication is the film seeing itself in terms of its legacy in cinema. It operates as an indictment of the Hollywood

film industry, which is, unquestionably, one of gender and racial imbalance, in front of the camera as well as behind it.[7] But by showing historical as well as contemporary time periods, *Sucker Punch* also effectively dispels the type of progressive narrative that accompanies some of the discourse around race and gender—that which suggests that change happens slowly and that things will become more equitable if only we are patient. What we *can* hope for in films like *Sucker Punch* is an eschewal of the very form that has, for too long, functioned in the realm of white supremacist patriarchal culture.

Engaging with works like *Sucker Punch* can be productive, especially when they are viewed through the context of other films with young female protagonists like *Winter's Bone, The Hunger Games,* and *The Girl with the Dragon Tattoo*. It also joins the ranks of recent films that explicitly question their form, such as Ari Folman's, *The Congress* (2013), which blends live-action footage with animation while offering a commentary on the business of filmmaking, or Joe Wright's *Hanna* (2011), whose eponymous central character is a 16-year-old girl raised to be an assassin. Like *Sucker Punch, Hanna* features a vibrant visual palate combined with a prominent musical backdrop. But while the soundtrack of *Sucker Punch* is mainly used as the glue that holds the film together during transitions among worlds, *Hanna*'s soundtrack, much of which is written and performed by the virtuosic Chemical Brothers, unites the diegetic and non-diegetic space in a nearly seamless way. It is worth noting, however, that Joe Wright, the British director of *Pride and Prejudice* (2005) and *Atonement* (2007), was never accused of bastardizing the film with the flash and action of a music video.

It's not that this film is unproblematic, but it does attempt to enact feminist theory without necessarily preaching to the choir. For far too long, subversive film theory has languished within the confines of the ivory tower: Feminist theory, postcolonial theory, and queer studies, while often embraced in academe, are just as often unwelcome in the larger culture. Further, it can be argued that sexism and racism, particularly that in the film industry, should be confronted and cured by white, male directors given that they have had some part in their perpetuation. Thus, it's incumbent upon them to fix it. Indeed, the female leads of *Sucker Punch* prepared for the film by spending months in physical training. In fact, their regimen was the very same one followed by the "beefcake" men of Snyder's *300*. Fostering young female actors' physical prowess is, I would argue, an intervention in itself, particularly in the

context of an industry that encourages them to be waif-like, a state often accomplished by extremely unhealthy means.

LEVEL 4: GAME OVER. PLAY AGAIN?

Will films like *Sucker Punch* revolutionize cinema, liberating women from the ubiquitous male gaze? It almost doesn't matter. The conversation they beget is nearly as valuable in the sense that it can shape tastes and expectations, challenging audiences to think outside of generic boxes.

Peter Greenaway, the British filmmaker known for his "painterly" approach to making movies, contends that we have not seen an era of image based films. Rather, the film industry is characterized by 115 years of illustrated books. In order for cinema to advance, he argues, it must rid itself of four tyrannies: the tyranny of the text, the frame, the actor and the camera (UAW, *nd*). And while escaping these tyrannies, as films like *Sucker Punch* partially manage, will not automatically beget a more equitable and inclusive field of representation, they are certainly a rich place to start.

NOTES

1. This Hollywood Reporter review is indicative of the charges as the reporter maintains that Snyder's storytelling skills are questionable and that he may lose the *Man of Steel* project due to the 'failure' of Sucker Punch. Snyder did not lose *Man of Steel* which did quite well worldwide. http://www.hollywoodreporter.com/movie/sucker-punch/review/171187

2. James McDowell's piece, "Questioning 'Empowerment': The Reception and Feminism of Sucker Punch," from Alternate Takes is the only one I was able to find from that time period (2011). A video essay titled "You Don't Understand Sucker Punch," was posted to YouTube in 2013, which is similar in complicating some of the more knee-jerk reactions to the film. This piece is able to argue with the type of textual evidence that is now possible with emergent technologies. (http://youtu.be/qQm1rBqh53Y)

3. This is according to Snyder's IMDb (Internet Movie Database) profile in the "Trivia" section: http://www.imdb.com/name/nm0811583/?ref_=fn_al_nm_3

There is little reason to doubt Snyder about the planned PG-13 rating, since he freely admits to both compromises and mistakes: for instance, he says that the original ending was scrapped due to audience testing, which, in retrospect, was a mistake.

4. Giroux, Jack. "Interview: Zach Snyder on the Sexuality and Fanboy Hate of 'Sucker Punch'." Film School Rejects. March 27, 2011. Online. Accessed April 4, 2012. Available at: http://www.filmschoolrejects.com/features/interview-zack-snyder-on-the-sexuality-and-world-of-sucker-punch.php

5. I have argued this point in slightly more detail in: Filmic Texts and the Rise of the Fifth Estate," *International Journal of Learning and Media*, available here: http://scalar.usc.edu/anvc/kuhn/index

6. Peter Travers, review of *Sucker Punch, Rolling Stone*, 3/25/2011: http://www.rollingstone.com/movies/reviews/sucker-punch-20110325

7. For in-depth research on gender disparity in female characters, as well as in the entertainment business itself, see the Geena Davis Institute on Gender in Media: http://www.seejane.org/

Works Cited

ASC (Antisocial Commentary). Review "You Don't Understand *Sucker Punch*." Slashfilm.com. 27 Jan. 2013. Web. 13 Mar. 2013.

Bartyzel, Monika. "Faux Feminism in Sucker Punch." Girls on Film. *Moviefone*. 28 Mar. 2011. Web. 4 April 2012.

Baudrillard, Jean. *Simulacra and Simulation*, Ann Arbor: U of Michigan P, 1981. Print.

Bechdel Test Movie List. 2015. Web. 25 July 2015.

Childress, Erik. "Zach Snyder Goes to Tideland" *eFilm Critic*. 25 Mar. 2011. Web. 25 April 2011.

Giroux, Jack. "Interview: Zach Snyder on the Sexuality and Fanboy Hate of 'Sucker Punch.'" *Film School Rejects*. 27 Mar. 2011. Web. 4 April 2012.

IMDB: Internet Movie Database. Video Interview with Zach Snyder. 2011. Web. 25 July 2013.

Jay, Jay. Interview. "Peter Greenaway Interview Following Review of Entries to MachinimUWA III: Journeys." *The University of Western Australia (UWA) in Second Life*. 17 Mar. 2011. Web. 25 July 2015.

Kuhn, Virginia. "Filmic Texts and the Rise of the Fifth Estate," *International Journal of Learning and Media*. 2.2-3 (Spring–Summer 2010): Web. 4 Apr 2012.

MacDowell, James. "Questioning 'Empowerment': The Reception and Feminism of Sucker Punch." *Alternate Takes*. 26 May 2011. Web. 5 June 5 2011.

Meyer, Clive. "Playing with New Toys: An Interview with Peter Greenaway," *Critical Cinema: Beyond the Theory of Practic*. Ed. Clive Meyer. London: Wallflower P, 2012. 225-53. Print.

Mulvey, Laura. "Visual Pleasure and Narrative Cinema." *Screen*. 16.3 (Autumn, 1975): 6-18. Print.

—. "Passing Time: Mediations on the Old and the New." *Critical Cinema: Beyond the Theory of Practice.* Ed. Clive Meyer. London: Wallflower P, 2012. 71-81. Print.

Rabin, Nathan. "Furtively Feminist, Mostly Misunderstood Case File #197: *Sucker Punch*." *The Onion*. September 14, 2011. Web. 4 April 2012.

Scott, A.O. "Well, Here They Are, Wherever This May Be" Review of *Sucker Punch*. *New York Times*. 24 Mar. 2011. Web. 25 July 2012.

Travers, Peter. Review of Sucker Punch, *Rolling Stone*. 25 Mar. 2011. Web. 25 July 2012.

Yamato, Jen. "Zack Snyder on Male Moviegoers and His Subversive Sucker Punch: 'We Are the People in the Brothel'" *Movieline*. 23 Mar. 2011. Web. 25 July 2015.

Contributors

Nina Cartier is a doctoral candidate at Northwestern University, where she is completing her dissertation on Blaxploitation. She studies representations of blackness in media, focusing upon urban cinema of the 1960s–1980s and critical race theory, Afro-Futurism, and narration. Her recent articles appear in *Cinema Journal* and in *Beyond Blaxploitation*, Ed. Gerald Butters and Novotny Lawrence (Wayne State University Press).

Courtney Brannon Donoghue is an Assistant Professor of Cinema Studies at Oakland University in Rochester, Michigan. Her research interests include local-language productions, Brazilian media, conglomerate Hollywood, distribution cultures, and blockbuster and franchising practices. Brannon Donoghue's work has appeared in *Cinema Journal, Media, Culture & Society*, and *Quarterly Review of Film & Video*. She currently is completing a book manuscript that explores Hollywood international operations and localization strategies across Europe and Latin America since the 1990s.

Anna Froula is Associate Professor of Film Studies in the Department of English at East Carolina University. She is co-editor of *Reframing 9/11: Film, Popular Culture, and the "War on Terror"* (Continuum, 2010) and of *It's a Mad World: The Cinema of Terry Gilliam* (Columbia UP/ Wallflower, 2013) and is currently collaborating on an edited collection about television series dealing with war. She has published on gendered representations of war and on zombies in a variety of journals and edited collections. Froula is Associate Editor of *Cinema Journal*, the journal of the Society for Cinema and Media Studies.

Shelleen Greene is Associate Professor in the Department of Art and Design, University of Wisconsin, Milwaukee. Her research interests include film and media studies, visual cultural studies, race and represen-

tation, and postcolonial studies. Her book, *Equivocal Subjects: Between Italy and Africa—Constructions of Racial and National Identities in the Italian Cinema* (2012), examines the representation of mixed race African Italian subjects in the Italian national cinema.

Nettrice R. Gaskins was born in Baltimore, Maryland. She received a BFA in Computer Graphics with Honors from Pratt Institute in 1992 and a MFA in Art and Technology from the School of the Art Institute of Chicago in 1994. She worked for several years in K–12 and post-secondary education, community media and technology before enrolling at Georgia Tech, where she received a doctorate in Digital Media in 2014. Her model for 'techno-vernacular creativity' is an area of practice that investigates the characteristics of this production and its application in STEAM (Science, Technology, Engineering, Art and Mathematics). When she is not advancing interdisciplinary education, Ms. Gaskins blogs for Art21, the producer of the Peabody award-winning PBS series, *Art in the Twenty-First Century* and publishes articles and essays about Afrofuturism. Her essay was included in *Meet Me at the Fair: A World's Fair Reader* published by ETC Press.

Lorien R. Hunter is a 2013 Research Enhancement Fellow, a 2010 & 2011 Annenberg Fellow, and a Ph.D. Candidate in the School of Cinematic Arts' Critical Studies program at the University of Southern California. Her research interests are grounded in popular culture and are particularly concerned with questions pertaining to Africa, race, identity, diaspora, new media, music and industry. Her dissertation examines the shape and practice of the African Diaspora comparatively using African hip hop websites and their surrounding communities. Other recent projects include an archival research project exploring diasporic practice in 1980s & 1990s Los Angeles via the KCRW radio program "The African Beat," and an ethnographic study surrounding the use of websites and digital media by independent hip hop artists in the South African music industry.

Melanie E.S. Kohnen is a media scholar who examines the interplay of traditional and new media with particular focus on how media function as platforms for negotiating diversity. Her current research investigates the claim that convergence culture has produced a more diverse media landscape in the areas of distribution platforms, cultural

representations, and audience participation. Her forthcoming book *Queer Visibility, Sexuality, and Race in American Film and Television: Screening the Closet* traces the uneven history of queer media visibility through crucial turning points in American history. Kohnen's research has been published in several anthologies and in the journals *Creative Industries* and *Popular Television*. She also blogs in online scholarly venues such as *Flow*, *In Media Res*, and *Antenna*. She received her doctorate from Brown University.

About the Editors

Vicki Callahan is Associate Professor in the Division of Media Arts + Practice in the School of Cinematic Arts at the University of Southern California, where she teaches courses focused on the integration of theory and practice with attention to issues of media history and theory, digital culture, social media + remix, transmedia, and media strategies for social change. She is author of *Zones of Anxiety: Movement, Musidora, and the Crime Serials of Louis Feuillade* (WSUP 2005) and editor for the collection, *Reclaiming the Archive: Feminism and Film History* (WSUP 2010). Her essays on feminist history and theory appear in the journals *Camera Obscura, Cinema Journal, Velvet Light Trap,* and *Sight and Sound.* She is working on a monograph on the silent film star, Mabel Normand. Founder of the Feminism 3.0 website and co-founder of the Transmedia Activism site, she works with Sarah Atkinson on the Transmedia Database Project, a scholarly resource site for cross-platform storytelling.

Virginia Kuhn is Associate Professor in the Division of Media Arts + Practice in the School of Cinematic Arts at the University of Southern California. Her work centers on digital rhetoric and visual culture and her current research project, the VAT (video analysis tableau), applies computational analysis to the study of vast video archives. In 2005 she successfully defended one of the first born-digital dissertations in the US, titled *Ways of Composing: Visual Literacy in the Digital Age,* which challenged archiving and copyright conventions, and published the first article composed in the digital platform, Scalar, titled "Filmic Texts and the Rise of the Fifth Estate." She recently edited her second peer-reviewed digital anthology, *MoMLA: From Gallery to Webtext,* and is now working on a monograph. Her work can be found in a variety of print and digital journals and serves on the editorial boards of several journals.

Index

300 (film), 149, 152, 161

academic discourse, 5
Academy Awards, 89
Accra, 75, 84–85, 88
Afghanistan, 111, 126
African Savage stereotype, 77–79, 82, 85–87
Afroalienation, 20
Afrofuturism, 3, 4, 11, 16–17, 20–21, 24, 39, 70, 73–74
Age of Discovery, 78
Aguilera, Christina, 15, 22
Amazing Spider-Man, The (film, 2012), 94, 102
American Dream, 32
Ant Farm, 27, 36
Antebellum, 71
Apparition Series, The, 70–71
Avatar (film), 60, 64, 66–67, 70, 73–74
avatars, 60, 61, 64–66, 68–72, 155

Baartman, Saartjie, 34, 61
Badu, Erykah, 24, 27–42
Bal Negre, 23
Banks, Azealia, 14, 23–24
Barbie, 20–21, 51–52
Barkley, Gnarls, 17
Battlestar Galactica, 96, 129
BBC, 83
Beale, Howard, 32, 37
Bell, Brad, 128–129, 131, 139, 143, 145, 147–148

Best Years of Our Lives, The (film), 110–114, 116–117, 120–121, 123, 127
birth control, 5
black identity, 14, 29
Blade Runner (film), 19
blaxploitation, 44, 49–52
blonde ambition, 16
Bond, James, 100, 145
Brazil (film), 19
Breitz, Candice, 62, 73
Brite, Rainbow, 101

Campbell, Naomi, 23
Chaka Kahn, 33
Christianity, 57, 79
Cinderella (film), 29
Clinton, George, 17, 21
CNN, 40, 83
Cold War, 20, 26
Color Purple, The (film), 29
Common, 30
Console-ing Passions Conference, 4
Culture Wars, 14, 23
CW: CW Seed, 130, 143, 144, 145
CW, the, 93, 129, 130, 134, 143, 144, 145, 148

dandyism, 18
Davis, Wendy, 5
Dealey Plaza, 27, 29, 34
DeGeneres, Ellen, 137, 141

171

Department of Defense, 111
desexualization, 129, 131, 139
diaspora, 16, 57, 87
disenfranchisement, 16
dominance, 8, 9, 15, 98
DuBois, W.E.B., 16

Electronic Arts (EA), 69
emancipation, 19
emergent media, 4
Enlightenment, 78
Espenson, Jane, 128, 129, 130–136, 143, 144, 145, 147, 148

Facebook, 5, 70, 76, 134
feminism, 4–9, 13–16, 18, 19, 22, 24, 28, 30, 40–41, 89, 111, 118, 126, 149, 159, 161
third wave feminism, 13–14, 18, 22, 24
feminist writing, 4
film franchises, 46, 47, 58, 91–99, 102, 103, 104
Fincher, David, 91, 96, 98, 105–106
Flaming Lips, The, 38, 40, 41, 147
Fluke, Sandra, 5
future texts, 3, 4, 9, 11, 29, 43, 145

GamerGate, 5
Ganja and Hess (film), 44, 52, 55, 56
Gaye, Marvin, 31, 32
Geena Davis Institute for Gender, 89, 163
gender, 3–6, 8, 9, 15, 16, 19, 24, 28, 29, 37, 39, 51, 60, 62, 65, 70–73, 80, 89, 93, 103–104, 107, 110–111, 117–118, 121–123, 124, 126, 136, 145, 150, 158, 161, 163
gender identity, 89
Generation Y, 14, 15, 16, 21, 22, 24

Ghana, 75, 76, 77, 81, 82, 83, 84, 85, 86, 87, 88
Girl with the Dragon Tattoo, The (film, 2011), 91–92, 95, 102, 106, 109, 161
Glee, 137, 138, 146, 147
Great Chain of Being, 79
Greenaway, Peter, 162, 163
Guerilla Girls style, 7, 31

H&M, 102, 103, 108, 109
Hanna (film), 161
Harajuku, 20, 21, 51, 52
hegemonic texts, 3, 9, 11, 89, 118
HER (game), 60, 69, 72
heterosexism, 13, 19
HIV, 133, 148
hollywoodization, 93, 98, 104
Home of the Brave (film), 110, 112, 117, 118, 119, 120, 121, 123, 127
Huffington Post, The, 41, 103, 130, 145, 147, 148
Husbands, 128–148
hybridization, 17, 20, 61, 72, 80, 89, 152
hyper-realism, 152, 154
hypersexuality, 79

I Love Lucy, 131
identity politics, 4
IndieWire, 99, 101, 109
inequity, 5, 158
Invisible War (documentary), 111
Iraq, 111, 117, 119, 120, 124–127
It Gets Better project, 132, 146, 148

Jet (magazine), 29, 42
Jim Crow, 63

Kennedy, John F., 27, 34, 36
King, Jr., Martin Luther, 37
Knowles, Beyoncé, 6, 7, 15, 16, 25, 48

Kwasi, Paa, 76, 81–82, 85–88

Lady Gaga, 14, 15, 16, 21, 26
Larsson, Stieg, 91, 95, 96, 100, 104, 107
Lennon, John, 33
LGBT representation, 14, 128, 129, 130, 131, 132, 135, 136, 138, 141, 142, 144, 146
LGBT rights, 14, 128, 129, 130, 131, 132, 135, 136, 138, 141, 142, 144, 146
liminality, 47, 48, 53, 54
Lucky Ones, The (film), 110, 112, 117, 118, 119, 120, 123, 126, 127

M.I.A., 22
Madonna, 13, 14, 15, 16, 21, 22, 23, 24, 25, 26
Mara, Rooney, 91, 99, 100, 101, 104, 105, 106, 107, 108
marginalization, 16, 81
Marvel, 150, 154
masculinity, 19, 110, 111, 112, 113, 114, 116, 118
materialism, 14
Matrix, The (film), 61, 67, 68
Matt and Kim, 36, 41
Mayweather, Cindi, 17, 18, 19, 20
Metropolis (film), 14, 17, 19, 25
Middle Passage, 16
Minaj, Nicki, 14, 16, 20–24, 26, 43, 49–52
Modern Family, 129–132, 137–139, 141–148
Monáe, Janelle, 14–20, 23 –26, 38–39, 41, 42
Music Box Films, 95, 96
Mutu, Wangechi, 71, 74
Myrthia, 53, 54, 56, 57

narrative, 9, 25, 34, 36, 45–48, 51–57, 63, 92, 103–106, 110–112, 114–116, 128–132, 138, 149, 150–155, 157–158, 161
narrative structure, 3–4, 63, 89, 99, 104, 129, 150, 152
Nation of Islam, 32
National Socialism, 17
necromancy, 29
Nelson, Alonda, 3, 10–12, 16, 18, 26, 29, 41, 61, 72, 74
neo-soul, 29, 31, 39
Netflix, 95, 131
Network (film), 32, 111, 127, 144
New Normal, The (film), 129, 132, 139–142, 144
New School, The: Eugene Lang College, 6, 9
New York Times, 15, 20, 22, 26, 29, 42, 89–90, 149, 164
Nichols, Nichelle, 45
Norment, Camille, 70, 74
Northwestern University, 65

Ofori-Mensah, Kwadwo, 81–82, 86, 87
OMG! (website), 75–77, 81–88
Ono, Yoko, 33, 36
Oplev, Niels Arden, 91, 96, 97
othering, 65
OutKast, 17, 30

paganism, 53, 56, 57, 79
patriarchal culture, 4, 153, 161
patriarchy, 4, 8, 13, 16, 22, 24, 44, 56–57, 153, 161
polyvocality, 4
popular culture, 3, 5, 13, 16, 20, 22, 43, 76, 89, 91, 116, 150
pornification, 93, 98–99, 101
Post Traumatic Stress Disorder, 111, 118, 121
post-black culture, 14
post-Civil Rights era, 19, 24
postcolonial Africa, 22, 82, 161

postfeminism, 14, 19, 24, 111, 113, 118–119, 120, 124, 126
posthumanism, 6
postmodernism, 13, 14, 15, 16, 22, 24

R&B, 14, 15, 18, 19, 24, 31
race, 3–4, 8–9, 15, –16, 24, 28–29, 37, 39, 41, 45, 47–48, 60, 65–66, 70–73, 84, 150, 161
racial difference, 3
racism, 13, 19, 44, 50, 52, 161
Renaissance, 59, 153
Return (film), 33, 41, 42, 110, 112, 117–118, 120, 123, 127, 136, 148
Rolling Stone, 33, 102, 108, 149, 153, 159, 163–164

Saldana, Zoe, 43, 45–49, 59, 66
San Diego Comic-Con, 130
Santigold, 71–72, 74
Sarkeesian, Anita, 5
scopic, 6, 8, 9, 89
scopophilia, 7
Second Life, 65, 73, 163
sexism, 7, 13, 19, 50, 52, 161
sexuality, 3, 5, 14–16, 20, 21, 45, 51, 57, 71, 78, 80, 86, 111, 123, 126, 133, 139, 145–146
Sherlock Holmes, 145
slavery, 20, 61, 63
SNL, 44, 49, 50
Snyder, Zach, 149, 152–154, 158, 160–164
Social Text, 3, 10, 12, 26, 41, 74
Sony, 91–100, 102–107
Spears, Britney, 14, 15, 22
Star Trek (film. 2012), 21, 35, 44–48, 50, 58, 94
Sucker Punch, 149–154, 156 –164
Summerville, Trish, 102
synchronizing, 3, 4, 9, 29, 33, 35, 39

technology, 3, 16, 18, 52, 61, 66, 67, 72, 81, 84, 88
The Archandroid, 17
third wave feminism, 13–15, 22, 24
Tobago Jazz Festival, 36, 37
Tomb Raider, 68
Tuskegee Syphilis experiment, 18
Twitter, 35, 38, 70, 130, 134

Underground Railroad, 20
United Nations, 7, 10
universalism, 28
USC Annenberg School of Communication and Journalism, 89, 90

Variety, 89, 90, 148, 149
V-E Day, 116
video games, 22, 27, 60, 64–66, 68–70, 120, 135, 144, 150–152, 154, 158
Vietnam, 112, 124, 127, 138
violence, 5, 16, 27, 62, 78, 85–87, 103, 118, 153
virtual reality, 60, 61, 64–66, 68, 71–72, 82
VMA Awards, 6, 7
Vogue (magazine), 14, 22–23, 103, 108

Walker, Kara, 60, 63, 70–73
Warner Bros., 92, 94, 95
Watchmen, 149, 152
Watson, Emma, 7, 10
webisodes, 134
Western culture, 11, 18, 48, 75–88, 163
Whedon, Joss, 134, 148
womanism, 27–28, 30, 34, 37, 39
World War II, 110, 112, 126–127

YouTube, 9, 25–26, 39, 40–41

www.ingramcontent.com/pod-product-compliance
Lightning Source LLC
Chambersburg PA
CBHW032215230426
43672CB00011B/2563